GET THE MOST FROM YOUR
DIGITAL CAMERA

GET THE MOST FROM YOUR DIGITAL CAMERA

THE ULTIMATE GUIDE TO DIGITAL CAMERAS, SOFTWARE, PRINTING AND TECHNIQUE *SIMON JOINSON*

David and Charles

PICTURE CREDITS & ACKNOWLEDGMENTS

All photographs by Simon Joinson except:

Julian Cornish Trestrail 29, 145 (bottom two) · **Stephanie Krahn** 53 (2nd from bottom, left) · **Gavin Stoker** 74 (right), 85 (bottom right), 140 (top) · **Claire Joinson** 134 (bottom right) · **Steve Davey** 66 (top left and 2nd from left), 80 (middle right), 127 (sidebar 2nd down), 105 (sidebar centre) · **Gordon Solomon** 65 (bottom) · **istockphoto.com** 138 (bottom), 97 (top left), 101 (top), 100 (top & centre left), 103 (top & centre bottom), 104, 105 (centre left), 106, 107, 112 (bottom), 115, 116 (bottom left), 118 (bottom right), 119 (bottom left), 85 (top), 86 (top left), 87 (centre left), 90, 91 (right top & bottom), 92, 93, 94 (centre & bottom left), 95 (bottom).

Other pictures supplied by **Photodisc, Ulead, Ingram Publishing, Getty, Alamy, Adobe.** Many thanks to the various hardware and software manufacturers who supplied product photography and equipment. All trademarks and registered trademarks are the property of their respective owners.

Thanks also to Claire for her patience and help.

For Felix.

A DAVID & CHARLES BOOK

David & Charles is an F+W Publications Inc. company
4700 East Galbraith Road
Cincinnati, OH 45236

First published in 2004 and revised and updated for this new edition published in 2007

ISBN: 978-0-7153-2598-8 paperback
ISBN: 0-7153-2598-1 paperback

Original edition and this edition designed by Simon Joinson

Printed in China by Shenzhen Donnelley Printing Co., Ltd for David & Charles
Brunel House, Newton Abbot, Devon

Commissioning Editor: Neil Baber
Assistant Editor: Louise Clark
Head of Design: Prudence Rogers
Production Controller: Bev Richardson

Visit our website at www.davidandcharles.co.uk

David & Charles books are available from all good bookshops; alternatively you can contact our Orderline on 0870 9908222 or write to us at FREEPOST EX2 110, D&C Direct, Newton Abbot, TQ12 4ZZ (no stamp required UK only); US customers call 800-289-0963 and Canadian customers call 800-840-5220.

Contents

Introduction

The digital camera opens up new creative worlds that can turn anyone from a snapper into a photographer. With no film to waste and a screen to check your results, you have no excuse not to start taking better pictures!

Unlike many photography books, this one has been written from the start as a companion to a digital camera, and the vast majority of the photographs featured were taken on the same non-professional compact and entry-level single-lens reflex (SLR) models that you, the readers, are likely to be using. You'll discover how to take advantage of, and overcome, some of the unique foibles of modern digital cameras. This book will also tell you when and how to use all those modes and menus to get the best possible picture every time. Finally, I hope this book will open your eyes to the creative possibilities available if you carry your camera wherever you go and learn to think before you shoot.

Part of the beauty of digital photography is that, unlike film, pressing the button is only the start of the process; you can shoot less-than-perfect photos safe in the knowledge that the flaws can be removed later using simple software techniques. Some of the image-editing basics are covered in the final chapter of this book.

This is not a replacement for your camera's manual, but a guide to the technology and techniques you can use to turn simple snapshots into something you'll be proud of. Taking better pictures is an addictive pastime, and once you have enjoyed the unique satisfaction of producing something special you'll never look back!

Modern digital cameras are extremely sophisticated devices that are capable of producing perfectly acceptable results in a wide variety of situations with no user intervention at all. Because of this, and the lack of fully manual controls on many popular models, I have concentrated on techniques that can be used with even the simplest of digital cameras. You'll learn how to frame pictures, how to use the various settings common to all cameras, how and when to use flash and when to turn it off. You'll also learn how to avoid the common pitfalls of digital photography and why you sometimes have to get out of bed at 4.30am to get the perfect picture.

Finally, and perhaps most importantly, you will learn the value of experimentation and practice. Digital cameras turn the traditional paradigm on its head; the cameras are expensive but each picture is, to all intents and purposes, free. You're not wasting film, and you can view, and delete if necessary, every picture you take the instant after you've taken it. Professional photographers often take hundreds of pictures to capture one good shot, so you can't expect to improve your hit rate if you take only 50 photos a year. Photography has the power to move you, to inspire you, to make you laugh out loud or hold back a tear. Every shot is a moment, so make them all count.

Digital basics

In the space of a few years, digital cameras have gone from being overpriced toys to enjoying such levels of popularity that they now outsell their film equivalents. With this new technology has come new challenges. There's a lot to learn, but don't worry; here you'll find everything you need to know to start taking great pictures.

The digital camera

They may all look very different, but the majority of digital cameras are similar under the surface, and shouldn't be any more difficult to use than a film camera. This section looks at how digital cameras work, which of the many features and functions you need to master – and which you can safely ignore.

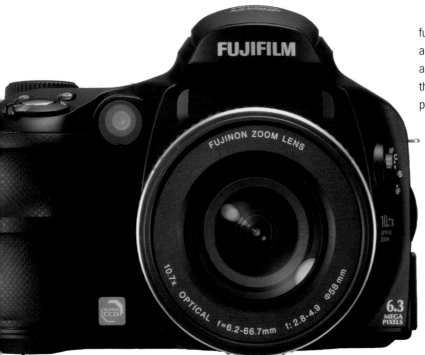

▲ High-end digital cameras such as this one often rival serious film SLRs in terms of features and controls, and can produce images of similar – or better – quality. All also have simple 'point-and-shoot' modes for the uninitiated user.

The revolution starts here

Digital cameras have revolutionized photography by doing away with film, instead capturing and saving your images electronically. This has several benefits. Perhaps the most significant is that it allows the use of a colour screen to check your pictures once you've taken them, and to delete or retake shots that don't turn out as you wanted. No longer do you need to have every picture you take printed before you decide whether or not it is worth keeping. This is why, in the long run, and despite their higher initial price, digital cameras have lower running costs than the film models that have been used for the last century or so. But there is an even more

fundamental difference between shooting digitally and using film. Because the photos can be easily and quickly transferred to your home computer, there is virtually no limit to what you do both practically and creatively with your images. Creating special effects; inexpensive sharing via email or websites; printing; viewing slideshows on your TV screen; producing professional-looking flyers and newsletters; or making your own cards, calendars and screensavers — the only limit is your imagination. If a picture is worth a thousand words then a digital photograph must be worth a thousand conventional postcard prints; such is the versatility of the modern personal computer.

The same, but so different

Fundamentally, digital cameras differ little from modern 35mm or Advanced Photographic System (APS) cameras, which in turn are merely a development of the same basic design first seen more than 150 years ago with the earliest plate cameras. A light-sensitive material (film or the digital sensor) sits inside a light-tight box behind a shutter that can be opened for a set time (usually a fraction of a second). In front of the shutter is a glass (or plastic) lens that focuses light sharply onto the sensor/film. In most cases, there is a variable aperture inside the lens that can be used to control the amount of light entering the camera to take account of the difference in brightness between, say, a bright summer's day and a grey winter morning. And that's all there is to it; in a traditional camera each photograph is stored on the film itself, which then has to be chemically developed and

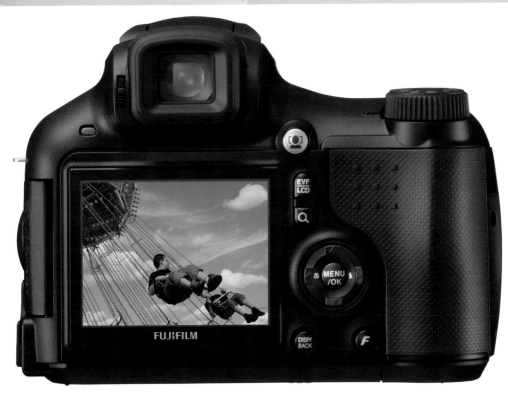

printed before you can see the picture. A digital camera stores your photographs on a special memory chip in a file format that can be read by suitable software on your computer. Once you have copied or printed the pictures, the memory can be reused time and time again (at least a million photos per card, according to one manufacturer).

Like modern film cameras, the latest digital models offer a huge range of additional features designed to give you more control over your picture-taking, or to make getting a good shot easier. From zoom lenses to multi-area autofocus systems and special scene modes, over the next few pages you will discover all you need to know when choosing – and using – a digital camera.

One of the biggest advantages of shooting digitally is the colour screen on the back of the camera. As well as allowing you to compose your pictures perfectly (the preview shows exactly what the lens sees), the screen offers instant feedback. Switch to 'play' and you can immediately review the pictures you've taken – zooming right in to check sharpness if you wish. This means you can delete poor shots and avoid disappointment when you get back home and print the pictures or put them up on screen.

Camera types

Take a look in any camera shop and you would be forgiven for finding the range on offer daunting. The hundreds of models on sale can be divided into four broad categories, however:

▲ Entry-level
Up to five million pixels, with limited features, plastic body and a small zoom lens.

▲ Mid-range
The majority of cameras in the marketplace; six to ten million pixels, plenty of features and good value for money.

▲ 'Prosumer'
Bridging the gap between mid-range (see above) and SLRs (see below); high resolutions, big zooms and lots of control.

▲ Digital SLR
High-quality, expensive and extremely versatile units with interchangeable lenses and extensive system back-up.

Anatomy of a digital camera

Take a closer look at what makes up a digital camera, and discover how each component contributes towards making the final picture.

DSP: The digital signal processor (DSP) turns the signal produced by the sensor into the zeros and ones of a digital file. How well it does this has a huge impact on image quality.

The lens: Focuses the light from the scene sharply onto the CCD or CMOS sensor (see far right). Most focus automatically, and most have the ability to zoom – ie, change the angle of view from wide to telephoto.

Lens hood: Usually an optional extra, and generally only available for top-end cameras, the lens hood stops stray light from entering the lens at glancing angles (which can cause internal reflections, resulting in 'flare').

Break open a digital camera – even a cheap and cheerful point-and-shoot model – and you'll find a tightly packed jumble of electronics, processors and optics. Taking a look inside yours is, of course, not recommended!

▼ **Look closely at a digital image and you'll see how it is made up; by dividing the scene into a patchwork of squares, each with its own colour and brightness value.**

In order to take a sharp, clear picture, every component of a digital camera has to be optimized to capture the most detail with the least noise (interference).

There are four key contributors to image quality: the lens; the exposure, focus and white balance system; the CCD or CMOS sensor (see far right); and the processing applied to the raw data as the camera creates the file it saves to the memory card. Despite the fact that virtually all digital cameras are sold on their resolution (the number of pixels

on the sensor), the other three factors mentioned above have as much – if not more – to do with the sharpness, colour, brightness and contrast of your photos. This is why two cameras with seemingly identical specifications can produce such different results, and why – like taking a car for a test drive – you should ask to see sample prints or download samples from the Internet before you buy.

Sensors

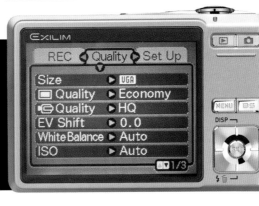

Flash: All but the cheapest cameras have a built-in flash unit for when it is too dark to take a picture with available light. Some cameras have a connection for an additional, more powerful and more versatile flashgun.

Sensor: Deep in the heart of the camera, directly behind the lens, lies a special light-sensitive chip covered in tiny 'pixels' (see right), each of which turns the light falling onto it into an electrical signal. This signal is then passed onto the camera's DSP to be turned into a digital file.

Viewfinder: Some cameras have an optical viewfinder; some an electronic viewfinder (some don't have one at all). It is useful for when shooting in bright light when the colour screen can suffer from glare. It also uses less battery power than the colour screen.

Controls: Although they vary from model to model, you normally find external controls for zooming, macro (close-up) mode and flash mode. More advanced cameras will have external buttons and switches allowing fast access to creative controls; simpler models use on-screen menus to change most settings.

Most compact cameras use the colour screen not only for previewing and playing back photos already taken, but also for access to advanced controls and options. The on-screen menu systems used in modern cameras are fairly advanced and becoming easier to use all the time. Navigating through the menus often involves the use of a four-way controller, as shown here. The design of the interface and menu system has a huge impact on the usability of the camera.

At the heart of every digital camera lies a chip that turns light into electrical current. Most cameras use a CCD sensor (Charge-Coupled Device), although several entry-level and a few high-end cameras use an alternative design known as a CMOS chip (Complementary Metal Oxide Semiconductor). The sensor is made up of anything from 300,000 to many millions of tiny light-sensitive photodiodes arranged in a simple grid, each with its own tiny microlens and colour filter.

The number of these 'pixels' defines the camera's resolution – a measure of its ability to record sharp detail. Although there are only a few manufacturers (many cameras share the same sensor), they don't produce the same results. This is because the lens, exposure and focus systems and image processing (the in-camera computer that produces the final digital file) all affect image quality. This is why an excellent five million pixel camera offers better results than a poor ten million pixel camera; it isn't only about numbers.

Basic digicam features

Cameras have come a long way since Kodak's famous slogan 'you press the button and we'll do the rest'. Most models have a plethora of features, functions and options guaranteed to befuddle the first-time user.

▲ **Digital video cameras now offer stills capabilities able to rival most entry-level stills cameras. What you won't get is any real creative control.**

Buttons, buttons everywhere

The first attempt at using a digital camera can be a rather daunting experience. Most mid-range and high-end camera bodies are cluttered with buttons and switches, and most also have pages and pages of on-screen menus for all the functions left when the designers had run out of surface area for more buttons. How easily you master the many controls – and whether you actually ever need to – will depend on your photographic experience (many of the controls are identical to those found on a 35mm film SLR) and on your desire to take creative control of your photography. If you want nothing more than to 'point and shoot'

then even a semi-professional beast of a camera bristling with knobs and buttons will offer a simple fully automatic mode that will produce perfectly acceptable pictures in all but the most extreme of shooting situations. But if all you wanted to do was to take some straightforward family snaps then you wouldn't be reading this book, would you? The next section will look at how you can take pictures of real, lasting value and discover how easy it is to take control of your camera and use the features of even the simplest model to lift your photography above the norm. For now, here is a brief introduction to the various features and functions found on the majority of digital cameras that are on the market today.

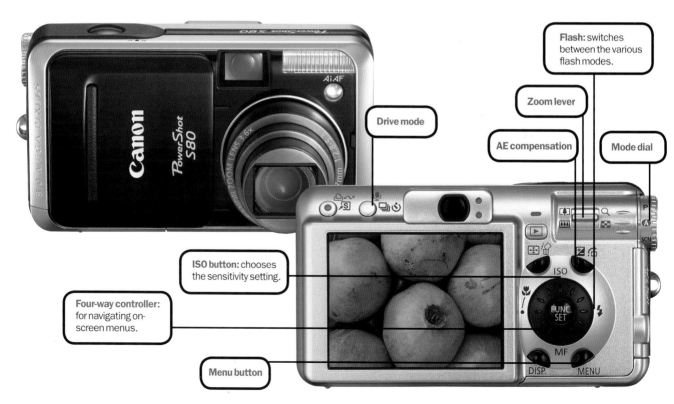

Flash: switches between the various flash modes.

Zoom lever

Drive mode

AE compensation

Mode dial

ISO button: chooses the sensitivity setting.

Four-way controller: for navigating on-screen menus.

Menu button

Digital camera power

Digital cameras are extremely power-hungry, especially when using the colour screen. Battery life is therefore a serious issue. Modern cameras use either special proprietary rechargeable packs (usually good for about 300 shots or an hour or so of the colour screen in continuous use) or standard AAs. If your camera takes AA batteries, use the latest NiMH (Nickel Metal Hydride) rechargeables – these are the only type powerful enough to run a digital camera for a reasonable time.

Photographic functions

All but the cheapest digital cameras offer a range of photographic controls that are similar to a good high-end film camera. As you move further up the camera range, you will find more and more sophisticated features and functions.

Zoom

More than 90 per cent of digital cameras have a zoom lens that allows you to alter the field of view without physically moving yourself (see page 55). On compact models, zooms tend to be motorized, so zooming in (for a closer view) or out (to take in more of a scene) is a simple press of a button.

Focus

The lens has to be focused on the main subject of your photo to ensure a sharp end result. Generally, focusing is fully automatic, with manual focus options and advanced multi-area focus systems now common on more expensive cameras (see pages 60–63). Virtually all cameras have a special macro mode for taking close-ups. Some allow you to get as close as a couple of centimetres from your subject (see pages 116–119).

Exposure and metering

In order to avoid overexposed (too bright) or underexposed (too dark) results, the camera must measure the brightness of the scene and set the exposure accordingly. Many cameras offer a variety of metering options (including spot metering for measuring a tiny portion of the scene), and all set the exposure for you automatically (see pages 61–69). The ability to override the chosen exposure (to make the picture darker or brighter than the camera has decided) – known as Auto Exposure Compensation (AE-C) – is also almost universal on modern cameras. True exposure control, where the user can choose to set their own apertures and/or shutter speeds, is now increasingly common on even relatively cheap cameras (and is standard for high-end models). The ability to set your own exposures is one of the key elements of creative photography, and taking the time to master the controls will pay rich dividends once you start shooting.

File formats

Most digital cameras store the pictures they take in a file format, JPEG, which is the closest thing there is to a universal standard for digital photographs. JPEG is so popular because it can 'squash' files down so they take up much less space on the memory card. The downside is that JPEG files lose a small amount of quality as they are compressed. The JPEG format allows you to choose the level of compression; high compression makes much smaller files, but at the cost of lower quality. This is the basis of your camera's 'quality' settings; you choose more pictures or better quality. Many cameras also offer an uncompressed RAW or TIFF mode for the ultimate in quality.

MIC

PowerShot S50

SET

▲ There are many more cameraphones being sold than digital cameras, and they are getting better all the time. However, they offer none of the versatility or the picture quality of a dedicated digital stills camera.

Subject/scene modes

If you don't want to get bogged down in exposure considerations, a camera with a decent array of subject modes will allow you to take more professional-looking pictures at the push of a button. You simply choose from a list of subjects – portraits, landscapes, sports, night photography and so on – and the camera tailors the exposure and focus systems to get the best possible result. Although not a complete replacement for doing it all yourself, such modes can seriously improve the results you get when shooting awkward subjects such as night portraits, sunsets or sports action.

Flash

There are always going to be times when there simply isn't enough light available to take a photograph. It is fortunate, then, that the majority of cameras have their own powerful light source in the form of a built-in flash, which fires by default whenever it is needed. Although undoubtedly useful, flash is by no means suitable for all low-light photography – when shooting a sunset, for example. In such cases, you will need to turn the automatic flash off. Conversely, you may want to fire the flash even if the camera doesn't need it (to fill in shadows, for example); thus cameras usually offer a simple 'flash on' mode too.

Finally, there is often a red-eye reduction mode that uses a small pre-flash to help counter the 'evil eyes' that blight so many portraits. More advanced features such as slow sync mode and flash output control are covered – along with flash techniques – on pages 89–91.

White balance

No two light sources are the same colour: standard household lightbulbs are very warm (orange); a bright sunny day is much cooler (blue-ish). Our vision adapts continually to these changes, meaning we hardly ever notice them – a white shirt looks white no matter what light source you look at it under. Photographs are

It's playback time

Switch to playback mode and you can review all the pictures you've taken, zoom in to check focus, view six or nine pictures at a time (as thumbnails), see information about exposure and white balance and delete any images you don't like. Most cameras have a video-out socket allowing you to run slideshows that can be watched on a television or recorded on to videotape.

Very cheap and basic cameras offer true point-and-shoot operation with little or no control. At the bottom end of the market, a colour screen is rare and a built-in flash or removable storage uncommon. Designed primarily for use as webcams, many will lose any pictures stored if the batteries run out and some – as here – don't even have a proper viewfinder (you look through a little hole).

a lot less forgiving, and the camera must measure the colour of the light in a scene and compensate accordingly. This process is known as white balance. Although all cameras do this for you automatically, they are far from foolproof, so most have manual overrides. As with exposure, you can make a significant difference to the quality of your pictures by taking control of white balance, especially in unusual situations. There is more information on white balance and colour on pages 59–60.

Movies and sound

As the technology has advanced and in-camera processing has improved, the ability to shoot short digital movies with a stills camera has become ubiquitous – and sometimes surprisingly useful. Some models are now capable of recording almost TV-quality clips limited in duration only by the amount of memory available on your card; movies use a huge amount of memory – approximately one gigabyte (1GB) for 15 minutes of the best quality currently available. Also increasingly common is the ability to record voice notes with each picture. This is useful if you are attempting to keep a record of what you have been shooting.

Digital effects

It is perhaps surprising, given the sophistication of a digital camera's processor, that so few cameras offer much in the way of special effects. More common is the option to change the amount of software sharpening, with some cameras also offering black and white and sepia tone modes and an option to select how vivid (saturated) the colours in the image appear. Digital zoom is now fairly standard on cameras with more than two million pixels. It is worth pointing out that few, if any, of these digital effects are worth paying too much attention to, as they can all be recreated with considerably more finesse using imaging software on your PC. The advantage of doing this in 'post processing' is that you still retain the original unaltered file should you decide the effect was a bad idea. The only exception to this observation is if you are using your digital camera without a computer (see right).

ISO (sensitivity)

All cameras have the ability to adjust the CCD's sensitivity to light (either automatically or manually). The settings use the same ISO numbers as film, where low numbers (ISO 50–100) are for use in bright conditions, and high numbers (ISO 400-plus) are for use in low light. It is important to understand that the lowest setting on any camera will always produce the best-quality pictures, as increasing the ISO value also increases noise (digital interference). Very few compact cameras produce acceptable results at ISO 400 or higher (unless you intend to produce only very small prints), although DSLRs are much better. Cameras offering ISO settings of up to 3200 are now available, allowing handheld photography in very low light. These settings are useful in an emergency, but don't expect great results.

No pc?

There was a time when a computer wasn't just handy for digital camera users; it was essential. This is no longer the case. As well as being able to take your memory card to a high-street printer to get a set of prints, you can also buy direct-connect printers for home use; special CD writers with built-in card readers to archive your images; and even inexpensive systems for displaying your images on a television screen directly from the memory card. What you won't get without a PC is the ability to manipulate, correct and share your images via email or the Internet – which is half the fun of working digitally in the first place. That said, the lack of a computer should not be – and is not – a reason not to take part in the digital photography revolution. For more on printing options and 'PC-free' accessories see pages 40–49.

▼ Some digital cameras offer docks or cradles. These remain attached to the host computer permanently and allow you to transfer images with the click of a button, recharge batteries or view your images on a TV screen.

Essential extras

Now that you have had a brief tour of a typical digital camera, it's time to look in a little more detail at the other things you need to start shooting digitally; from the special memory cards that store the images to useful accessories to have at hand when travelling with your camera.

▲ As cameras become smaller and smaller so the demand for tiny, high-capacity storage cards grows – thus the emergence in recent years of Sony's Memory Stick and the Fuji/Olympus xD-Picture Card.

It's all on the cards

Almost all modern digital cameras store the photos you take on special removable memory cards (sometimes also known, somewhat confusingly, as 'digital film').

There are several different card types in common use, although Secure Digital (SD) cards are by far the most popular. Each camera (with a few notable exceptions) accepts only one type, and they are not interchangeable. This is not quite the nightmare it might appear, as there is very little difference in price, performance or availability between the various formats; you simply have to make sure you buy the right type for your camera. Memory cards can be used, erased and reused hundreds of thousands of times (many come with a lifetime warranty), will keep your photos safe for decades without any power, and are getting cheaper all the time. Between 1997 and 2004 the average cost per megabyte (MB) fell by more than 99 per cent.

Size is everything

Just as cassette tapes used to come in 30-, 60- and 90-minute varieties, memory cards are available in a variety of capacities from 16MB to 4GB (4000MB) or, in the case of CompactFlash, as high as 16GB for professional photographers with deep pockets. It is generally better to buy two smaller cards than a single large one for the simple reason that cards are easy to lose and can on rare occasion become corrupted by camera malfunctions. It is better to lose half your photos than all of them.

The capacity of the card defines how many pictures you can take before it is full; this is of great importance if you are shooting away from your computer or when travelling, when the opportunities for downloading to a PC may be limited.

Card type	Capacities*	Comments
CompactFlash I	16MB to 8GB	One of the oldest and most widely used formats. Fast, and by far the cheapest for higher capacities.
Microdrive	512MB to 4GB	Tiny hard disk housed in a CompactFlash Type II card. Gradually disappearing.
Secure Digital (SD)	16MB to 2GB	Since 2005 has become the single most popular storage card type on the market thanks to its small size and high capacities. A new version (SDHC) offers capacities of 4GB and higher.
SmartMedia	8MB to 128MB	Once very popular, SmartMedia has not been used in cameras since 2004 and is effectively dead.
Memory Stick	16MB to 1GB	Developed and owned by Sony but used in some other camera brands. Slightly pricier than others.
xD-Picture Card	16MB to 1GB	Tiny card format developed jointly by Fuji and Olympus. Not used by any other manufacturer.

* At time of publication

On the move

Taking a digital camera on an extended trip – or even just a fortnight in the sun – brings about its own unique set of challenges. The biggest are power and storage. As battery and memory card prices have fallen, this is far less of an issue than it was, but if you are shooting a lot of pictures with a high-resolution camera you may want to look at the alternatives to stocking up on media cards. Several manufacturers now produce 'digital wallets', small devices containing a high-capacity hard drive and a slot for memory cards.

▲ As digital cameras have increased in popularity the number of accessories available has risen dramatically. Lens converters extend the range of your camera's built-in zoom (wider or more telephoto); card readers make image transfer fast and easy; and special high-power batteries ensure you can keep shooting for longer. Accessories for film cameras such as tripods, flashguns and filters can also be used with many high-end digital cameras.

This allows you to safely copy your photos (and in some cases view them on a colour screen) before erasing and reusing the memory cards. Standalone battery-powered CD writers with built-in card readers are also now available.

Power up

It often comes as a surprise to new users how battery-hungry digital cameras can be – especially anyone used to a film camera, many of which can run for years on a single battery. Manufacturers have been fighting a long battle to increase battery life, with power-saving circuitry and new battery technologies, but the truth is that if you are using the colour screen the best you can hope for is around one hour of continuous usage, or maybe 150 to 300 shots before the juice runs out. Cameras that use their own special rechargeable cells (like those used in video cameras or mobile phones) usually offer the most shots per charge, but the batteries themselves are expensive to replace and without a spare you will be stuck if you run out of power when out shooting for the day. New rechargeable battery technology – specifically NiMH – has seen camera manufacturers gradually moving back to the use of standard AA cells. This is useful if you find yourself stuck, as these batteries are available virtually everywhere in the world. It is always worth investing in a few extra sets of high-capacity NiMH batteries and a good, fast battery recharger; the extra initial outlay will pay for itself time and time again.

From camera to computer

These days all cameras use a standard Universal Serial Bus (USB) connection to transfer your photos from the card to the computer (although not all use the latest high-speed USB 2.0). As connecting the camera to the computer each time you want to copy photos to your hard disk can be annoying – and uses valuable battery charge – many people invest in a USB card reader. These inexpensive devices stay permanently attached to the PC and have a slot for one or more type of card. Put the card in and it appears on your desktop as though it's a new drive.

All cameras come with some bundled software on CD; this can be anything from a simple transfer utility (allowing you to view thumbnails and choose files for copying to the PC) to a fully fledged image-editing application, such as Adobe Photoshop Elements. Check what you will get before you buy.

The digital SLR

The ultimate camera for the enthusiast photographer – versatile, offering superb image quality and total control – the digital SLR camera has truly come of age. No longer the preserve of the professional photographer, a digital SLR is now a serious alternative to a high-end compact.

The digital SLR (DSLR) has been around for much longer than most people realize; the models were simply so exorbitantly expensive that sales were few and far between. Now DSLRs are widely used by professionals, and, with the introduction of consumer models costing little more than a top-of-the-range compact digital camera, they are also the fastest growing sector of the enthusiast market.

So why bother with an SLR? What is it that makes people want to carry a big, heavy – and often very complex – camera around instead of a compact model that they can fit in a breast pocket?

Snobbery aside (professional photographers often like to be seen using top-of-the-range kit), there are two compelling reasons for the serious photographer to invest in a digital SLR: versatility

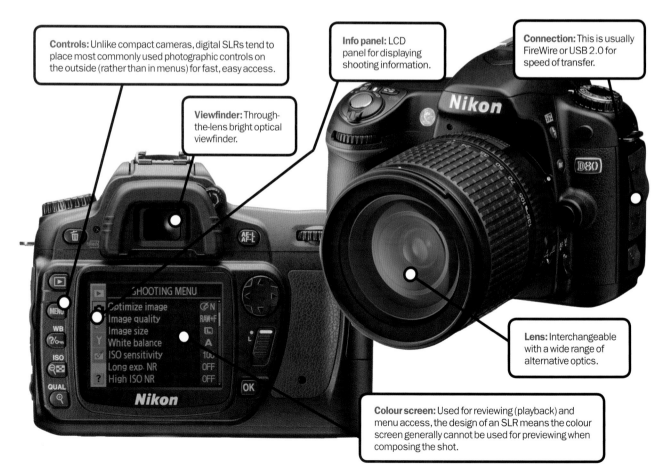

Controls: Unlike compact cameras, digital SLRs tend to place most commonly used photographic controls on the outside (rather than in menus) for fast, easy access.

Info panel: LCD panel for displaying shooting information.

Connection: This is usually FireWire or USB 2.0 for speed of transfer.

Viewfinder: Through-the-lens bright optical viewfinder.

Lens: Interchangeable with a wide range of alternative optics.

Colour screen: Used for reviewing (playback) and menu access, the design of an SLR means the colour screen generally cannot be used for previewing when composing the shot.

Inside the digital SLR

The principle behind the SLR has been around for more than 50 years. Rather than using a separate viewing and taking lens, a single, interchangeable optic is attached to the front of the camera using a bayonet. A hinged mirror inside the camera body reflects light from the scene onto a ground-glass focusing screen. Above this sits a special glass pentaprism that directs the image into an eyepiece on the back of the camera. At the point of exposure the mirror flips up in a fraction of a second. At the same time the shutter (behind the mirror) opens for the chosen exposure duration. The mirror then flips back to its original position.

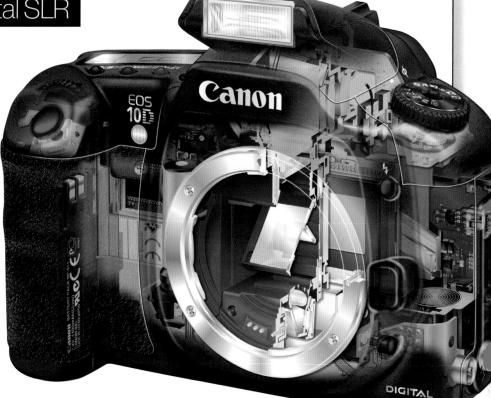

and image quality. The versatility comes from being able to take the lens off and change it for one of the many alternatives offered by camera and independent lens manufacturers. Most digital SLRs are designed to be compatible with established 35mm film SLR systems, giving users access to lenses from ultra-wide fisheyes to super-telephotos capable of picking out subjects from a long distance. Professional systems, such as those offered by market-leaders Nikon and Canon include such esoteric delights as macro bellows (for getting really close to your subject), microscope and telescope adapters, a wide variety of flashguns, infrared remote controls and much more. The point is that you are buying into a system that can grow with your photography.

▶ Much of the appeal of the digital SLR is the access it gives you to the huge systems built around conventional 35mm SLR cameras.

Crop factor

Most digital SLR sensors are much smaller than a 35mm frame of film, and because they use lenses originally designed for film SLRs, their field of view is reduced. This results in a 'crop factor', which increases the effective focal length of any lens used by a fixed factor determined by the size of the sensor. The magnification varies, but typically can be between 1.5x and 2x the indicated focal length. This is great for sports photographers using long lenses, but less useful for anyone wanting a true wideangle. It is for this reason that ultra-wide zoom lenses have been developed, starting at about 17mm. Digital cameras with full-frame (36x24mm) sensors do not suffer from this effect.

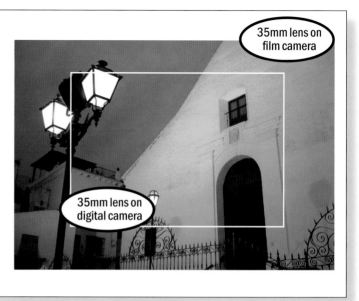

35mm lens on film camera

35mm lens on digital camera

You are not stuck with the features and the lens built in to your camera. The increased quality comes in the main part from the use of much physically larger CCD or CMOS sensors. Although the top resolution of many SLRs is similar to that of the best compacts (eight to ten million pixels is common), the sensors – and thus the pixels themselves – are much larger. This means they are more sensitive to light, resulting in lower noise and better dynamic range. Using a larger sensor also puts less strain on the lens in use (it doesn't have to resolve as much detail into a tiny space), resulting in much sharper-looking images.

There are several significant differences between using a digital SLR and a digital compact. For one thing, you cannot use the colour screen

to frame shots. Although 'live view' has recently been introduced on some models, in general you have to use the optical viewfinder. As the design of an SLR is such that looking through the viewfinder shows you exactly what the lens is seeing (you are looking through the lens, after all), this is not a disadvantage. In fact, an SLR viewfinder suffers from none of the problems of a colour screen, such as low resolution, glare in sunlight, or being too dark in low light. Digital SLRs are generally faster than compact cameras. The focus and shutter delay is negligible,

▼ Canon's EOS 300D, launched in 2003, heralded a new era of affordable digital SLRs that offered professional-quality results for little more than a top-of-the-range compact camera. Since then the market has grown immensely, with all the major players offering entry-level SLR kits.

Canon

CANON INC.

5.6

The sheer versatility of interchangeable lenses turns a digital SLR into a remarkably powerful photographic tool. From top left: 50mm macro, 17mm wide and 500mm telephoto.

Lenses

Digital SLRs can accept lenses with a wide range of focal lengths including zooms. Most systems offer everything from extreme wideangle (6–35mm), to telephotos as long as 1000mm. Each manufacturer has its own special lens mount and its own range of lenses, including those specifically tailored to the needs of digital cameras. Typically these 'tailored' lenses offer a wider angle or are specialized optics with improved resolution developed to account for the smaller sensor size. You can also use any lens made by an independent manufacturer that is designed to fit your SLR. Independent lens manufacturers such as Sigma and Tokina offer a cheaper alternative to the genuine article for anyone who is on a budget.

but they are also less forgiving of poor focus and can disappoint when used in their point-and-shoot fully automatic mode. But then you wouldn't buy a camera like this unless you intended to take control every now and again, would you?

Focus

Digital SLRs use sophisticated autofocus (AF) systems that are extremely quick and do not suffer from the focus delay often associated with compact digital cameras. Of course, you can also switch the AF off and focus manually.

Metering and exposure

As you might expect, metering and exposure systems on digital SLRs have been taken from their film counterparts. Evaluative (or matrix) metering is standard, usually complemented by spot and centre-weighted options and advanced features such as AF-area metering and auto bracketing.

Custom functions

Digital SLRs often come with comprehensive custom functions that allow you to tailor the camera to your needs or the shooting situation at hand. These functions allow you to set the camera up in a certain way and save it so that you access settings for a specific subject at the press of a button.

Flash

All digital SLRs come with a hotshoe for use with an accessory external flash. Most models also have a flash x-sync port for use with studio flash. However, not all models come with a built-in flash.

The digital image

Despite the efforts of manufacturers to make taking, editing and printing digital photos a fully automatic process, it is far from foolproof. A basic understanding of the underlying technologies will help you get the most from your digital camera and avoid disasters.

Pixels, dots and points

If there is one thing that is guaranteed to leave digital camera novices bewildered, it is the thorny question of pixels and resolution. Most cameras are sold and bought on resolution above all else. So what do all the numbers mean, and what difference do they make in the real world?

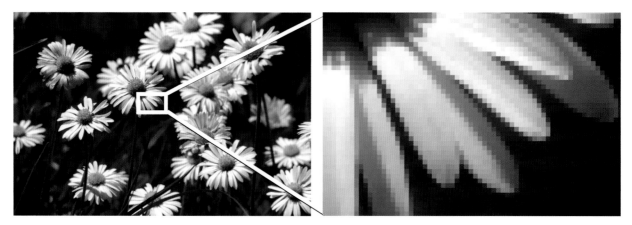

▲ All digital images are made up of thousands – usually millions – of tiny squares (pixels). When the pixels are small enough they are invisible to the human eye, which means the image looks like a 'real' photograph. The photograph of the daisies (above left) has been reproduced at approximately 175 pixels per inch (ppi). This means that there are about 30,600 pixels in each square inch. The enlarged area (shown above right), by comparison, is printed at about 25ppi. When printing an image, the key is to ensure that the pixels are small enough to be invisible.

Pixels and pictures

When a scene is photographed using a digital camera (or a photograph is scanned), it has to be converted into a form that can be understood by a computer – the zeros and ones of digital data. In simple terms, the digital process splits the scene into a grid of tiny squares (pixels), each of which has a value relating to its brightness and colour. Obviously, the finer the grid (and therefore the more pixels) used to digitize the scene, the more detail will be captured. All other things being equal – such as lens, focus, exposure and so on – more pixels means better picture quality.

Camera resolution

In digital-imaging terms, resolution refers to the number of pixels, and thus image detail, in a picture. In digital cameras, this is determined by the number of pixels on the sensor used to capture the image in the first place. Digital camera resolutions are quoted in one of two ways (although they both mean the same thing). It is common these days to

simply quote the total number of pixels on the chip used to capture the image (known as the effective resolution). Today you can buy cameras with resolutions of anything from about 3 million to 22 million pixels – 1 million pixels being 1 megapixel (1MP). The other way of quoting digital camera resolutions, which may be more useful for our purposes, is to use the actual pixel dimensions of the images produced; 3072 x 2304 pixels for a 7-megapixel camera, 2592 x 1944 pixels when using a 5-megapixel camera, and so on.

Resolution and image quality

Digital cameras are sold on resolution above any other factor, with the associated implication that the more pixels you have, the better your pictures are going to look. This is slightly misleading, however, because it places all the emphasis on what is only one part of the image quality equation. This equation also includes lens quality and sharpness, focus and exposure accuracy, sensitivity, Analog to Digital (AD) conversion, signal processing, white balance,

Top Crops

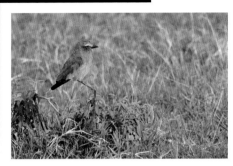

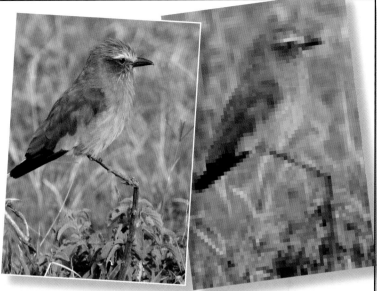

Higher-resolution images allow you to effectively enlarge a small part of the scene. The image above shows a full-frame shot as taken on a 10-megapixel (10MP) camera. The two sectional enlargements reproduced on the right show the result of cropping and enlarging the main elements with a high-resolution (10MP) and a lower-resolution (2MP) image.

Crop from 10MP image

Crop from 2MP image

noise, and any compression artefacts – and that's a simplified list! Generally, a photograph is considered to be good quality if it is sharply focused on the main subject, neither under- or overexposed, has rich but accurate colour, and is free from serious distortion or grain (noise). Yet none of these is solely (or in most cases even remotely) related to the sensor resolution. In fact, what resolution really affects is the size of the image; specifically the size it can be printed without the individual pixels being visible to the naked eye. A 4-megapixel camera can therefore produce a sharp print at exactly twice the size of a 2-megapixel camera. This only really breaks down at very low resolutions (under half a million pixels), where anything bigger than a small passport photo is going to look fuzzy and indistinct because of the lack of detail. The same applies to viewing images on-screen; you need more pixels to fill a 21-inch screen than you need for a 15-inch screen.

Camera pixels

Digital camera sensors have millions of pixels in a regular grid pattern on their surface. Each pixel is made up of a light-sensitive area (photodiode); some circuitry to carry the signal away; and a microlens to ensure as much light as possible lands on the photosite. The photodiode captures light and turns it into a measurable voltage; more light means a higher voltage. Once a value has been assigned to the output from each pixel, the image can be stored in a file and reassembled to be viewed or printed. The sensor itself is a monochrome device (it cannot see or record colour), so each pixel has a colour filter placed over it in a repeating pattern of (usually) red, green and blue (RGB). This means each pixel records light of only one colour; the three RGB channels are recombined in the camera's processor to produce the full colour image.

Photosite

Microlens

Circuitry

Colour filter

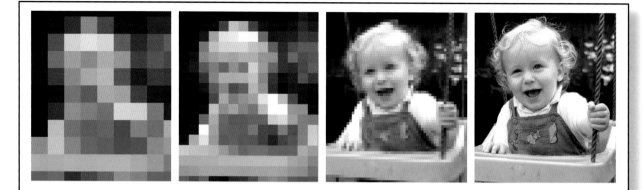

Print and printer resolution

▲ As you increase the resolution of a digital image, the pixels in the final print get smaller and smaller until you cannot see them. It is generally considered that you need to get up to about 200ppi (about 40,000 pixels per square inch) for photo-quality printing, although many people go as high as 300ppi for the very sharpest results. At 200ppi, a 3-megapixel image can safely be printed at around 8x10in.

▼ The table below shows the maximum print size in inches for various digital camera resolutions at 150, 200 and 300ppi.

Printer resolution

The relationship between camera resolution and print size is fairly straightforward, but it is complicated somewhat by the rather misleading way in which photo inkjet printers are specified.

Colour inkjet printers use patterns of tiny dots that are invisible to the human eye to build up the print. The printer has only four or six coloured inks (black, cyan, magenta and yellow and sometimes photo cyan and photo magenta). The millions of tones in your photo are recreated using complex patterns of these four or six colours. The inks themselves do not mix to make new colours; your eye is tricked into seeing a full spectrum of colours simply because the individual dots are so small.

When you buy a photo inkjet printer, the print resolution will be quoted in dots per inch (dpi) and can be anything from 720 to 4800dpi. This is a measure of the number of the printer's tiny dots; it has nothing to do with pixels. This is perhaps the most common misconception in digital printing – that your image needs to be the same resolution (in pixels per inch or ppi) as the printer's quoted resolution (in dots per inch or dpi).

Each pixel in your image has to be reproduced on paper in all its glorious colour using dots of the four or six coloured inks inside the printer. Each pixel in your image may therefore be reproduced using as many as six of these printer dots.

Can you see the dots?

So how does image resolution relate to print size? Simple. Your camera produces a fixed number of pixels per image. The following example uses a 2-megapixel camera: the maximum file dimensions of the photos the camera takes are 1200x1600 pixels. If you printed that image at a resolution of one pixel per inch, you'd get a photo 1200x1600in, but with each pixel appearing on the paper as a one-inch square. The printer would still be laying down its 2880 or 4800 dots per inch, but your image would – unless you were viewing it from a considerable distance away – look very blocky (pixellated). Of course, you don't want to produce images to be viewed from a ludicrous distance or that are three metres high! What you want are prints that don't have visible pixels at normal viewing distances (about 46cm/18in away). It turns out that printing your digital photographs at somewhere between 200 and 300ppi is about right, so in this example you could happily print at up to about 8x6in (200ppi).

Print resolution >	150ppi print	200ppi print	300ppi print
3MP (1536x2048 pixels)	10x14in	8x10in	5x7in
5MP (1920x2560 pixels)	13x17in	10x13in	6.5x8.5in
6MP (2112x2816 pixels)	14x19in	10.5x14in	7x9.5in
7MP (2304x3072 pixels)	15x20in	11.5x15in	7x10in
10MP (2736x3648 pixels)	18x24in	14x18in	9x12in

Interpolation

Most software applications, and a few cameras, allow you to increase the number of pixels in an image to increase its resolution. The process – known as interpolation – is highly complex but in essence does little more than 'fill in the gaps', adding new pixels according to intelligent guesswork.

What interpolation cannot do is add extra detail; to get that, you need to reshoot at a higher resolution. Generally speaking, increasing resolution by up to 30 per cent in order to produce less-pixellated prints is worthwhile; any more is pointless. Interpolating very low-resolution pictures is, as shown below, rarely successful.

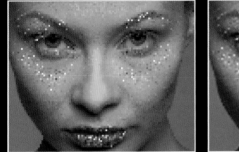
Original low resolution image

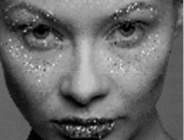
Interpolated to a higher resolution

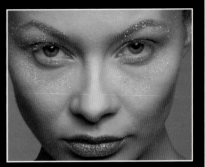
Reshot at a higher resolution

What this all means is that if you only ever print postcard-sized photos, and your pictures are well exposed and sharply focused you do not need more than, say, three million pixels. Of course, shooting at low resolutions does have a drawback: you cannot add detail back into a photo if it wasn't captured in the first place, so you can't then have a poster print made and expect to see ultra-sharp fine detail. That said, for the majority of casual users, there is little benefit in shooting with compact cameras at resolutions over around seven million pixels; the increase in noise means heavy noise reduction is used in-camera, and there simply won't be any more detail in your pictures.

But is it effective?

Before leaving the subject of camera resolution behind for now, it is worth mentioning the potentially confusing matter of how manufacturers actually define their own cameras' resolutions. All sensors have more pixels than actually appear in the final image; those around the edge are not used for picture-making. The absolute number of pixels on the sensor – including those that do not appear in the final image – is known as the 'total

resolution' or 'sensor resolution'. This means that a 7-megapixel (7.2MP) camera will usually produce a 6.9-megapixel image. The latter figure, which is known as the 'effective resolution' is the important one, and is the one that camera manufacturers are supposed to quote.

Size is everything

As image resolutions increase, so does the file size of the digital photos captured. This has serious ramifications for digital camera users with a fixed amount of storage on their memory cards. For example, a 2MP colour image contains around 5.5MB of data, while the equivalent file from a 5-megapixel camera comes in at a hefty 15MB. Given that most cameras come with, at most, a 64MB memory card, this puts an unacceptable limit on how many pictures you can fit on a single card – even if you buy a large one. The answer lies in the file format used to store the images on the card prior to transferring them to your computer.

Files and formats

Most computer users are aware that the files on their PC are not all the same; there are many

JARGON BUSTER

Noise: All digital cameras suffer to some degree from 'noise' caused by interference in the sensor's circuits. Noise appears as randomly coloured pixels in solid areas of colour and gets progressively worse as light levels fall. (See page 34 for more information.)

JPEG and TIFF image quality

As these enlargements of a small section of an image show, there is little visible difference between the image shot in (uncompressed) TIFF mode and that taken at the highest JPEG quality setting (1:10 compression). Moving on to the lowest-quality JPEG, however, the characteristic JPEG artefacts (errors) have appeared, with the image obviously degraded and broken up into a visible grid of squares. Even so, this image could still be printed at a smaller size with perfectly satisfactory results.

Uncompressed TIFF: 2.6MB Best-quality JPEG: 0.3MB Lowest-quality JPEG: 0.05MB

different file formats in existence, as indicated by the three-letter suffix (such as '.txt') that comes after the filename. Many are specific to particular applications – '.doc' for Microsoft Word, '.psd' for Photoshop and so on, but there are some relatively universal formats in existence that can be opened and edited by a wide range of programs. JPEG (.jpg) is the nearest thing there is to a universal digital photo file format, and is the default for all but a handful of (professional) digital cameras. Aside from being compatible with every image-editing and Internet-related application available, JPEG has one unique advantage for the digital camera user: its ability to compress or 'squash' files so they take up less valuable space on your memory card.

Understanding JPEGs

The first thing to understand about JPEG is that it doesn't change the number of pixels in a file; it merely reduces the amount of space the file takes up on the card or your computer's hard disk. JPEG is very efficient at squashing files. It can reduce a digital photo to as little as one-twentieth of its original size, but (and this is a big but), it does carry a cost. This is because, in order to achieve such huge reductions in file size, JPEG compression changes the data in the file by throwing away information it

considers to be expendable. The result is a slight degradation in image quality, with the loss of some fine detail and the introduction of artefacts or errors that are visible when viewed very closely. This is known as a 'lossy' compression system; something is lost every time it is saved.

The amount of compression applied when a JPEG file is created is not fixed; the system allows you (or the camera) to choose a level of compression from low (resulting in a file around 75 per cent smaller) to very high (which can result in a file as much as 99 per cent smaller). At the lowest level of compression, the quality loss is negligible on all but the lowest-resolution images, whereas at the highest level of compression, the loss of detail is so great that the end result is of very limited use.

Digital cameras usually offer three or four levels of compression, although they are invariably referred to as 'quality settings', from basic, through normal to fine or high. The compression in these cases usually ranges from around 1:4 (best quality) to 1:20 (lowest). Obviously, the lower-quality settings allow you to fit more pictures on your memory cards, but at the cost of picture quality. In the long run, it is far better to pay for some extra memory than to venture too often into the 'basic' quality mode. Most cameras also allow you to reduce the resolution you

shoot at, again to allow the capture of more images. Thus a 6-megapixel camera may, in addition to the quality settings mentioned above, offer a 3-megapixel and a 1-megapixel setting for snaps you never intend to print at a large size. A word of warning, however: shooting at a very low quality setting – or a lower resolution – should be approached with caution; you can never put back into a photograph what the camera didn't capture in the first place, or threw away in compression.

TIFF and RAW files

Most high-end digital cameras offer one or two alternatives to the ubiquitous JPEG file format. TIFF is a relatively common file type used in professional graphics and desktop publishing that can be opened and edited by the majority of image-editing programs. TIFFs can be compressed slightly, but only by making the code more efficient, and at no cost to image detail (this is known as a 'lossless' compression system). This means that shooting in TIFF mode will produce files anywhere between two and ten times bigger than the very best quality JPEG, but with the guarantee of total fidelity. That said, most users cannot see the difference between TIFF and best-quality JPEG from most digital cameras, especially when the photos are printed. It is worth experimenting with your camera to find out if it is worth sacrificing all that memory card space for an improvement in quality so marginal that it is not visible to the naked eye.

RAW files are a different matter altogether, and – although not for the inexperienced user – offer a whole new degree of control, and the possibility of maximum image quality (see page 33).

Digital colour

The final element of the digital image equation is colour. As mentioned previously, digital camera sensors are 'colour blind' – they measure only amounts of light, not colour. Colour can be described digitally in many ways, but the most

▲ All digital cameras offer a selection of quality settings when shooting in JPEG mode. Most advanced models also feature TIFF or RAW modes (see page 33) for the highest possible picture quality.

More is not always better

Although the word 'resolution' is often used to describe how many megapixels a camera has, strictly speaking the two are completely separate. Resolution is a measure of a camera's ability to capture ('resolve') fine detail, irrespective of how many pixels it has. In the early days of digital photography, resolution and pixel count were closely linked; the more pixels, the more detail. Recently, the race to squeeze more and more pixels onto the same tiny sensors has seen this relationship break down for compact cameras, with more megapixels sometimes producing lower-resolution output. The reason is noise: smaller pixels (if you put more pixels on the same size CCD they inevitably become smaller) produce more noise, and the camera has to use stronger noise reduction to 'smooth away' the noise. Unfortunately, you can't get rid of noise without getting rid of fine detail too (particularly low-contrast detail such as hair or foliage). Digital SLR cameras, with their bigger sensors, don't have the same problem.

▲ This detail from a 10MP shot clearly shows the effect of noise reduction on low-contrast detail.

JARGON BUSTER

JPEG: Graphics file format designed by the Joint Photographic Experts Group for the efficient storage of digital photographs. Allows a variable level of 'lossy' compression.

Pixel: The smallest building block of a digital photograph. The name derives from a contraction of 'picture element'.

Analog to Digital (AD) converter: A processor designed to turn the continuously variable output from a sensor (voltage) into the discrete values demanded by a computer. The more steps (values) the AD system has to choose from, the more accurately the digital file will match the original information that comes out of the sensor. 24-bit colour uses 256 'steps' (from zero – no signal to 255 – maximum signal) for each of the three colour channels, giving a total of 16.7 million (256x256x256) colours.

Dynamic range: A measure of a camera's ability to capture the range of tones in a scene from the darkest shadows to the brightest highlights. Many digital compact cameras have limited dynamic range, which can lead to the clipping of highlights in high-contrast situations.

Digital colour

The colour in a digital photograph is stored in three channels: red, green and blue (RGB). Each of these channels has a possible 256 values (from zero to 255), making a total of 16.7 million possible combinations (different colours). Computer monitors (as well as the colour screens on your camera) also represent colour using varying proportions of red, green and blue.

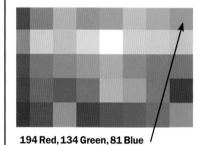

194 Red, 134 Green, 81 Blue

Every single pixel in an image has an RGB value to describe its colour. The light falling onto each pixel on the sensor is analog, or continuously variable, so the Analog to Digital (AD) converter in the camera has to choose the nearest value from zero (darkest) to 255 (brightest). In this way, the infinite number of shades and tones in the real world are reduced to the 16.7 million possible tones of a 24-bit RGB image. This is considered beyond the ability of the human eye to see colour differences. Some professional cameras use 1024 steps per channel for finer colour gradation.

common, and the one almost exclusively used in cameras, is RGB (red, green and blue). By mixing differing proportions of red, green and blue light, it is possible to recreate a huge range of colours. Most cameras manage just under 17 million different tones and shades; certainly enough to trick the eye into thinking it is seeing 'real-world' continuous tone. The camera sensor uses a matrix of red, green and blue filters so each pixel records light of only one colour. Blocks of pixels (usually eight) are then examined and the actual colour of each one determined using the data from its immediate neighbours. It's not a perfect process – there has to be some guesswork involved as no single pixel actually records full colour information – but it works well enough to produce a colour image that looks natural to the human eye. This system – three colour channels with 256 brightness levels each – is known as 24-bit colour (it uses 24 bits of data to describe each pixel). In most cases, it is more than adequate to represent colours in digital images. A few professional cameras allow colour to be captured at higher 'bit rates'; some can even distinguish billions of different colours.

RAW files

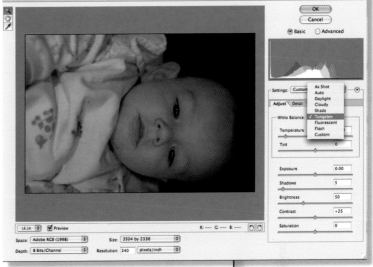

When a digital camera captures a digital photo, it does quite a lot to the picture before it is saved in a file on the memory card. As well as demosaicing (turning the red, green and blue grid of squares into full-colour pixels), software sharpening, colour and saturation alterations, contrast adjustments and other tweaks are applied to the 'raw' data before it is encoded as a JPEG. Shooting in RAW mode – as the name implies – saves only the raw image data, with no corrections or alterations applied. RAW files cannot be viewed or edited using normal image-editing or viewing software; they have to be processed by a special application (a RAW file converter) and saved in a standard JPEG or TIFF format before you can use them. Each manufacturer has its own RAW file format and they are all incompatible with each other (although a standardized RAW format, DNG, has been proposed by Adobe, take-up of this has been slow). The RAW converter application allows you to set your own white balance, exposure, contrast, sharpening and saturation values, usually working with a preview image to monitor the effect of your changes. Many professional and high-end amateur photographers insist on using RAW mode for all serious photography, regarding the RAW file as a kind of unadulterated digital negative. Although it adds an extra stage to the workflow, shooting in RAW puts you in total control of the picture-making process and – with some cameras in particular – yields significantly better results.

All digital SLRs and a few high-end compacts have a RAW mode, and many will also offer an option to save a matching JPEG at the same time (useful for quickly sorting through images before the RAW conversion processing). The files can be huge – 20MB or more – but with today's 2GB and higher memory cards, this is less of an issue than it used to be. More troublesome for compact camera users is the performance hit (some models take ten seconds or more to save each RAW file). Obviously, this limits the type of photography suitable for using RAW mode.

All cameras with RAW capabilities ship with a RAW conversion application on the CD in the box, but many are far too basic (some offer no control at all beyond 'convert to JPEG'). The best alternative is Adobe's Camera Raw plug-in. This works with Photoshop CS and the less expensive Photoshop Elements 4.0 or later.

The RAW advantage

Working with the CCD's raw data allows you to do several things that are difficult with JPEGs, including altering white balance after the shot has been taken, tweaking the exposure (or combining several exposures) to maximize dynamic range and avoid highlight clipping, and overriding the camera's default sharpness, contrast and colour/saturation settings. With a little practice, you can produce images of significantly higher quality than the out-of-camera JPEG or TIFF files. You should always keep the original RAW files for back-up in case you want to try different settings another time.

▲ RAW file converter software (in this case the Adobe Camera Raw plug-in for Photoshop) allows fine-tuning of a wide range of image variables. You can even alter the white balance and exposure setting after you've taken the shot.

▲ Don't like the level of sharpening or noise reduction your camera applies to the JPEGs it creates? RAW files allow you to take control of the processing yourself.

Sensor size, sensitivity and noise

Sensor sizes compared

The rectangles below show the relative sizes of three typical sensors (shown at approximately their actual size). In order to fit the same number of pixels onto each sensor the pixels themselves obviously have to be made much smaller. The first two are used in digital SLR cameras; the smaller two are used only in compact models.

1/1.8in (5.3x7.2mm)

APS-C (16.7x25mm) 1/2.7in (4x5.3mm)

Full frame (24x36mm)

▲ All digital cameras have the ability to change the ISO setting either automatically or using one of the presets.

which will catch the most water?). This low sensitivity to light means that the camera's processor has to work with a very weak signal, and that brings about a whole new set of problems.

The problem of low sensitivity

Low sensitivity means that you need a lot of light to produce a signal from the sensor that is strong enough to record an image. In bright sunlight this isn't really an issue, but, of course, we don't always shoot in bright light. We also want to be able to take pictures in low light, or to be able to use very short exposures for freezing motion.

A question of size

The CCD sensor used in most compact digital cameras is small; very small indeed. Typically, CCD sensors measure from around 9mm to 14mm diagonally, compared with 30mm on most digital SLRs, and 43mm on full-frame SLR models. However, with only one or two exceptions, there is little real difference between the pixel counts offered by compact cameras and DSLRs. At the time of writing, both types of camera max out at about 10 million pixels.

It doesn't take a rocket scientist to work out that if you have two sensors with 10 million pixels on them and one is more than ten times smaller than the other, the pixels themselves will also have to be a lot, lot smaller to squeeze them all in. And so they are.

The trouble with very small pixels is that they are a lot less effective at gathering light (if you leave a thimble and a bucket out in the rain for two minutes,

ISO settings

In the days of film you could simply buy a higher-sensitivity film (with a higher ISO or ASA rating) for use in low light or for shooting fast action. In the digital era, you can change the ISO setting in-camera – from around ISO 50 (low) to ISO 1600 or even higher. It is important to remember, however, that what you are really doing is amplifying the signal from the CCD – you can't actually increase the sensitivity of the sensor itself. Of course, you rarely get something for nothing in this world, and there are some serious trade-offs associated with increasing the ISO setting too far.

Noise

Like all electrical circuits, CCD sensors are not perfect, and produce some noise – unwanted random errors in the signal (think of it as being analogous to the interference you get with poor TV or radio reception). Noise in digital images appears as graininess or specks of false colour. Although it increases with longer exposures and at higher temperatures, broadly speaking for normal photography the amount of noise produced in a sensor is fairly consistent. At low ISO settings the amount of noise relative to the signal produced by the CCD is very low, so it doesn't have a huge impact

ISO 64

ISO 400

ISO 1600

on the picture quality. At higher ISO settings, the camera's processor is having to amplify a much weaker signal, and as it doesn't know what is noise and what isn't, the noise gets amplified too and you end up with an image where the noise is much more visible. This relationship – between the relative strength of the signal (containing real image information) and the noise (containing unwanted false information) – is known as the Signal to Noise Ratio (S/N Ratio); the higher this is, the less noisy your pictures will look.

Most digital SLRs produce essentially noise-free images at their lowest ISO settings (usually ISO 100–200), and, thanks to their relatively sensitive CCD or CMOS sensors, don't suffer too badly from noise at higher ISO (400–800) settings either. A few models can produce perfectly acceptable results at ISO 1600 or even ISO 3200.

Small sensor compacts, by comparison, tend to be able to produce low-noise images only at their very lowest ISO setting (usually ISO 50–80). At any higher setting, noise becomes very intrusive, and once you get to ISO 400 or higher the results are so noisy that they are suitable only for very small prints.

Noise reduction

All cameras use some form of noise reduction to attempt to reduce the visual impact of noise at higher ISO settings, but few are particularly effective. The very nature of noise makes it very hard to remove without also removing the fine detail from the image. Some cameras allow you to adjust the strength of noise reduction used. It is often better to use the lowest setting, as it is simple enough to remove noise with software if it really bothers you; however, it is impossible to put back detail blurred away by over-aggressive noise reduction. The very high megapixel counts that are used in modern small-sensor compacts mean noise reduction is often used even at the lowest ISO settings, and this can have an impact on low-contrast noise such as hair or foliage (see box on page 31). The ability to control both the amount and type of noise reduction used is one of the many advantages of shooting in RAW mode (see page 33).

High ISO modes

As mentioned above, digital SLRs can usually produce perfectly acceptable results at ISO 800 or higher, with the best models allowing you to shoot right up to ISO 3200 – a high enough setting to allow handheld photography by candlelight. Increasingly, manufacturers of compact cameras are also using high sensitivity as a selling point, either by including ISO 800, 1000 or 1600 presets or by adding special low-light modes that turn the sensitivity up as high as ISO 3200 (or even 6400). It is important to note that these settings rarely produce acceptable results: the pictures will be either noisy or blurry or both. Some high ISO modes operate only at a seriously reduced resolution, using a process known as 'pixel binning'. Ultimately, such modes are fine for social snaps where flashlighting would ruin the mood, or for small prints; for serious photographic work, however, only a digital SLR can offer anything like usable high ISO performance.

▲ Magnifying the output from a typical small-sensor 8MP compact reveals how much impact noise and noise reduction have on the overall quality of an image. It is best to use the lowest ISO setting possible.

▲ Low noise reduction (top) produces a grainy-looking image, but one that still has some detail. Using high noise reduction (bottom) produces a much smoother image, but much of the fine detail here has been sacrificed.

The digital imaging PC

Although you do not need a computer to enjoy many of the benefits of digital photography, once you've got your pictures on to a PC there really is no limit to the exciting and creative things you can do. So prepare to take your photography into a whole new dimension.

The personal computer forms the hub of a digital photography system, acting as a go-between connecting together the camera, printer and wider world. It also opens up an exciting new world of possibility where you can do virtually anything to, or with, your photographs. Digital imaging is quite intensive work; it's easy when playing with multi-layered images in an application like Photoshop to end up with files as big as 100 or 200MB, and you need plenty of processing power and memory if you don't want your PC to grind to a virtual halt. That said, for everyday digital photography, such as transferring and viewing your pictures, the odd tweak here or there and printing or sharing via the Internet, the system requirements are much lower. You can safely buy any PC on the shelves today, such is the power of the modern home computer.

As with most things, you tend to get what you pay for with computers, but there are plenty of retailers happy to sell needlessly expensive machines to people interested in digital photography. As long as you know what is important and what is just window dressing, you won't end up spending more than you need to. The following pages look at each part of the computer in turn and explain what it does and how important it is for handling images. We also examine the other components of what would constitute the ideal 'digital darkroom'.

Processor

The processor is the heart of your PC, upon which digital photography makes particularly heavy demands. Like the engine of a car, the more powerful it is the faster you can go, so the processor is one area you really can't compromise on. This doesn't mean you need the most expensive chip in the world, but bargain processors are to be avoided. It is impossible to make specific recommendations in a book such as this, as processor technology moves far too quickly. Suffice to say that it is rarely worth buying the absolute latest, fastest processor as the extra performance rarely justifies the

▼ **Modern personal computers, such as this 24-inch iMac, are easily powerful enough for the majority of digital photography tasks and often come bundled with free software.**

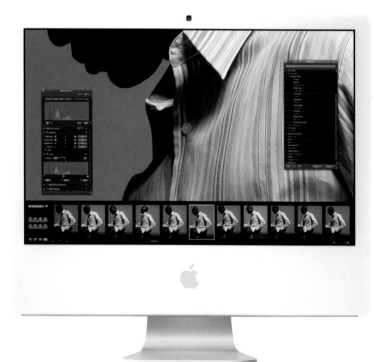

Apple Macintosh or Windows PC?

There was a time when all imaging work was done on an Apple Macintosh (Mac), which was designed from the start as a graphics machine; Windows simply wasn't up to the task. Today there is little functional difference for the digital photographer between the Mac and Windows operating systems, and Windows PCs are cheaper, marginally more powerful and make up more than 80 per cent of the market. Yet the Mac is still popular, especially in creative industries. This is partly historical (if you've used a system for 20 years there's little reason to change), partly due to the Mac's more intuitive and easier-to-master interface, and partly down to the unique design of the machines themselves. If you are choosing between the two, my heart says go for a Mac, but my head knows a Windows machine is a more sensible buy. Either way, make sure you do lots of research before buying your first PC or considering a major upgrade.

extra cost. Look instead for the previous top-of-the-range processor from Intel or AMD and always make sure that you're getting at least 3.0 GigaHertz (GHz) processor speed. Avoid budget chips, especially those with integrated graphics.

Memory

The computer's memory (or RAM) is where the machine stores the information it is currently working on, and for digital imaging the simple rule is that you can't have too much. Most new computers come with 256MB installed, which is the absolute minimum required to run the operating system and look at pictures. Increasing this to 1GB is essential, and if you want to get serious with larger images you had better budget for about 2GB.

Hard drive

The hard drive is where your computer stores all the files and programs you use. Like RAM, there are plenty of acronyms and jargon to contend with, but

the general rule is that bigger is better. Most new systems come with a 60GB drive, but digital photographers will undoubtedly need more. 100–250GB drives are fairly common now and will take a while to fill up, so this should be about the figure you're looking for. Replacing your hard drive for a bigger one can be a technical process, so make sure you buy a computer with plenty of memory to begin with.

Rather than replace the drive at a later stage, the best way to extend the capacity is to invest in an external plug-in drive. These are becoming cheaper all the time, and photographers will find them an ideal way to hold all their photographs. Aside from the capacity, you will also need to take into account the hard-drive speed. This is quoted in rpm; you should avoid 5400rpm drives and go for a 7200rpm model if at all possible. If your computer has a FireWire port then you should go for a FireWire drive as they are fast and reliable. If not, opt for a drive with a USB 2.0 connection.

▲ Choosing between a Windows PC and a Mac is a matter of personal experience and preference. You will get more for your money and access to a much wider range of software with a PC, but a Mac has a more elegant operating system and is often considered easier to use.

Digital cameras on the Internet

The Internet is a rich source of information and services for digital camera users, from in-depth review and news sites that help you choose your new camera, to user groups, forums and bulletin boards where you can exchange tips and queries with other users around the world. You will also find commercial and non-commercial sites designed to help you take better pictures, online photo competitions, print services and photo-sharing sites that act as digital photo albums that you can invite friends and family – or complete strangers if you so desire – to visit. You really need an unmetered, high-speed Internet connection to make best use of all the world wide web has to offer.

▼ It is perfectly possible to use a laptop for digital photography purposes, and if you are on the move a lot a laptop can be essential. Be aware, however, that specification (memory, speed and so on) will be lower and prices much higher than a desktop PC. Also make sure that the screen is large enough (and good enough) for working with digital images.

Graphics card

The graphics card generates the on-screen image, and digital photographers will need one that is capable of high-resolution work. Look for the amount of memory that the graphics card has: 64MB should be the minimum, but 128MB and 256MB cards are ideal. These tend to be aimed at the games market (and feature fast 3D capabilities), but such cards are also excellent for photographic work and playing DVDs smoothly. If you're going to be editing and tweaking your images on screen, you need to work at a minimum of 1280x1024 pixels and your graphics card should handle this at 24-bit or 32-bit colour depth.

Monitors

For digital imaging, the monitor is perhaps the single most important component of your PC. However, for many first-time buyers the monitor is either a bundled freebie or an ill-considered afterthought. You are likely to spend hours looking at it, so you need to get a good one. The traditional TV-style Cathode Ray Tube (CRT) has begun to die out fairly rapidly. Flat panels are well priced, but you need a large one to work with digital photos: at least 17 inches. There is also a huge variance in the quality of LCD screens, with older designs simply

not up to digital imaging work. If in doubt, make sure you get a full demonstration before buying.

With LCD screens, the physical size of the monitor is less important than the resolution (how many pixels make up the screen). Most 15-inch and 17-inch screens have a top resolution of 1024x768 pixels, which is not really enough for work on large image files. It is better to pay the extra for a screen that has a little more resolution; 1600x1200 or higher is best, although expensive, and is only available on 19-inch or larger models. It is also vital that you connect your LCD monitor to your computer using a digital connection (DVI). All but the cheapest LCD panels have a DVI connector, but some older computers may not. If this is the case, now is the time to upgrade your video card to something more suitable.

Back up now or pay the price later

Despite continuous refinement of computer hardware and software, there are still plenty of opportunities for things to go wrong. It is therefore vital that you implement some kind of back-up system to ensure that you can get yourself up and running again quickly, and, more importantly, that you don't lose your pictures forever. At the very least, make one copy (or two copies to be really safe)

Extras and add-ons

Aside from the basic computer, monitor and printer, there are several add-ons worth serious consideration. Firstly, a CD writer is essential for storing and sharing your images. Luckily, these are pretty standard fare for new PCs. Now that most of us have DVD players sitting beneath the TV, DVDs are also increasingly the medium of choice for storing and displaying images, so a DVD writer is worth considering, especially if you take a lot of pictures at high resolution. Compared to the 650MB of storage on a recordable CD, recordable DVD is extremely capacious, currently topping out at an impressive 9.4GB per disk. Card readers are also a useful purchase; these are attached to a USB port on your PC and accept up to seven different memory-card formats. Simply insert your card into the reader's slot and it appears on your computer as a new drive. You can then view and transfer images without needing to have the camera to hand.

If you are out and about shooting away from your computer a lot then you might want to consider a 'digital jukebox' device; this is essentially a battery-powered hard drive with built-in card reader and USB connection for the PC. Some models even sport a colour screen for checking your pictures on the go.

Once you have transferred your pictures onto the computer, you will be itching to start transforming them into digital works of art using your image-editing software. If you have an artistic bent you may want to consider a graphics tablet, which allows you to control the cursor using a special wireless pressure-sensitive pen. If you can draw, you will find such 'art pads' allow subtle retouching that a mouse simply can't match. That said, they are quite difficult to master, so it may be worth trying one out before committing.

One last piece of advice: when buying any new computer or accessory, always check the warranty. Many Internet and mail-order retailers offer little or no free support, and many insist that even large items are returned to the supplier for repair – often at your own cost. Digital hardware is generally pretty reliable, but it does no harm to be prepared.

▲ Portable image 'jukebox' with built-in card reader and colour screen.

▼ USB card reader.

▲ Graphics tablet.

of all your photos, before you make any alterations to them, preferably on a safe medium like a CD. CDs are extremely cheap and can store hundreds of photos each. Keep them safe – and separate from your PC – and you will never have to worry about losing everything.

It might also be worth considering a more regimented back-up system that will keep a copy of your system, files and applications for restoration in the event of a major loss (be it computer failure, theft or damage to your PC). Inexpensive back-up software such as Dantz Retrospect Desktop can be scheduled to back up to CD, external hard disk, tape, CD or DVD daily without any user intervention. Remember, however, that if you leave the back-up device attached to the computer at all times you risk losing that too in the event of theft, fire or flood. DVD is an ideal back-up medium – it has plenty of capacity, the disks are cheap and you can keep your back-ups in a safe place away from the computer. This may sound alarmist, but your attitude to back-up will change the first time your hard drive fails.

From camera to computer... and beyond

Until recently, photography was very simple for most users; buy a film, take some pictures, and have them developed. But with digital technology comes a whole new way of doing things, and a lot more choice.

▼ Digital photography is still in its infancy, meaning that many of the systems and processes involved are less user-friendly than they could be. This is changing, and it is now possible even for technophobes to take, store and print pictures without going near a computer. You can take your camera into a high-street lab and get a set of prints (and a back-up CD), print without a computer or even view your pictures on your TV screen and save slideshows on to videotape. The future will only continue this trend.

For most users of film cameras, their involvement in the process of making pictures ends at the moment they press the button. As you will discover over the next few pages, things can be very different for the digital photographer; pressing the shutter release is only the beginning of the process – and of the potential of your photos.

It can be helpful to break down the digital photography process into three broad steps: input, processing and output. Each step involves choices and options, and there is no set sequence of events that takes you from start to finish.

Step one: input

Before you can do anything interesting with your photos, you need to get them into a digital format. With a digital camera this is a simple case of pointing the camera and pressing the shutter. Scanners allow you to use all your old photos in the digital age by digitizing prints, slides or negatives. You can do this yourself at home or have your pictures put onto a disk for you by a photo lab.

Step two: processing

The second stage of the process can be very long and involved, such as when producing a montage (see pages 142–143), or removed completely if using direct-connect printers or dropping your memory card off at a processing lab. The processing stage, which takes place once the photographs have been transferred to the computer, can involve simple colour, brightness and contrast corrections, cropping, special effects, cataloguing, preparing for use on a webpage or sending via email, to list just a few of the thousands of possibilities.

Step three: output

This is another broad area that includes printing, sharing your photographs via email, the Internet, disk or videotape, projecting them on a wall or viewing them on a computer or television screen. Printing is discussed in more detail on pages 42–49 and the some of the other options are covered later in the book (see pages 154–157).

Better safe than sorry

There are so many alternative pathways in the digital process that it is misleading to attempt to define the right or wrong way to do things. However, there are a few simple, universal rules that are worth remembering to avoid disasters:

■ **Start with the best 'input' you can.** Wherever possible, use your camera at its highest resolution and best (or second-best) quality setting.

■ **Never work on originals.** Before you do anything to your shots, make a back-up copy of the original files as they came from the camera; ideally on CD or some other removable storage. Think of these files as your digital 'negatives' – you never know when you might need to come back to them.

■ **Keep (almost) everything.** Hard disks and CDs are cheap, so there is little reason to delete shots unless they are complete duds. Again, you never know when they might come in useful.

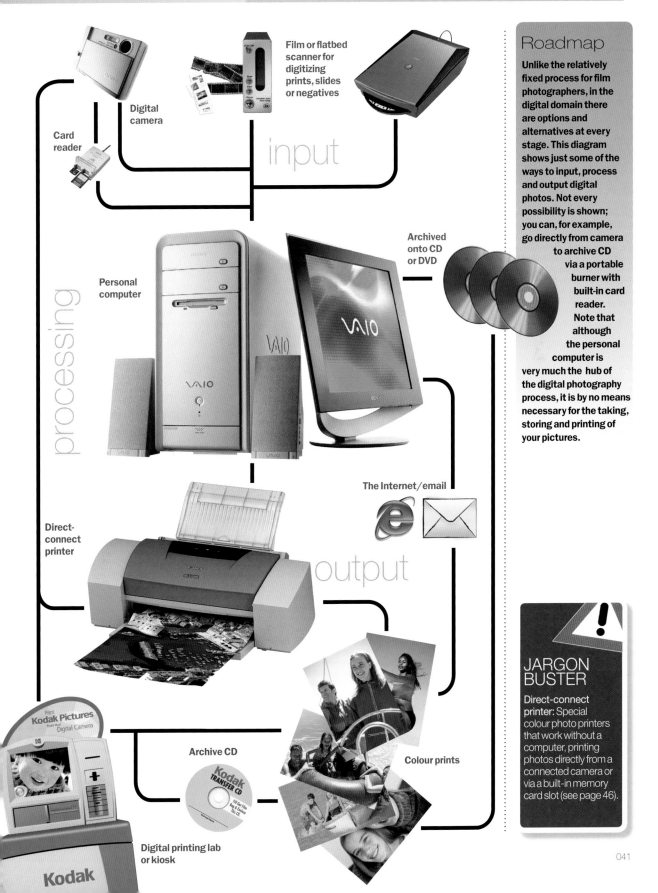

Digital camera

Card reader

Film or flatbed scanner for digitizing prints, slides or negatives

input

Personal computer

Archived onto CD or DVD

processing

Direct-connect printer

The Internet/email

output

Kodak Pictures from your Digital Camera

Archive CD

Colour prints

Digital printing lab or kiosk

Kodak

Roadmap

Unlike the relatively fixed process for film photographers, in the digital domain there are options and alternatives at every stage. This diagram shows just some of the ways to input, process and output digital photos. Not every possibility is shown; you can, for example, go directly from camera to archive CD via a portable burner with built-in card reader. Note that although the personal computer is very much the hub of the digital photography process, it is by no means necessary for the taking, storing and printing of your pictures.

JARGON BUSTER

Direct-connect printer: Special colour photo printers that work without a computer, printing photos directly from a connected camera or via a built-in memory card slot (see page 46).

041

Printers and printing

The final piece of the digital photography jigsaw for many users is a print they can put in a frame, send to a relative or put in an album. There are various home, high-street and online options to consider.

▲ The modern colour photo-quality inkjet printer is inexpensive, capable of amazing results and relatively easy to use. Consumable costs such as paper and ink are still quite high, and even the fastest printers struggle to produce an A4 (12x8in) print in less than three or four minutes.

The last few years has seen nothing short of a revolution in colour printing. With home photo-quality inkjet printers available for very reasonable prices, affordable postcard printers offering computerless digital photography, and the huge growth of high-street and Internet digital print services, we've never had it so good – or so easy.

Colour printing is far from stress-free, however, and it can take more than a little experimentation and practice to fine-tune the results to get exactly what you are hoping for. The next few pages discuss the options available, and how to avoid ending up with disappointing prints.

Printing at home

Part of the appeal of digital photography is its immediacy, and if you want colour prints on demand this will mean investing in a home colour printer. Like everything else in digital photography, the colour printer – usually in the form of an inkjet – has come a long way in a short time. Modern inkjet printers are capable of remarkable quality, easily rivalling conventional photographic prints. The latest models can produce photographs that look like, feel like – and even last as long as – chemically produced prints from film.

It is now possible to find inkjet printers on sale at absurdly low prices, but to get good photographic results you will need to invest in a model that offers photo-realistic quality. A4 (12x8in) models are pretty reasonable; A3 (18x12in) models cost considerably more. You can expect to pay extra for more specialized printers that use inks with greater longevity. Look out too for printers that use six or even eight colour inks to extend the ability to print subtle tonal detail.

Printers will come with special driver software, which most people tend to use without much thought when printing. This software allows you to select the number of copies and whether the

How printers make colour

Digital cameras, scanners and monitors use a combination of red, green and blue light – RGB – to create all the colours in the spectrum. This is known as an additive process, as the more colour you add the closer you get to white. A wide range of colours can be generated by this method, although some very dark tones can be difficult to achieve – a computer monitor, for example, will rarely display anything approaching a true black.

Printers use a combination of cyan (C), magenta (M) and yellow (Y) pigments in a subtractive process (adding pigments 'subtracts' from white, resulting in a darker colour). In theory, 100 per cent each of the three pigments should result in black, but as this is rarely the case, a fourth ink (black) is added to produce the very darkest tones. This CMYK (K for black) process is the basis for all printing, from books and newspapers to home inkjets.

RGB light: an additive process.

Inkjet printers lay the ink down as tiny dots using a dither pattern. This process lets some of the paper show through, allowing pale tones to be recreated (the inks themselves can only be used at full strength). At normal viewing distance, the dots themselves are invisible to the naked eye and the eye 'mixes' them to give the impression of a continuous range of tones. Photo-quality inkjet printers add two extra inks (pale cyan and pale magenta) to reduce the visible graininess in pale pastel tones that is caused by the wide spaces between the dots.

CMY printing: a subtractive process.

orientation should be portrait or landscape. When printing photos there are usually a greater number of settings to consider. You will, for example, need to specify the paper type. Glossy or matte, heavyweight or light, each will need slightly different ink consideration and you need to ensure that the optimum is used each time. You may – depending on the printer – even have the option of printing from a roll of photographic-quality paper or making edge-to-edge borderless prints.

Printing without inks

Inkjets aren't the only way to print at home. Dye sublimation printers (known more commonly as dye subs) produce high-quality photographic prints – indistinguishable from 'real' photographs – using a dye transfer process. Prints emerge from the printer completely dry and with a glossy finish. Until recently, dye sub printers for home use were limited to postcard-sized output. Recently this has risen to 6x4in and even A4 (12x8in). Dye subs offer perhaps the easiest route to real photos from your digital pictures, but they cost considerably more than inkjets. Price per print from a dye sub is also slightly higher.

6x4in dye sub printer.

Photo-quality inkjet printer

Inkjet printers have evolved greatly in the last few years, and have now reached the point where – at their best – they can rival traditional photographic processes.

Inkjets print images by squirting tiny dots of colour ink in complex patterns that are invisible to the naked eye. Anywhere from three to eight different coloured inks are used; you see millions of colours because the individual dots are too small to see, so the eye 'mixes' them together.

Photo-quality or not?

Although you can print your photos using any colour inkjet, there are a few things that make a true photo-quality printer. For one thing, such printers use more inks (up to eight), as there are many natural colours that it is difficult to produce smoothly using only CMY or CMYK. It is very rare for a printer with fewer than six inks to produce true photo-quality images.

Photo-quality printers also have the highest resolution – up to 4800 dots per inch (dpi). Although this doesn't directly relate to image resolution, it does have an effect on how smooth the gradation between colours and shades appears; higher resolution means you are less likely to be able to see the dots. Finally, photo-quality printers have special print-driver software designed to optimize output for the highest-quality photo paper, and to use sophisticated dither patterns when laying down the ink, ensuring you get the finest possible detail. Some of the latest models also use newly developed inks that – if used with the correct paper – are claimed to be able to last for at least 100 years. By comparison, the colour output from a conventional inkjet printer can start to fade in just a few weeks. (See opposite for more information on inks and papers.)

Running costs

Although the printers themselves are remarkably cheap, photo-quality inks and paper are not. In fact for smaller prints (postcard-sized) it can be cheaper to have your photos printed commercially. For larger prints (8x10in and above), the advantage swings back in favour of printing yourself.

Photo-quality inkjet printers pros and cons

✔ Inexpensive
✔ Work with all PCs
✔ Print sizes up to A3+
✔ Can be used for letters and other 'normal' printing

✗ Consumable costs
✗ Prints can smudge and not waterproof
✗ Slow for highest-quality prints
✗ Prints can fade

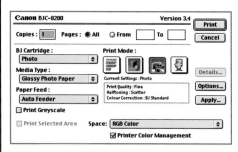

▲ Photo-quality printer-driver software is highly sophisticated and allows a fine level of control.

Portable photo inkjet printers are compact, and don't require a PC.

Connections and compatibility

Almost all modern colour printers use the USB for connection to PCs or Macs. USB is fast enough for colour printing, easy to use and easy to set up and is standard on every computer built in the last few years. There are a few printers left with Parallel port connections, but these are few and far between and should be avoided.

When you unpack your new printer, you'll need to install the printer-driver software from the supplied CD. Virtually all printers support Windows 98/ME/2000/XP and Mac OS (9 and X). Direct-connect printers come in two types: those using a cable connection (usually USB) and those with a built-in card reader. Printers using a cable will work with any make of camera as long as they use the ExifPrint, DPOF or PictBridge standards – check before you buy. Printers with built-in card readers will also usually work with photos from any standard digital camera, although again you need to check before deciding to buy.

Inkjet consumables

Home photo-quality inkjet printers may be getting cheaper all the time, but the running costs of them aren't, because of the high prices of the paper and inks that you need to use with them. Most photo-quality inkjet printers now use individual ink tanks for each colour (standard printers use a combined colour tank), so you only replace colours that have actually run out. There is a huge market for compatible ink cartridges that cost as much as 75 per cent less than the printer manufacturer's own version. My experience of these – and of refill kits – has not been good, however, with leaking, poor output and short life problems, but they may be worth experimenting with if you are on a tight budget.

In order to get the best possible quality out of your printer, you need to use special photo-quality paper. There are lots of types to choose from – both those sold by the printer manufacturer and a swathe of independent producers. Again, quality is variable, as is compatibility. Many paper manufacturers offer free – or at least inexpensive – trial packs containing a sample of each of their papers for you to try before committing to a whole box. There are lots of different papers on the market, from premium-quality high-gloss card to special surfaces such as watercolour or linen. Try out as many types as you can before finding one or two that you really like.

Inkjet prints fade in time – sometimes within a matter of weeks, which is quite a problem if you have hung your favourite photo on the wall in a frame. There are sprays and overlays that claim to increase archival permanence, but the only real answer is to buy a printer with long-life inks and use the manufacturer's own inks and papers.

▲ Papers come in a variety of different surfaces, weights and sizes.

▼ Replacing ink cartridges is simple, but can be costly.

The whole gamut

This diagram (based on the CIE 1931 Chromacity diagram, if you're interested) illustrates the huge difference between the gamut of the human eye – all the colours we can see – and the gamuts of a typical RGB monitor and CMYK printer. Note that the overlap between monitor and printer is especially small, which is why getting the screen and print to match is so troublesome.

Gamut of the typical human eye.

Gamut of a typical computer screen.

Gamut of a typical colour printer. Note that the best modern photo printers have a slightly wider gamut than shown here.

▼ Specialized calibrators such as this Pantone ColorVision system will measure the output from your printer and produce a colour-management profile for every type of paper you use.

Printing without a PC

Most home dye sub models (and those using the similar Thermo Autochrome process) and several inkjets can act as standalone printers – either via a direct connection to the camera or by the use of a built-in card reader – as well as when attached to a computer. Those that connect directly to the camera are usually restricted to cameras from the same manufacturer, although the PictBridge system has been developed to standardize how cameras and printers talk to each other. A PictBridge printer can communicate directly with any PictBridge camera, dramatically widening the choice of printers for the user determined not to use a PC.

Getting your prints right

It can sometimes be disappointing to see your first home print. Those bright, vibrant colours seen on screen seem to have lost their edge and come out somewhat muted. And that bright blue of the glorious summer sky seems to have become a muddy grey!

There are a huge number of factors governing how well prints come out, and optimizing your system can appear to be nothing short of a mystical art. Colour issues are usually a problem of calibration – that is, your computer's screen not displaying colours accurately. Overall print quality can be affected by incorrect printer-driver settings or use of the wrong paper type. Many printer manufacturers specify (if not demand) that you use only their media with the printer, warning of dire consequences of doing otherwise. Although you are unlikely to face catastrophes of the type implied by using third-party inks and papers, using the recommended media should at least give consistent results.

There is also a fundamental difference between the way that colours are displayed on screen (and the way that they are captured by digital cameras) and how they are printed on paper. This difference means that some colours that look perfect on screen simply cannot be reproduced in print.

Calibration and colour management

Getting your prints to match, even roughly, what you see on screen is one of the biggest challenges the serious digital photographer faces. Whole books could be written on how to manage colour issues throughout your workflow, but even the casual photographer can benefit from a basic understanding of how to anticipate, prevent and address potential problems.

In truth, colour matching isn't a serious issue for holiday and other snaps, where slight colour, contrast or brightness differences between screen and print are unlikely to be noticed. But once you start to get serious about your photography there will inevitably come a time when calibration and colour management issues really need to be addressed.

There are two major issues here. The first of these is the colour characteristics of the devices in use – how accurately they display or print colour. The second is the fundamental difference between how colour is produced by monitors (mixing red, green and blue light) and printers (mixing cyan, magenta, yellow and black inks). This leads to a difference in gamut – the range of colours that can be produced (see opposite page). Printer gamut is smaller than monitor gamut, so there are colours on screen that simply can't be printed. The printer has to 'squash' the range of colours in the image to fit its gamut, which is why prints can look a little muted compared to the on-screen version of your photo.

Calibration

The first - and by far the most important - step towards accurate colour is to calibrate your computer's screen so it represents colours accurately. There are several free tools for basic screen calibration (a good starting point for Mac users are those built into MacOS X). Many serious image-editing applications also include screen calibration tools. Using them is a simple matter of following the on-screen prompts; you will be asked to move sliders until colours match and the whole process takes no more than ten minutes. This simple step alone will solve a significant number of screen-to-print discrepancies. For even more accurate screen calibration you can invest in a hardware solution that measures the colour of your screen and produces a calibration profile.

Profiling and colour management

Now it starts to get a lot more complicated. It is possible to take account of the differing ways in which your camera, screen and printer capture or reproduce colour using a colour management system, now built in to both Windows and Macintosh computers. Colour management relies on profiles – descriptions of the colour characteristics of each device in use. These are used to map colour from camera to screen to printer, thereby ensuring consistency. Printers are usually supplied with profiles, and you can create your own monitor profiles (as described above). Only high-end digital SLRs have supplied profiles, but you can buy profiling solutions for any digital camera. In most cases this is not necessary as long as your monitor and printer are correctly calibrated and profiled.

The good news

Most amateur photographers face far fewer colour problems than the many books, forums and magazine articles on the subject would suggest. If your prints are satisfactory without even looking at calibration or colour management then I wouldn't worry – although I would certainly recommend you calibrate your monitor if nothing else. Modern printers and printer-driver software are designed to produce vivid results with accurate colour with the minimum of user intervention, and they seem to work. So, unless you are getting green skies and yellow clouds then, until you have become a colour expert, I would leave well alone.

▲ Calibrating your monitor takes minutes and could make all the difference to how well your prints match what you see on screen.

Dye sub photo printers

Dye sub photo printers pros and cons

✔ Easy to use
✔ Don't need a PC
✔ Superb continuous-tone output
✔ No fading

✗ Cost per print
✗ Small print size
✗ Can be slow
✗ Can only be used to print photos
✗ No paper choice

▲ Dye sub consumables – a single pack combining dyes and paper.

Inkjets have many advantages, and on good paper they come close to the quality available from a photo print. For the most intense colour saturation, however, it's hard to match dye sublimation (or dye sub), which literally melts dye into the paper as it prints. Fuji, Sony, Canon, Olympus and others all produce small-format (6x4in) dye sub photo printers for a reasonable price. Designed purely for printing photographs (the small size and cost per print precludes using them for any standard printing tasks), dye sub printers are easy to use and offer great quality. They are slightly more expensive to run than inkjet printers, and there is no choice when it comes to consumables: you have to buy the dedicated paper/dye packs sold by the original manufacturer. These come in boxes of 20 or 36 sheets at a fixed price per print. The results are very close in look and feel to a conventional photographic print, and archival permanence is excellent. Unlike inkjet printers, dye subs (and their close cousin Fujifilm's Thermo Autochrome) mix the four CMYK colours to make the full range of colours in the print, producing

▲ Most dye sub printers can be used without a PC.

what is known as continuous-tone output. Because of this, dye sub resolution is usually no higher than 300 or 360 dots per inch (dpi) – all that is needed for true photo quality. Virtually all dye sub printers can be used without a PC – you can use them either via a direct connection to a compatible camera or through the use of a built-in memory card reader.

Continuous tone dye sub (6x6 pixels)

Dithered inkjet (6x6 pixels)

▲ Dye subs don't need as much resolution as they don't use patterns of dots to reproduce colour.

This is due to their different gamuts (see page 46) and can lead to unpredictable results. Fortunately, modern software and hardware does an excellent job of minimizing such problems.

High-street printing

But what if you don't want to produce your own prints at home? No problem. Nearly all high-street and mail-order processing labs now happily accept digital photos for printing in exactly the same way as film (and at a very similar cost per print). Most outlets will accept photos for printing on memory card or CD, and most will copy pictures from your memory card onto a CD at the same time for a small additional cost. Prints are produced using exactly the same machines as those from films, so they look, feel and last exactly the same. You will also find there are very few colour problems when having your digital photos lab-printed, as they employ sophisticated systems to remove colour casts and correct brightness and contrast problems. At the moment, most labs offer standard 6x4in or 5x7in prints and modest enlargements (up to 8x10in), as well as gift ideas such as mugs, placemats,

coasters, mousemats and jigsaws featuring your favourite photographs.

An increasingly popular service for smaller shops is a digital print ordering kiosk. These self-service units have slots for memory cards and use a simple touch-screen system for ordering prints. Most also offer basic image corrections from cropping to removing red eye or even adding decorative borders. These kiosks do not actually produce the prints; your images and orders are either sent over a high-speed Internet connection to the main lab or the unit itself burns the order on to a transfer CD, which is sent for printing. In either case, your photos will be ready for collection after a day or two.

Internet print services

If you have a fast Internet connection – ideally broadband – you can now order prints from your digital photographs from your own home.

Most sites combine photo sharing (online photo albums) with print ordering in a single, slick interface. The process is simple; you sign up for a free account and upload photos to one of your freshly created albums. How you upload varies from site to site: some use a small application that you download and install on your computer's hard drive; others have a browser-based system. In either case, all you need to do is select photos using the simple interface, click on the upload button and wait. Your photos appear in a web album that you can direct friends and family to, and ordering prints is a simple matter of making selections and filling in the payment and delivery sections. Most sites will deliver within a few days, and most offer enlargements and photo 'gifts' as well as standard prints. Online print services use the same systems as high-street photo labs, so the quality is excellent and pricing very reasonable.

▼ Online and high-street printers can turn your digital images into 'real' photos virtually identical to those you used to get from film.

Print tips

- **Always ensure your monitor is properly calibrated to avoid disappointing and costly mistakes.**

- **Don't try to print too large; for prints over 5x7in you need at least three million pixels.**

- **Different inkjet papers affect the colour and quality of prints in different ways: once you have found one you like, stick to it.**

- **Produce small test prints before going for a big enlargement if you're not sure you've got the colour right.**

- **Remember that you can resave manipulated images onto disk or memory card and have them printed on the high street.**

Taking pictures

You bought a digital camera to take pictures, so it's time to start shooting! Part three looks at the basics of exposure, focus and composition – the key factors in taking great photos. Every camera is different, so you may want to keep your manual to hand to find out how you access the various controls. Remember, it doesn't take much to transform a humdrum snapshot into a great image…

The light fantastic

It's all around us and most of the time we take it for granted. But light is so central to photography that we have to learn to see it, use it and control it.

Look at every picture on this page and notice how important the light is to the overall image. Many of the shots would be considerably less successful – and certainly very different – if they had been taken at different times of the day or under different lighting. The still life (below), for example, is as much about the warm, soft light as it is about the careful placement of the book and pen. It simply wouldn't work if it had been shot with direct flash.

The very word 'photography' comes from the Greek for light ('photo'), and it is impossible to understate the importance of light in creative photography. Obviously light is needed to make an exposure, but it goes much deeper than that; it is the quality of the illumination in a scene that defines the quality of the final photograph. The colour, direction, softness or hardness and intensity of light have a dramatic effect on every photograph; it would not be going too far to suggest that lighting is more important than composition or even subject.

As well as providing the basic illumination required to actually take a picture, light affects modelling (the interplay of light and shadow that gives objects 'depth' in a 2D photograph), texture, mood and atmosphere. In many cases it is the light – and shadow – alone that makes the difference between an everyday photo and a really special one. As a photographer you have to learn to 'see' light in terms of the final photograph, which can be difficult when we take it so much for granted, and when our brains are wired in such a way that they filter out colour and intensity differences without us even noticing. The most abundant source of light – daylight – is chameleon-like in its ever-changing qualities. From the warm glow of dawn and dusk to the cool, harsh light of a summer's day to the long shadows on a clear winter's morning, daylight provides the photographer with an infinitely rich canvas of colour and intensity. It is not for nothing that dedicated landscape photographers sit freezing in a field waiting for the sun to come up or return time and time again to the same spot throughout the year.

Try to get into the habit of looking at light as much as you look at the physical objects in a scene. Keep records of when and how you take pictures and, above all else, experiment. A digital camera gives you the luxury of almost limitless shooting, as you are not wasting film and you can learn as much from your mistakes as your successes.

Colour temperature

Every light source is a slightly different colour (measured in degrees Kelvin, K). Digital cameras attempt to neutralize these differences (using Auto White Balance), but you can turn off the correction and use the different colours to add mood.

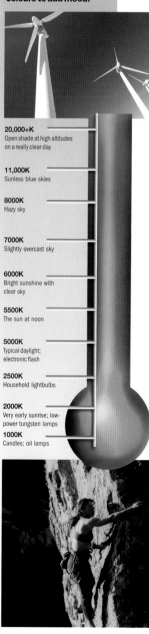

20,000+K
Open shade at high altitudes on a really clear day

11,000K
Sunless blue skies

8000K
Hazy sky

7000K
Slightly overcast sky

6000K
Bright sunshine with clear sky

5500K
The sun at noon

5000K
Typical daylight; electronic flash

2500K
Household lightbulbs

2000K
Very early sunrise; low-power tungsten lamps

1000K
Candles; oil lamps

Settings and controls

If you've never used a camera with lots of manual controls before, a mid-range or high-end digital camera can seem a little daunting. But don't worry, the following pages will help you to familiarize yourself with all the buttons and menus you'll ever find, as well as all the techniques and tips you will need to get the most out of them.

Before digital imaging appeared in the mid-1990s, two basic types of camera made up nine-tenths of the market; point-and-shoot compacts with little or nothing in the way of creative control, and SLRs that allowed more serious users to set their own exposures and choose from a wide variety of lenses. If you wanted control over how the camera focused, over exposure levels, over shutter speeds and apertures and so on, you bought an SLR. The rest of the world bought a compact and left the technical stuff to the camera.

By the early 1990s, compact cameras had reached a peak of sophistication, with huge zoom lenses and sophisticated metering systems. What they didn't have was anything in the way of real photographic control. This was a pity, as it is only by understanding these controls and using them where appropriate that you can fully exploit the amazing power of photography to produce arresting and highly memorable images. This isn't to say that a point-and-shoot compact can't produce stunning photographs; any photographer with

a good eye can capture a great image using just about any camera. It's just that by learning to use the various manual controls you will discover that every subject has the potential to be photographed in many different ways, often producing wildly varying outcomes. The great news is that even the most basic digital cameras offer some degree of photographic control; many come close to a 35mm SLR in the array of options available. From white balance to Auto Exposure Compensation (AE-C) to subject modes to manual focus and full manual overrides, the range of tools on offer allows for a considerable degree of creative control. This section looks at these controls in some detail, as well as discovering and applying some basic rules for taking great pictures of people, places, pets and many other subjects.

I'll start by explaining the various controls on a range of typical digital compacts, from the most basic snapper to the top-of-the-range prosumer models that offer enough to keep the most dedicated enthusiast happy.

Basic settings

There are several controls and settings common to all digital cameras (not counting webcams and other novelty models that can be found on supermarket shelves). These controls tend to be more on the digital side than on the photographic side of things, but nonetheless need to be understood. Some settings can also be used to ensure better pictures or for creative effect.

Zoom setting

Virtually all decent digital cameras have a zoom lens. A zoom allows you to change the camera's field of view by altering the focal length of the lens. Thus you can zoom right out to fit in more of a scene (wideangle setting) or zoom right in to isolate a detail (telephoto setting). Whereas film cameras always quote the actual focal length ranges (ie 28-70mm) – a tradition that goes back to the very dawn of photography – digital camera specifications tend to talk about zoom ranges in terms of how much longer the tele end is than the wide end. Thus most cameras have a 3x zoom range, with a few going to 4x, 5x, 6x or even as high as 12x. What this designation doesn't tell you is how wide the wideangle end of the zoom is (all compact camera zooms start at a modest wideangle). For this reason, most manufacturers (and this book) also quote a 35mm equivalent figure for their zooms. This tells us what focal length would give us the same angle of view on a 35mm camera.

▶ Extreme wideangles not only allow you to fit a lot in, they also provide an exaggerated perspective that can make for very striking photographs.

▼ A telephoto lens can be used for effect – as below, where the flattened perspective reduces the apparent distance between objects – or to fill the frame with a distant subject (below right).

◀ A short telephoto and natural light; the most flattering combination for a closely cropped portrait.

Common 'equivalent' focal ranges for 3x zooms include 35–105mm and 38–114mm. The smaller the first figure is, the wider a field of view you can obtain without having to use add-on lenses. 28mm or lower is quite rare, but it allows you to shoot broad vistas; 35mm is much more common and allows you to fit plenty in without too much distortion. To put things into perspective, the human field of vision is considered to be roughly equivalent to a 40mm lens. So anything much shorter will give a wider view than we are accustomed to (a bit like the view in a car's convex wing mirror). Anything longer gives a narrower field of view than the eye, and magnifies distant objects (in the same way as things appear when looking through a telescope or a pair of binoculars).

Which zoom setting?

The creative uses of different lenses are discussed in more depth on pages 70–75, but for now here's how you can use lenses for everyday snapping.

■ **Short wideangle (24mm or less).** This type of lens is really only available to compact camera users by the attachment of add-on lenses. Extreme wideangles are used mainly for creative effect; they introduce quite a lot of distortion (a bit like reflections in the back of a spoon) and exaggerate the difference between near and far objects (which appear giant and tiny, respectively). 24mm lenses are great for shooting wide vistas in landscape photography and for producing visually arresting pictures of buildings and other large-scale structures. These lenses are also ideal for capturing shots of interiors when you can't back away far enough to fit the entire scene in.

◀ Using a special fisheye adapter allows you to produce wildly distorted images with a field of view of up to 180 degrees.

■ **Modest wideangle (28–38mm)**. This lens is the starting point for most compact digital camera zoom lenses. Modest wideangles are ideal for shots of landscapes, groups of people and buildings. There is still some distortion, but it is rarely too distracting. Unless you are deliberately aiming for shock appeal then wideangles are rarely used for portraits, as they distort facial features, making for unflatteringly large noses and small ears!

■ **Mid-range ('standard' 40–60mm)**. This type of lens is often overlooked, as it is too easy to zip from one end of the zoom to the other. However, the middle part of the zoom range is perfect for head-and-shoulders or three-quarter-length portraits, small groups of two or three people and many other everyday shots. Because the field of view and perspective are close to the eyes, shots in this range generally look natural.

■ **Short telephoto (70–150mm)**. The zoom lenses that are found on most compact digital cameras stop at around 130 to 140mm. The short telephoto range is perfect for creating flattering portraits (face or head-and-shoulders), for picking out details in scenes, for magnifying distant objects and for creative effect (the compression of perspective makes objects appear much closer to each other than they actually are).

■ **Long telephoto (150mm plus)**. Long telephoto lenses are used for wildlife and sports photography and for any shots where you need to fill the frame with a subject you cannot get near to. Long telephotos are extremely difficult to hold steady, so they need to be used with a tripod and – if the subject itself is moving – a high shutter speed if you are to avoid blurring.

Focus

A lens can focus sharply on only one distance at a time. Most cameras do this for you automatically, using whatever is in the middle of the frame as the focus point. More advanced cameras use several focus points to make sure the main subject is sharp even if it is off-centre or is moving, but even these systems can be fooled by certain conditions (such as very high-contrast subjects or when

shooting through glass). In these relatively rare cases you may need to switch to manual focus and enter the distance using a menu. Most cameras can automatically focus on any subject from a few metres to many kilometres away (technically called 'infinity'); if you want to shoot anything closer you need to switch to macro mode (usually indicated by a flower symbol).

Quality and size settings

Digital cameras have a fixed resolution – a measure of the number of pixels on the CCD or CMOS sensor. Most cameras will allow you to choose from two or three lower resolutions (this means fewer pixels).

▲ Macro mode opens up a whole new world of creative possibilities – even for taking photos in and around the house.

No manual control? No problem!

The lack of any true photographic controls is no barrier to shooting creatively. These three shots were all taken on very basic point-and-shoot cameras with (top and above) the flash turned off and (left) the white balance control deliberately set to the wrong preset (tungsten setting used in daylight) and overexposed using the Auto Exposure Compensation (AE-C) function.

Auto Exposure Compensation

◀ No matter how sophisticated the metering system, there are some scenes that will fool virtually any camera. Here the majority of the frame is correctly exposed except the actual subject, the bird, which is underexposed and appears as a silhouette. This scenario (known as a backlit scene) is very common – people in front of windows, scenes with a bright sky and so on.

▶ One way to counter backlighting is to use an Auto Exposure Compensation (AE-C). AE-C overrides the automatically set exposure, usually in steps of 0.3 or 0.5 EV (1.0 EV represents a doubling or halving of the amount of exposure). You can think of AE-C as a simple 'lighter/darker' control; '+' settings make the picture lighter, '–' settings make the picture darker. In this instance, an AE-C of +2 was needed to correctly expose for the bird.

Do so with caution as lower resolutions mean less detail is captured; these images won't be as sharp unless you stick to tiny prints. If you intend to use the images only on screen, using a smaller resolution setting allows you to fit more pictures on your memory card. Quality settings are actually different levels of JPEG compression. JPEG allows you to choose a level of compression according to your needs; more compression makes smaller files (so you can fit more pictures on your card), but the cost is a reduction in picture quality. Use the best quality setting whenever possible; memory cards are cheap, reshooting a photo is not!

Many cameras offer a totally uncompressed setting, using either a TIFF or a RAW file. Most image-editing applications can read TIFF files, but RAW files need to be converted using the supplied software before you can use them.

White balance

No two light sources are the same colour. Household lightbulbs, for example, are very warm (orange-tinted); flash light is very cool (blue-ish); fluorescents are a bit pinkish; and daylight can vary from warm to cool depending on the time of day, the time of year, the weather and the location.

▲ Although neutral colours are usually desirable, there are times when it is better to preserve the atmosphere of the scene by keeping some of the warmth. Here, the white balance has been set deliberately 'incorrectly' to produce an orange colour cast.

You don't really see this most of the time, as your eyes constantly compensate to ensure white always looks white, no matter what colour the light illuminating it. Digital camera sensors have no such ability, so the camera needs to adjust itself to ensure your photographs don't all have a colour cast. This is usually done automatically using an Auto White Balance (AWB) system. These systems

▲ Almost all cameras have a +/– exposure function (Auto Exposure Compensation; AE-C). Some use a menu option, although many have a dedicated button – press it and you can dial in an exposure increase ('+') to make the picture brighter or decrease ('–') to make it darker.

EXPERT TIPS

■ Always make sure the focus confirmation light is on before taking the picture. Get into the habit of applying half-pressure to the shutter and waiting a fraction of a second before pushing it all the way down.

■ If your subject is off-centre, use focus lock (if you are unsure where this is, check in your camera manual).

■ When shooting portraits always focus on the eyes, not the centre of the face (the nose).

think of the AE-C setting as a 'darker and brighter' control. As well as being used to correct situations where the automatic metering system has been fooled by an unusual situation (someone standing in front of a sunset for example), AE-C has several creative uses. AE-C is usually available in half or one-third stops, where one stop represents a doubling or halving of the amount of exposure. Thus a '–1' adjustment uses half the automatically determined exposure (and so produces an image that is darker), whereas a '+1' adjustment doubles the exposure and produces a brighter photo.

Flash settings

Most cameras have built-in flash, and most offer four or five different settings. Of these, the auto setting (with the camera firing the flash whenever it is deemed necessary) is the most commonly used, but the ability to turn off the flash entirely (and use a long exposure) or to combine a flash of light with a long exposure (slow sync flash) opens up a world of creative possibilities when shooting in low light.

Macro mode

The small sensor size and small lenses of modern compact digital cameras have allowed manufacturers to include the kind of close-up facilities film users can only dream of. The ability to shoot at a very small distance reveals a whole new world of potential subjects.

Focus and exposure

Even if you have absolutely no interest in what goes on inside your camera, it is still important to understand how it determines and sets focus and exposure, how and when the automatic systems can go wrong, and how to avoid such situations arising and ruining your photographs.

Stay sharp

Hold your hand a short distance from your eye with your fingers splayed and focus on one of your fingers. You'll immediately notice that any distant objects you can see between your fingers look fuzzy and indistinct. Without moving your hand, look

▲ Slow sync flash, where a burst of flash is combined with a long exposure, is a simple technique that can add dynamism to an otherwise everyday shot. Compare the motion in the main image with the smaller version below using flash alone.

are easily fooled, however, and you will often find indoor shots at night coming out very orange if you stick to AWB. Because of this, most cameras have a series of preset white balance settings covering the most common shooting situations (cloudy, sunny, lightbulbs, fluorescent, flash and so on). You can usually tell from the on-screen preview or playback when the white balance is off, but it still pays to be aware of the potential pitfalls – and creative possibilities – of using the wrong white balance setting for the light you are shooting under.

AE Compensation

The most basic exposure control, Auto Exposure Compensation (AE-C) is offered on all but the simplest digital cameras. AE-C allows the user to increase or decrease the automatically determined exposure in preset increments. If you have no experience of metering and exposure, it's best to

◀ This shot was taken with a wideangle lens, lots of light and a distant focus point; just about everything from near to far perfectly sharp.

◀ With a longer lens and a subject a short distance away, focus is far more critical: most of the frame is out of focus.

at one of these distant objects and you'll notice your hand now looks fuzzy. This is because a lens (including the one in your eye) can only sharply focus objects at one distance. You don't normally notice because your eyes are constantly and unconsciously refocusing on what you are looking at, giving the impression that everything is always in focus. Unfortunately, this isn't the case with a photograph – the camera must focus the lens on the main subject to ensure it comes out sharply. Anything in front of or behind this point will be, to a greater or lesser degree, fuzzy and indistinct. Most cameras focus completely automatically. The latest systems are not only very good at measuring the distance to the subject; they are also getting better at guessing where the main subject lies in the frame (until recently cameras always focused on whatever was bang in the middle of the picture). One quirk of compact digital camera design is that they have considerably more depth of field (see page 65) than their film predecessors. Greater depth of field means that getting focus exactly right is far less critical. This has a bearing on most of the situations you encounter in everyday photography. This is especially true when shooting in bright light, when focused on distances of more than about 3m (10ft) or when using a fairly wide lens.

Understanding exposure

Although it can seem inpenetrably complex, photographic exposure is nowhere near as difficult to understand as you might think. Perhaps the most basic principle to understand about exposure concerns the amount of light needed to produce a picture with the optimal spread of tones, from

EXPERT TIPS

■ One of the most common reasons for pictures being out of focus is not giving the camera long enough to focus. Always make sure you half-press the shutter first to activate the focus (indicated by a green light next to the viewfinder, a beep or an indication in the LCD monitor). Then – and only then – press the shutter all the way down. With a little practice, this will soon become second nature.

Focus pocus

▼ At close distances you need to be even more careful. This shot of a squirrel shows how narrow depth of field can be with a long lens at its minimum focus distance. The squirrel moved just before I took the shot, meaning the focus point (top centre of the frame) was no longer on its face. Result: the important part of the shot is out of focus.

▲ Digital cameras generally focus on whatever is dead centre of the frame (although more advanced models have three or more additional focus points for off-centre subjects). This is fine if your subject is actually in the middle of the picture, but this is rarely the case in creative photography. The focus area is etched on to the optical viewfinder, and often appears as a coloured or white square on the colour screen when used in preview mode.

▲ Getting focus right is important if you want sharp pictures, and if you are using a long lens with a wide aperture, depth of field may be so narrow that getting it spot-on is critical. The example above shows the result of shooting the same scene with a 50mm lens focused on infinity (left) and on 1m/3ft (right). Get it wrong and your shot is ruined.

▼ When your subject is off-centre you need to get into the habit of using 'focus lock'. Frame the scene with the subject in the focus area and half press the shutter until the green focus confirm light comes on. Without taking the half pressure off the shutter, re-frame and press down fully. The picture taken will be focused on the subject, not the background.

Focus point 'locked' here before reframing.

New centre of frame – if you focused here, the main subjects would be out of focus.

the darkest shadow to the brightest highlight. Four variables are involved in exposure: the amount of light needed by the CCD (which is defined by its sensitivity to light and the ISO setting); the brightness of the scene; the lens aperture (how wide the variable hole that lets the light through is); and the shutter speed (the duration of the exposure). A good analogy is filling a glass with water from the tap. The amount of water needed to fill the glass is fixed and equates to the amount of light needed for the correct exposure. If you turn the tap on just a little it may take, say, ten seconds to fill the glass. Turn the tap so the valve is fully open and it may take only two or three seconds. This is exactly the same relationship as that between the aperture (how far you turn the tap) and shutter speed (how long you

run the tap for). In this analogy, the brightness of the scene equates to the water pressure; if it increases it will take less time to fill the glass without opening the tap any further. Digital cameras will also allow you to increase the sensitivity (ISO setting) of the CCD by amplifying the signal produced (effectively making the glass smaller), although this does increase the amount of noise (grain) in the image. In automatic exposure systems, the camera measures the light, does the calculations and sets both aperture and shutter speed.

Metering

As mentioned earlier, cameras use sophisticated metering systems to decide how much light there is in the scene, and how much exposure is needed. The very simplest use 'average' metering. This means that the entire frame is measured and the brightness levels averaged out to decide exposure. Most 'weight' the metering to give more importance to the centre of the frame, where – as with focus – the main subject is assumed to be. Centre-weighted metering is a distinct improvement

▲ Examples of underexposure (left), correct exposure (middle) and overexposure (right). Mild under- or overexposure can be corrected in software, but only to a degree.

Camera histograms

▲ Most mid- and high-end digital cameras have an option to display a histogram in preview and review modes showing the distribution of tones in the scene from shadows (left side) to highlights (right side). Histograms are a more reliable indication of exposure problems than the screen itself.

▲ With an under-exposed image the histogram will appear to be bunched up on the left side, and there will be nothing on the right side.

▲ An overexposed image has a histogram that is bunched up on the right side. Once you've learned to read histograms you should be able to spot problems before you shoot.

EXPERT TIPS

■ **Bracketing**
More advanced cameras offer exposure bracketing, where a series of shots are taken at slightly different exposure levels. You can then choose the best one when you look at them on your computer screen. A few models also offer white balance and focus bracketing, ensuring at least one shot comes out exactly right.

on full-frame average metering, especially once you learn its foibles, but once again it can be easily fooled by off-centre subjects or large areas of extreme light or dark (such as a great expanse of sky). In such situations, two tools offered by virtually all cameras become invaluable: Auto Exposure Lock (AE-L) and the previously mentioned AE-C.

The majority of modern mid-range and high-end cameras feature a much more sophisticated metering system that divides the frame up into as many as 256 separate segments and analyzes each individually. The results are compared with a database of thousands of scenes stored in the camera's processor in an attempt to identify the kind of situations that normally fool simpler systems; off-centre subjects, the sun in the frame,

a large expanse of sky and so on. Variously known as 'evaluative', 'pattern' or 'matrix' metering, such systems are getting better all the time at dealing with unusual scenes. However, they are far from infallible, so you may still need to reach for the AE-C and AE-L controls when things go wrong. A final metering option offered on many of the better cameras is 'spot' metering. Here, the camera measures the brightness of a tiny area at the centre of the frame and uses that to set the exposure. Almost always used with AE-L (so you can reframe once you've taken the meter reading), spot metering needs a little practice to master, but is an invaluable tool for the serious photographer.

Digital cameras offer a significant advantage over their film predecessors when it comes to metering and exposure, thanks to the colour preview and review screen. You can often tell simply by looking at the screen before you take the shot if the metering has been fooled by a non-standard scene. Even if the preview looks fine, going to playback (review) mode allows you to check immediately that you've got the result you want. Many cameras can also display a graph (a histogram – see page 63) showing the distribution of brightness levels in the scene and indicating any areas of overexposure.

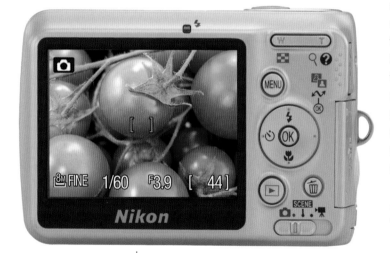

◀ **Most decent cameras will display the shutter speed and aperture in use, even when shooting in fully automatic mode.**

Apertures and shutter speeds

Aperture

The aperture control alters the size of the opening in the lens: a smaller aperture lets in less light, obviously, than a larger one. Apertures are described using f-numbers, and, in a confusing historical quirk, the larger the f-number, the smaller (narrower) the aperture. The reason – if you really want to know – is simple; the f-number actually describes the diameter of the aperture as a fraction of the focal

length of the lens (don't ask; it's always been that way). Thus, when we say we are shooting at f2.8 we really mean f/2.8, where 'f' is the focal length in millimetres. Now forget all that and remember this: a larger f-number means smaller aperture and less light; a small f-number means larger aperture and more light. Most digital cameras offer several apertures from the maximum (wide open), say

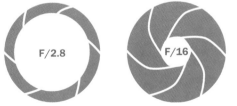

◀ The most significant effect of changing aperture is on depth of field: wider apertures have less depth of field. Other factors affect depth of field: when shooting close-ups or with a long lens it is very limited (right), and with very wide lenses almost everything is sharply focused (above).

f/2.8, to the smallest, usually f/8 or f/11. This isn't anywhere near the range offered by a decent film camera lens (some of which go all the way to f/64), but that's because digital camera lenses are so small; with a focal length of 7mm, even f/16 means making an aperture that can close down to less than half a millimetre, which brings with it a whole raft of new problems. This means that compact digital camera users are often left with a choice of five or six aperture values to choose from, and rarely any smaller than f/11.

Why change the aperture?

There are three reasons for changing aperture: to allow less light in because it is very bright or because you want to use a long shutter speed; to improve image quality (most lenses are sharper if you close the aperture down a couple of steps); and to control depth of field.

2 4 8 15 30 60 125 250 500 1000 2000 4000

▲ Long exposures create blurred results, short exposures freeze even the fastest motion.

▲ A tripod – or some other form of support – is essential when using slow shutter speeds.

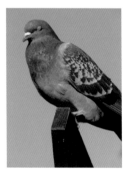

▲ When shooting at the long end of your zoom a higher shutter speed is needed to ensure that the image is free of camera shake.

Deep thought

A lens can only focus sharply on a single distance. So if your camera focuses on something 1.5m (5ft) away, anything nearer or further away will be slightly out of focus (ie soft or fuzzy). Depth of field is a measure of how far either side of the focused point is still acceptably sharp, and it varies with aperture. With a wide aperture, say f/2, the image will be sharp only a small distance either side of the focused point; at f/11 the sharp 'field' will extend much further. Depth of field also varies with distance (it's much less when you focus on something near the lens than something in the distance) and focal length (it's more with a wideangle than a telephoto) and is not symmetrical; it usually extends much further on the far side than the near side of your point of focus.

In film photography, depth of field is a vital consideration for most shots, but with digital (especially when using a compact camera) it is much less so. Why? Simply because digital cameras have much, much more depth of field than their film equivalents. In fact, it can be very difficult to create shots with a narrow depth of field using a compact digital camera. This is a pity as it can be a powerful creative tool, allowing you to isolate a subject (such as a person in a portrait) from their background. The only way to ensure narrow depth of field with many cameras is to shoot at the long end of the zoom at the widest aperture (macro shots also have very narrow depth of field, even when shooting digitally). Digital SLRs sit somewhere in the middle; they offer less depth of field than a compact digital camera, but still more than a film camera.

Shutter speeds

The ability to control the duration of the exposure of a photograph is arguably a much more powerful creative tool, especially when shooting digitally (where depth of field is difficult to alter). Most modern cameras allow shutter speeds (durations) of anything from several seconds to 1/1000th or even 1/10,000th of a second. There are several factors involved in choosing a shutter speed. Let's look at them individually.

■ **Avoiding camera shake.** If the shutter speed is too low, and you are holding the camera rather than using a tripod or other support, you will get camera shake – an overall blurring of the entire frame. There are no hard-and-fast rules; it depends on everything from the zoom setting in use to the size, shape and weight of the camera, to the steadiness of your own hands. As a rule of thumb, you need a shutter speed roughly the same as the (35mm equivalent) lens focal length in use. Thus a typical 38–115mm-lensed camera will need you to use – as a minimum guideline – 1/40th of a second at the wide end and 1/125th of a second at the long end of the zoom. Most cameras display the shutter speed in use on the colour screen, even when you are shooting in fully automatic mode. It's worth noting that cameras and lenses with optical image stabilization systems allow handheld exposures at much slower shutter speeds (usually two to four stops).

■ **Controlling the amount of light.** On pages 62–63 the relationship between apertures and shutter speeds was explained; both control the amount of light, and if one is reduced the other must be

ISO settings and sensitivity

There is, of course, one more variable in the exposure equation: the ISO sensitivity. Increasing the ISO value means less light is needed to produce a correctly exposed photograph, allowing you to take pictures in low light without needing a long exposure (and the resultant risk of camera shake).

As a rule of thumb, you should always use the lowest ISO setting (usually 50–100) in good light, as this will produce the best possible image quality with the most detail and lowest noise. A higher ISO setting (400 and above) is needed for indoor photography without flash – or when shooting at night without a tripod. A high ISO setting is also useful for avoiding camera shake when using a very long telephoto lens in anything but perfect light.

SLR users can normally turn the sensitivity up to ISO 800 without noise becoming a serious issue, but compact digital cameras are usually pretty useless at anything over ISO 200. If you do need to use one of the higher ISO settings on a compact camera, you will see noise in your images unless you only produce small prints.

Most compact cameras set the ISO value automatically by default, and for the most part this does a perfectly good job. Because many specialist photographic techniques require you to set the ISO manually, it's worth learning how and when to override the automatic function.

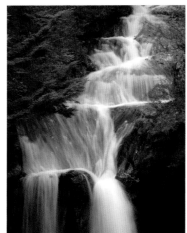

▲ Low ISO settings are used in good light to ensure the sharpest, cleanest results. They can also be used (left) with a tripod to allow long exposures for special effects.

High ISO settings – up to ISO 3200 – are needed ▶ for handheld shooting indoors and at night when you don't want to (or can't) use flash. Mid-range ISO settings (200–400) can also be useful for keeping shutter speeds high when using a long lens or shooting in less than perfect light.

increased to ensure that the picture isn't too bright or too dark. If you want to set a specific aperture in order to control depth of field, this will dictate the shutter speed you choose.

■ **Capturing motion.** High shutter speeds can freeze motion, while slow shutter speeds allow subjects to move during the exposure, creating blur within the image. Both are powerful tools for conveying action in a scene. With a long exposure, it is vital that the camera remains as stationary as possible to avoid camera shake and to ensure that the parts of the scene that are not moving are as sharp and unblurred as possible, helping to add to the overall sense of an object in motion.

Using shutter speeds for motion

When shooting action or movement, the decision to use a long or short exposure is a creative one. Short exposures freeze a moment in time, whereas longer shutter speeds allow the subject to move during the exposure, creating blur. The latter approach is more demanding, and is often quite hit or miss. Using a high shutter speed is a matter of pressing the shutter at the right moment (which is an art in itself). A continuous shooting (burst) mode can be a real boon.

High shutter speed (left) used to freeze motion and slow shutter speed (below) used to show motion through blur.

▲ A variation on panning (see page 94) – a slow shutter speed shot from the centre of a rotating roundabout.

▼ Most high-end cameras offer a range of exposure options, including 'scene' or subject modes.

Exposure modes

Most mid-range and high-end cameras offer several exposure modes, from fully automatic point-and-shoot (no control) to fully manual (you can set your own apertures and shutter speeds independently). More useful are the semi-automatic modes that allow you to choose either the aperture or shutter speed you want to use, with the camera then automatically selecting the correspon-ding shutter or aperture value needed for a correctly exposed photograph. This system means you don't need to worry about the amount of exposure, simply how the exposure is made – a long duration through a smaller aperture or a short duration through a wide open aperture – but without the worry of getting too much or too little light for the shot.

So what settings should you use? There are no hard-and-fast rules, but there are some general guidelines that you need to learn – and remember – in order to produce the result you are hoping for. Different types of photographs require different settings, as explained below.

■ **Landscapes.** When shooting landscape photos generally you want a small aperture (high f-number) as this will produce the maximum depth of field and – as mentioned – smaller apertures produce slightly

sharper results. Shutter speed is less relevant for landscapes as nothing is likely to be moving very fast. Of course you still need to use a shutter speed that is high enough to avoid camera shake unless you've got a tripod or other camera support.

■ **Portraits.** As well as using the longer end of your zoom (to fill the frame and ensure flattering perspective), portraits usually require the widest possible aperture (lowest f-number) to attempt to limit depth of field, providing an attractive, soft background, rather than clutter.

■ **Sports and action.** When it comes to photographing action the highest possible shutter speed is paramount; you need at least 1/200th of a second, and much more for very high-speed action (horses, cars and so on). In this case the aperture setting is largely irrelevant.

■ **Close-up.** This is one of the more difficult situations. Ideally it requires both a small aperture and a high shutter speed to avoid the inevitable camera shake and/or focus problems associated with working at very short distances. Most serious close-up photographers use some kind of support (such as a tripod) for the camera to ensure the sharpest possible results.

■ **Night photography (without flash).** As light is low, and simply getting enough to make an exposure is a challenge, there is little room for creative use of apertures or shutter speeds. Aperture will generally be set at its widest, and the shutter speed, which will be long, is determined by the light levels in the scene. It is possible to use a shorter shutter speed (or smaller aperture) by increasing CCD sensitivity – turning up the amplification – but this will generally reduce picture quality due to noise.

Subject modes

If all this talk of f-numbers and shutter speeds has put you off creative exposure control completely, fear not. Many cameras offer several fully automatic 'subject' or 'scene' modes. These allow you to tell the camera the type of picture you are about to take (typically the choice includes portraits, landscapes, sports and so on). The camera then chooses a suitable combination of shutter speed and aperture

for that particular kind of shot. These modes can be a useful aid for the inexperienced photographer, and will undoubtedly help to lift your pictures above the ordinary. But bear in mind that they won't teach you anything about how altering shutter speeds and apertures ultimately affects the look of your pictures, and won't encourage experimentation. I wouldn't like to say that you can't become a great photographer without manually controlling exposure (or at least knowing how to do it), but it does make it much more likely that you think before you shoot.

▲ Even a small amount of movement in a shot – as with the flags in this scene – can add atmosphere. Here a shutter speed of 1/30th of a second was adequate to blur the flags (the camera was supported on a bench).

The right lens

There are few more creatively powerful tools than the ability to change the field of view by altering the focal length of the lens. There are many different lenses on the market, so what does each type do?

EXPERT TIPS

Many cameras offer a 'digital' zoom. This simply crops the centre of the frame, throwing away valuable pixels in the process. It is best avoided.

The same scene, taken from the same viewpoint, will yield completely different photographs depending on which focal length the photographer uses to capture it. Learning how and when to use the focal length options that are available to you is something that will help to improve your photography immeasurably.

Lenses are classified according to their focal length. Shorter focal lengths (wideangle lenses) give a wider angle of view; longer focal lengths (telephotos) give a much narrower angle of view, allowing you to fill the frame with distant objects. In the middle are so-called 'standard' lenses – those with a field of view that are roughly equivalent to the human eye. The focal length of the lens also alters the apparent relationship between near and far

Field of view

The focal length of a lens defines its field of view: the shorter the focal length, the wider the view. Typical digital camera zooms range from 35mm to 105mm or 115mm. 'Super Zoom' cameras stretch the long end of the zoom to anything from 200mm to over 350mm. The human eye has an angle of view of around 40–50 degrees, which lies roughly in the middle of most 3x zoom cameras.

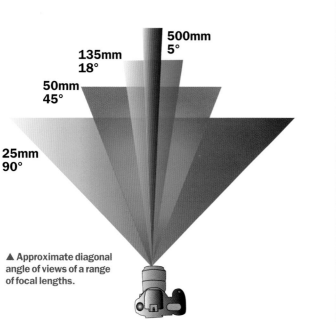

500mm 5°

135mm 18°

50mm 45°

25mm 90°

▲ Approximate diagonal angle of views of a range of focal lengths.

▼ **Wideangle lenses exaggerate perspective, making nearer things seem much larger than those far away. This can be used to great creative effect.**

◀ The longer the focal length, the smaller the field of view. This means a wide lens fits a lot of the scene in and a longer (telephoto) lens isolates a smaller area. From left, shots taken with a 19mm, 38mm and 105mm lens, all taken from the same spot.

▼ The standard lens – half-way through the zoom – should not be ignored (taken at 40mm equivalent).

objects, with wider lenses exaggerating the prominence of nearby objects and including considerably more of the background in the shot. Long telephoto lenses, by comparison, appear to compress perspective; these are both effects that can be put to great creative purpose.

▼ Even familiar subjects can yield an interesting shot with the careful use of unusual framing and a long lens.

specialist lenses offer a very wide angle of view (a full 180 degrees for a 7.5mm lens) and include fisheye lenses, which produce a circular image. The huge amount of distortion and massive field of view can be used to spectacular effect, but can also become over-used. If you own a compact digital camera, the only way to get anywhere near to ultra-wideangle shooting is via a special adapter that screws on to the front of the built-in zoom.

■ **Wideangle (from around 17–40mm)**.
Wideangle lenses are essential for shooting landscapes, interiors, groups of people and large buildings. At the very short end you get quite pronounced distortion and apparently crazy perspective, but this is rarely an issue when shooting scenic photographs. Very short focal lengths (up to around 28mm) also tend to lead to distortion of straight lines, giving buildings bent walls and adding a curve to the horizon. Lenses with focal lengths of between 28 and 38mm (the widest setting for all digicam zooms lie in this range) are among the most useful you'll ever find, able to take in a fairly wide field of view without excessive distortion.

▲ A fisheye adapter fitted to the front of your lens allows you to produce unusual shots like this one. The ultra-wideangle grossly exaggerates anything near to the lens.

▼ Move in close with a wideangle to emphasize depth in a scene.

Lens focal lengths are grouped into five rough categories. Zoom lenses – those whose focal length can be altered – usually cover the modest wideangle to short telephoto range. In all cases the 35mm lens equivalent value is quoted for focal lengths.

■ **Ultra-wideangle (from around 7.5mm to about 14mm)**. If you've ever looked through one of those 'peepholes' to check who's at the door you have a good idea what ultra-wideangle lenses do. These

▲ Same scene, two very different shots. Both were taken with the same compact camera, the top version using the wideangle adapter (giving a 28mm equivalent), the lower version at full zoom (210mm equivalent). Notice the apparent difference in perspective caused by the different angle of view.

◀ Telephotos are not just for wildlife or sports; they can be very effective in producing interesting views of scenic subjects. The flattened perspective makes things look much closer together than they actually are.

The right lens for portraits?

At first glance, choosing the right lens for portraits is fairly straightforward; for 100 years or so the ideal portrait lens has been considered to be somewhere in the 75–135mm range (in 35mm camera terms). This corresponds to the longer end of most digital camera zooms and produces the best head-and-shoulders and full-face shots, avoiding the distortion caused by wide lenses (which is hardly flattering) and limiting depth of field for nice blurry backgrounds. If you are trying to shoot a portrait, you need to set the zoom to near the long end and move yourself away until the head fills the frame. That said, it is often desirable to include some context in portraits – as with the cigar-seller shot above. In these cases, you'll need to use a wider lens (zoom out) to include some of the surroundings. Remember that a longer lens allows you not only to isolate your main subject, but also to reduce depth of field, so the background is less cluttered.

The only thing you shouldn't do with a wideangle is try to take a portrait at anything less than around a three-quarter-length view (ie from the knees up when standing) – get any closer to your subject and they'll look like the reflection of themselves in the back of a shiny spoon.

■ **Standard (40–60mm).** This range of focal lengths – usually in the middle of digicam zooms – is often ignored (it's too easy to flip from one end of the zoom to the other), but is well worth investigating. They provide the most natural-looking perspective in standard-sized prints viewed at arm's length. 50mm or 60mm is ideal for portraits from the waist up. For tighter photos you need to go longer.

■ **Telephoto (70–500mm).** As you increase the focal length, the angle of view decreases rapidly – it is only 5 degrees at 500mm. The effect is similar to looking through a telescope or binocular, with distant objects magnified to fill the frame. Telephotos (most digicams go up to about 135mm at the most) are ideal for portraits showing only the head and shoulders or face, providing a flattering perspective. Longer telephotos can be used to isolate details or for more specialist applications – wildlife and sports photography, for example.

■ **Super-telephotos (500mm and over).** Extreme telephotos (up to around 2000mm) not only have limited applications, but are also very difficult to use (a tiny movement of the camera can shift what you're looking at by half a mile) and cost more than

Focal length equivalents

The focal length of a lens is defined as the distance from the optical centre of the lens to the film (or sensor). The focal length is related to the angle of view, but only when looked at in relation to the physical size of the sensor or film itself. A 50mm lens will be a 'standard' on a 35mm film camera, a modest wideangle on a medium-format camera (which uses a larger film) and an extreme telephoto on a compact digital camera (which has a CCD sensor much smaller than a 35mm film frame). As there are so many different sensor sizes, the actual focal length needed for a particular angle of view will change from model to model. Because of this, the accepted way to refer to compact digital camera lenses is to use 35mm focal length equivalent values; the focal length on a 35mm camera that would give the same angle of view. Thus, a 7–21mm zoom on a compact digicam becomes a 38–115mm equivalent. This convention has been used throughout this book.

Ultra-wideangle lenses are ideal for large interiors (above), and for putting your subject in context with lots of background (right).

many people's cars. The longest telephoto lens (long end of a zoom) is around 350 to 400mm. Longer focal lengths require the use of an SLR with interchangeable lenses.

Which focal length to use?

Although there are some rough guidelines regarding what kind of lens to use for which type of shot (ie wide lens for landscapes; short telephoto for portraits), it is only by experimenting and breaking the rules that we can start to get really creative with our photography. Often the choice of lens is practical: we want to fill the frame with a particular part of the scene, be it a face, a building or an entire vista. This is a perfectly acceptable approach, but will never make you a great photographer. For that you need to start learning to look a little more carefully at what you are shooting, and to try to develop the ability to see shots within scenes, rather than simply trying to get everything in. You may find this easier when looking through the viewfinder and altering your zoom setting or simply by taking

a few minutes to stand still and look around you. Remember that there is no 'right' zoom setting or focal length, and the one way to guarantee humdrum photos is to stop for a second and 'point and shoot' at whatever zoom position your camera was last used at – or whichever one it defaults to when you turn it on. Take your time, take lots of pictures (there's no film to waste), and you will start to learn how the lens focal length affects the composition, mood and impact of the final photograph, and how to use the particular characteristics of each to best effect.

Composition basics

Learn and follow a few basic rules and not only will you improve your photography greatly, but you'll also gain the confidence to break them.

▲ Aim to place your subject's eyes roughly two-thirds of the way up the frame. And remember: fill the frame!

There may not be a universal formula for taking a good photograph, but there are some very reliable guidelines that can, and do, make the difference between a worthless snapshot and a photograph you'd be proud to hang on the wall. As you read the next few pages, you may well be struck by how obvious some of the advice is; this is because many of these rules of composition tap into the deepest unconscious level of human visual perception. Indeed, many of them have been understood, and used, for centuries.

Fill the frame

It's so simple, yet so often snapshots are ruined by not filling the frame with the subject. When you peer through the viewfinder of your camera, your mind tends to exaggerate the importance of the main subject, so you don't notice how small it is in the frame. The LCD screen can be a real boon here, as it allows you to see the scene as a picture, bounded by its frame. Try to get into the habit of thinking for a moment before you press the shutter. Do you need to zoom in a little, or move closer to the subject? Although you can always crop your pictures at a later date, doing so will throw away valuable pixels, thereby reducing quality.

Think in two dimensions

Having the benefit of stereo vision means that humans see the world in three dimensions, whereas we photograph it in two. Look at someone standing in front of a sapling and you instinctively know that the tree is behind them and therefore ignore it. Photograph the same scene and the tree will appear to be growing out of the top of your subject's head! It can help to close one eye when surveying a scene as you decide where to shoot. Alternatively, simply look carefully at the LCD screen preview before shooting. Capturing a scene in two dimensions can distort the physical relationship between near and far objects, and you have to take this into consideration. This rule could equally well be titled 'look at the background before shooting'.

Moving off-centre

Which of these two images of the same flamingo do you prefer? Why? The right-hand picture is far superior: not only does the off-centre composition add interest and dynamism to what is essentially a rather dull shot, but it now much more closely obeys the rule of thirds. This is one case where the 'fill the frame' rule needs to be applied not literally, but in terms of balance.

Whatever subject you shoot, placing the main point of interest off-centre helps to produce a more pleasing composition.

Move off-centre

Perhaps the biggest mistake that inexperienced photographers make is to place their subject dead centre in the frame. It is extraordinary how much difference it can make simply moving to the left or right. Look at pictures you like – especially of people – and you will soon see that few, if any, place the main subject dead centre. This is the first step towards understanding the only really technical rule: the rule of thirds.

The rule of thirds

Artists have understood this simple rule since the time of the ancient Greeks, and – although nothing can guarantee a good photograph – the rule of thirds is the nearest thing we have to a foolproof formula.

The basic idea is simple. You draw a horizontal line one-third of the way down from the top of the frame and another line one-third of the way from the bottom. Do the same thing vertically, so the frame is cut into nine equal squares (see the examples on page 78). The key to pleasing composition is to place the most important part of the scene on one of the four points where the lines intersect, or to

place a main horizontal or vertical line along one of the lines. It sounds complicated, but it isn't. In fact, if you look at your best photographs you will usually find that they conform to the rule of thirds to some degree. If you remember to place the main point of interest towards one corner, about one-third of the way in, you will find that your hit rate increases dramatically. The rule of thirds is especially useful when composing landscape shots, as it defines the placement of the horizon.

◀ Oops! Always remember to check the relationship between your foreground and background before you take the picture. That flagpole might have looked far away at the time, but it now appears to be sprouting from the subject's head.

The rule of thirds

Even if you stretch it, this is one 'rule' worth learning.

Placing the horizon on one of the horizontal lines is a sure-fire winner.

Here the rule of thirds has been stretched considerably, placing the main subject in the bottom right corner. The single splash of contrasting colour and leading lines of the street ensures that it still works.

Although the horizon is slightly too high in this shot, the rule of thirds still applies as the boy's head is placed on one of the intersections.

The key to a perfect portrait; fill the frame, focus on the eyes and make sure they end up somewhere near the line marking the upper third of the frame.

Here the image contains three bands that more or less correspond to the horizontal thirds. The deckchair is centred on one of the intersections.

Here, even though the main subject is centred, the head still lies at the intersection of two of the lines and the rock fits into the lower third.

Leading the eye

The use of diagonals, especially those that run from foreground to background, are an ideal way of leading the eye into a picture, or towards the main point of interest. They also reinforce the impression of depth and space in a scene.

There are very few situations where placing the horizon right in the middle of the frame makes for a good picture; the shots that do work usually follow the rule of thirds anyway, by placing another interesting feature, such as a dramatic cloud formation, on one of the horizontal lines.

In portraiture, the rule of thirds usually applies to the eyes, which are placed roughly one-third of the way from the top of the frame. The rule is so powerful, and so reliable, that some photographers etch the lines onto their viewfinders or mark the LCD screen.

Quick tips: portraits

There are several simple techniques that are guaranteed to improve your portraits.

■ **Lens.** First and foremost is to use the right lens for a more flattering perspective. Stick to longer focal lengths (the 'tele' end of your zoom) if you want to fill the frame. This will allow you to move further away from the subject and zoom in on the face without the dreaded 'back of the spoon' type of distortion effect (see page 99). This also gives you the additional benefit of minimizing any distracting background clutter behind the subject.

■ **The eyes have it.** The eyes are the most important feature in a portrait. Place them around one-third of the way down the frame. Make sure you focus on them, not the nose (which will probably be near the centre, and therefore what the camera tries to focus on). You may need to use focus lock and reframe to ensure the eyes stay sharp.

■ **Direction.** In many portraits the sitter is looking directly into the lens, which produces a powerful connection between the viewer and the subject.

▲ Use the rule of thirds and lines (here in the form of footprints) to lead the eye to the main subject of your photo and you can't go wrong.

▲ Framing a scene using something in the foreground is an old trick, but one that works well. Foliage is most commonly used, but look for anything you can shoot through; archways, windows or even a hole in a wall. In some cases (right) the frame can become the only reason for taking the picture.

If you shoot someone looking away from the camera, you should ensure that they are always looking 'into' the frame; if they're looking left, place them on the right of the frame and vice versa.

■ Angle. The most flattering shooting position for portraits is with the camera roughly at eye level. For more creative effects try shooting from above, but avoid shooting from below unless you are specifically aiming for a less flattering result!

Quick tips: scenes

Scenic shots (specifically landscapes) are those that benefit most from a fairly rigid application of the rule of thirds, but there is more to exciting composition than simple geometry.

■ **Leading the eye.** Use of diagonals, specifically those that lead the eye into the frame or towards the main point of interest are a powerful tool for producing arresting images. You can use a wall, a fence, a railing, a road or even a line of people. These diagonals not only add a dynamic element to the composition, but also act as good indicators of depth in a scene, connecting the foreground with the background.

■ **Foreground interest.** When shooting a landscape, try to include something nearer to the lens to add interest and to help convey the impression of depth in the scene. Generally speaking, anything nearer to the camera should be lower in the frame than distant objects, except in the case of overhanging branches – which leads on to the final tip…

■ **Framing a scene.** An extension of the idea of including some foreground interest is to use something in the foreground to frame the scene you are shooting. The most common technique is to use foliage (trees and overhanging branches), but you can use anything you come across; windows, buildings, old ruins; whatever seems to work.

General tips

A few final tips on composition that can be applied to most types of photography.

■ **Shoot, shoot, shoot.** Professional photographers take a lot of pictures that are discarded before they find the winner. Get into the habit of taking lots of pictures at different angles, different zoom settings and slightly different framings. Look around and try to find something other than the obvious shot. Zoom in to pick out detail. Remember that it is practice and experience that help you to develop an eye for a good photo.

■ **Direction of motion.** As with portraits, if you photograph anything in motion it is generally better to include more of the scene in front of the direction of travel than behind it. Thus if you shoot someone walking from the left to the right, make sure you place them towards the left of the frame. If you don't, pictures tend to look as if they were taken too late.

▲ You should generally try to show subjects moving – or looking – into the frame, not out of it.

▲ As the images on this page all show, stretching or even breaking the rules – placing the subject dead centre, shooting at odd angles, taking details out of context, or using nothing but colour for an almost abstract effect – can produce some of the most visually stimulating results. Look up, look down, and look all around when surveying a scene before you start shooting.

■ **Look for detail.** Most people shoot scenes with their zoom set to the widest possible setting, meaning they get as much as possible of the scene into the frame. While this is generally a good thing, don't ignore the opportunities offered by the long end of your zoom for isolating detail. Zoom in on anything that captures your interest and snap away – it is better to take 20 poor shots and one fantastic one than two mediocre shots that sit on your hard disk forever gathering the digital equivalent of dust.

■ **Try another angle.** Try shooting from very low on the ground, or holding the camera above your head. Stand on benches, crouch down; try anything that might produce an image a little out of the ordinary.

■ **And finally... break the rules.** Although the simple rules of composition outlined in the last few pages will help you to learn to see the best picture in any scene, photography is above all a creative process. Once you have mastered the basics of focus, exposure and composition, you can begin to experiment with bending or breaking the rules for impact and creative effect.

Night and low-light photos

Shooting in low light presents a challenge, but learn the tricks and techniques of the professionals and the results can be truly rewarding.

▲ Nothing compares to the atmosphere of a sunset or sunrise scene. Many cameras will produce results like this in fully automatic mode (with the flash off). You may have to reduce the exposure slightly (using the AE-C control) to get a proper silhouette; check the result on the screen and reshoot if it looks too light.

Your digital camera is designed to work in a wide range of situations and can cope admirably with everything from the brightest summer's day to the dimmest glow of a winter dusk. But no digital camera can work magic, and all have a limited sensitivity to very low light. What this means, in practical terms, is that when light levels drop below a certain point you can't simply point and shoot and expect to get picture-postcard results. By far the biggest problem is camera shake, caused when shutter speeds drop below around 1/30th of a second. Once the light gets very low – when shooting at night or in gloomily lit interiors, for example – the camera has to set long shutter speeds in order to avoid your pictures coming out as nothing but a black void.

There are three basic ways to deal with low light: using flash to add some illumination to the scene (this is the default setting on your camera); to increase the sensitivity of the sensor (ISO rating), which brings with it problems of noise; or to accept the longer exposures needed and take steps to combat the inevitable camera shake by using a tripod or supporting the camera some other way.

Reasons to avoid flash

To many photographers (myself included), flash is a necessary evil, and on-camera flash (the built-in type found on all compact digital cameras) is a last port of call when all other options have been exhausted. The reason is simple: on-camera flash is harsh, unflattering and frankly uncontrollable.

It robs scenes of atmosphere, and when used in its default setting is too powerful for anything close to the lens and too weak for anything far away. That is not to say you shouldn't use flash when snapping your cousin's wedding reception or at an office party, but that it is important to understand that as a creative tool the built-in flash is about as subtle as a sledgehammer.

▲ Cities come alive with rich and vibrant colours at night. The lower two shots were taken handheld in fully automatic mode with the flash turned off.

Long exposures

Long exposures are something of a challenge for any photographer, but as long as you support the camera properly to avoid camera shake, it's not too difficult and the results can be outstanding. Most decent digital cameras can set exposures of up to one or two seconds in their fully automatic ('program') mode; all you need to do is turn off the automatic flash and the camera will do everything else for you. Many models have scene (or subject) modes specifically designed for shooting in low light without flash, and some even have special long-time exposure settings. Roughly speaking (and presuming a sensitivity setting of ISO 100), dusk and dawn scenes tend to need exposures in the one-quarter to one-second region, whereas to get an exposure in the deep of night (such as the shots shown below) you might be looking at four or even eight seconds. Shooting well-lit night scenes (the neon glow of a busy city, for example) with a higher sensitivity setting might even allow handheld exposures in the 1/25th or 1/15th region – but only if you have a steady hand. Be aware that long exposures tend to exacerbate noise in the image (see opposite page) and can play havoc with the colour of the final photo.

▶ **Long exposures mean camera shake is an ever-present threat. A sturdy tripod is essential for the sharpest pictures, but a mini-(tabletop) tripod (right) can fit in a pocket and provide perfectly good support if placed on a wall or table. At the very least, lean on something solid if you have to shoot handheld photos at night.**

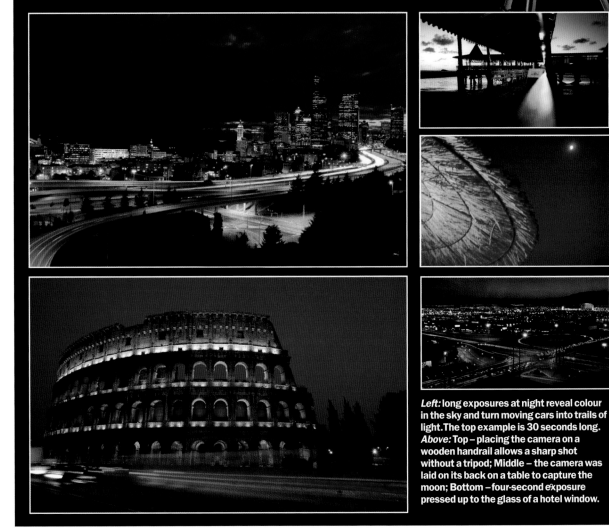

Left: long exposures at night reveal colour in the sky and turn moving cars into trails of light. The top example is 30 seconds long. *Above:* Top – placing the camera on a wooden handrail allows a sharp shot without a tripod; Middle – the camera was laid on its back on a table to capture the moon; Bottom – four-second exposure pressed up to the glass of a hotel window.

Noise and long exposures

Digital cameras all suffer from noise (random grain blotting the image) to some extent, and it always gets worse with long exposures and when you turn up the sensitivity (ISO setting) – both of which are common when shooting in low light. Every camera is different, so you need to try for yourself, but you'll generally find that increasing the sensitivity to its top setting will produce images so noisy they are unusable. As these examples show, the difference between the default setting (in this case ISO 100) and the top setting (ISO 400) is huge. Note also that many cameras have an 'automatic' sensitivity setting that will turn it right up if light levels are very low, so switch to manual ISO mode.

▼ **4 seconds at ISO 100.**

▲ **8 seconds at ISO 400.**

You can use flash to produce wonderful, subtle results, but this requires that you use a bigger, more diffused flash and move it well away from the camera (so it is illuminating the scene from the side or above). Ideally, you need more than one, and the ability to alter the output (power) of each flash to fine-tune the illumination of whatever you are shooting. This is why professionals in the studio use two, three or even four large flash heads fitted with huge softboxes or umbrellas and mounted on stands. You can buy home studio flash systems to use them with many compact cameras, but they are not convenient, and take a lot of practice to master. See pages 89–91 for more on using flash creatively and using external flash systems.

Shooting without flash

So, given everything I've just said, what should you do when shooting in low light if you don't want to use flash? Whether you are shooting indoors at night or trying to capture a sunset on your holiday, the secret to low-light photography lies in making sure that you manage the issues surrounding long exposures, chiefly the problem of movement – of camera or of subject – during the exposure. What this boils down to, basically, is keeping the camera as still as possible while the shutter is open, usually by mounting it on some sort of support such as a tripod. You also need to consider the separate issues of noise (graininess in the image that increases as light levels drop), colour (white balance systems can fail in very low light or when the light has a strong colour) and how you deal with movement of the subject itself.

Steady as she goes

Any movement of the camera or subject while the exposure is being made is going to result in blur. Movement of the camera during the exposure is invariably worse; resulting in an overall blurriness that ruins virtually every shot it appears in. On the other hand, movement of some or part of the scene you are shooting can be used to great creative effect; the long trails of car headlights caught in a three- or four-second exposure can bring a night shot of a city to life (see box, left). The key here is making sure that the only blurring is caused by movement in the scene, not of the camera.

By far the best way to avoid camera shake with long exposures is to use a sturdy tripod or, if you prefer a less unwieldy alternative to carry around, a monopod (a single-legged camera support).

EXPERT TIPS

■ When shooting sunsets always experiment with different AE-C (+/–) and white balance settings; the camera's automatic choices might not give the best results.

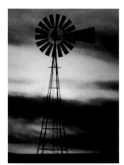

▲ Make use of whatever solid surface you can find to make sure you avoid camera shake.

If you're caught out without a tripod then you can make use of any suitably sturdy surface to support the camera; in the past I've made use of everything from postboxes to dustbins to dry stone walls to prevent camera shake, and often with great success. If possible, try to use the self-timer (or the remote control if your camera has one) to prevent jolting the camera as you take the picture. Just remember that any shutter speed under around 1/30th of a second (or more like 1/125th of a second at the long end of the zoom) is likely to result in camera shake if you try to take the picture handheld; therefore, get into the habit of checking the camera's display and looking for something to rest the camera on if the shutter speed drops too

low. You should also develop the habit of zooming into your recorded images in playback mode to check them for sharpness. Quite often blur does not show up when you are looking at the whole frame on a tiny screen.

As ever... experiment

Digital cameras make shooting at night easier than ever, and, as long as you are aware of the danger of camera shake and take steps to minimize it, you can shoot away to your heart's content. Take more pictures than you think you will need, and experiment with your camera's settings – there will always be a high proportion of dud shots when you are working with long exposures.

Colour and low light

When shooting in low light, most digital cameras' Auto White Balance will struggle to remove the colour cast – especially that caused by indoor lighting. The warm, orange results are often perfect for capturing atmosphere, but if you want a more neutral result you will need to turn off the Auto White Balance and manually select the setting nearest to the light source you are shooting under. Note also that sunsets and sunrises produce strongly coloured light, which is part of their appeal. Some, but not all, colour casts can be removed using software.

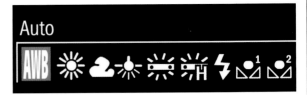

▲ Most cameras offer six or seven white balance presets. Auto is fine for most daytime work, but you will need to switch to manual when light is low or there is a strong colour cast.

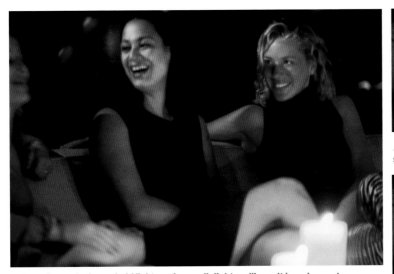

▲ Shooting under household light – or by candlelight – will result in a pleasant warm tone to your images if you leave the white balance set to automatic.

▲ Auto White Balance often fails in low light; set it manually if you want neutral colours.

Better flash photos

You certainly don't want to use flash for every shot at night, but there are always going to be times when nothing else will do. Here's how to avoid flash disasters.

You should, by now, be aware of the shortcomings of your camera's built-in flash. Without additional equipment, it is difficult to avoid 'rabbit caught in the headlights' type portraits when shooting with flash. However, there are several techniques you should learn to make more creative use of your flash and take more appealing images. Two of these, slow sync and fill flash, are covered on pages 90–91.

Firstly you need to understand what built-in flash units cannot do. They cannot illuminate large scenes or anything more than a few metres away. Your flash cannot light up a football pitch from the 42nd row, nor can it illuminate several square kilometres of night-time Paris from the top of the Eiffel Tower. Yet I have seen flashes going off in both these situations. There is a fairly strict distance range on your flash; it varies from camera to camera but is typically from around 50cm to 3m (2–10ft). Any nearer and the flash is too strong (resulting in overexposed photographs); any further away and it won't reach, resulting in dark, underexposed pictures. Check your manual to ensure you know the approximate range of your camera's flash.

There is one specific situation where direct flash cannot be used at all (aside from those, such as inside museums or auditoriums, where it is usually banned). This is when shooting through glass – be it a window, a mirror or the wall of an aquarium. Try it and see what you get – I can guarantee the resultant photo will have a huge white reflection of your flash and not a lot else.

Of course, there are many more situations where on-camera flash can be used quite happily, even if it is often less than desirable, so this section looks at some of the problems, and some of the solutions, when shooting the most common subject: people.

▲ Compare the result of direct (right) and bounced flash (left) and you'll see a huge difference.

▲ Add-on flash attached to hotshoe.

The dreaded red eye

Red eye is caused by the light from the flash bouncing off the back of the eye and heading straight back for the lens. The red you can see is actually the blood vessels on the inside of the eye and only occurs when the flash is near the lens and aimed directly at the subject (in other words, exactly the situation when using the built-in flash). It tends to be worse when the person is a little further away from the camera, and whenever the subject's pupils are wide open (in low light or after one too many drinks, for example). Anti-red

eye systems use a burst of light or a double flash to make pupils smaller (thus minimizing the size of the red dot), but can only do so much. The only real way to avoid red eye is to change the direction of the flash so it is no longer parallel to the lens (which means taking the flash off the camera or using an add-on bounce head flashgun) or to take pictures when the subject is not looking anywhere near the lens. It is often easier to accept that you are going to get some shots with red eye and remove it later using one of the many software tools available (see page 136).

Fill flash

Flash isn't only for shooting at night; it can be extremely useful in daylight too. Professionals often use a burst of flash to fill in shadows or to balance a darker foreground with a brighter background (someone standing in the shade in front of a bright sky, for example). Using fill flash is no more complicated than turning your camera's flash mode from automatic (the default setting) to 'on', meaning it fires even if the amount of light in the scene means the camera thinks it isn't needed.

▲ A burst of flash – even on the brightest day – can add a touch of sharpness and ensure your main subject is well lit.

▶ Using fill flash in backlit situations can avoid the silhouetting of your main subject when the foreground is not as well lit as the rest of the scene, and also ensures your main subject is recorded sharply.

EXPERT TIPS

■ If your camera doesn't have a slow sync flash mode, it may have a subject or scene mode that does the same thing. Look out for 'Night Portrait' mode.

Photographing people with direct flash will never produce the most flattering results. The harsh light highlights every blemish and wrinkle, and blasting them directly in the face with a burst of bright flash often produces unattractive results that neither you nor your subject will be happy with. It also produces hard, unsightly shadows behind your subjects and – more often than not – the demon red eyes caused by the light bouncing off their retinas and straight back into the camera lens.

You can try softening the light from your built-in flash by taping some diffusing material over it (tissue paper works well), but the improvement is rarely worth the effort. More effective is to use the slow sync flash setting (see box, right) to allow some of the ambient light into the photo. However,

ultimately the only way to produce more flattering flash portraits is to move the flash off the camera. This is usually done using an add-on bounce head flashgun that can be angled away from the direction you are pointing the camera, allowing the light to reflect off a wall or ceiling before it hits your subject. The difference is amazing, and – if your camera has the necessary connections – it is well worth investigating an additional flash unit if you take a lot of pictures of people indoors.

Quick tips for using on-camera flash

■ Anti-red eye mode can often make pictures worse (the twin flash tends to startle people and the delay can mean that they move). It only takes a moment to remove red eye using software later.

- An add-on bounce head flashgun will transform your indoor portraits.
- If your camera offers the option to reduce the power of the flash, use it when photographing anything nearer than a few feet away.

- Slow sync and fill flash are powerful techniques that are worth learning to use.
- Avoid using direct flash for still lifes and full-face portraits, and never try to use it when you are shooting through glass.

Slow sync flash

Nearly all cameras offer a slow sync flash mode. Slow sync, as its name implies, combines a long exposure (determined by the brightness of the scene) with a burst of flash. The effect is to combine a slightly blurred and a completely sharp image into a single photo. It can be used in bright light or at night (in which case, make sure you hold the camera still to avoid too much camera shake) and the results can be truly eye-catching.

The main advantage of slow sync mode is that it avoids most of the disadvantages of shooting with flash alone: black backgrounds at night, harsh, sterile lighting, and cold colours. It also allows you to experiment with motion in your photos without getting a completely blurred mess.

▲ One of the main uses for slow sync flash is to allow the light from an evening outdoor scene enough time to appear in the shot. You will need to use a tripod to avoid camera shake or motion blur.

◀ Here slow sync flash has been combined with panning to produce a shot with a real sense of motion.

▼ Rotating the camera as the picture was taken in slow sync mode has created a unique picture.

▼ Used in daylight, slow sync flash adds atmosphere and movement.

Capturing motion

With a little practice, good timing – and a modicum of luck – even the most basic digital camera can be used to capture captivating images that put you right in the centre of the action.

▲ Shooting sports requires fast reactions.

▼ Pre-setting focus and exposure is often the only way to catch the moment when shooting with a non-SLR camera.

From children playing in the park, to a dog running for a stick, to a local game of basketball, there are hundreds of occasions when you might want to take action photos; however, for the average snapper, they are rarely successful. Why is that?

The fact is that shooting any kind of action requires more skill, more practice and more dedication (and demands higher performance equipment) than pretty much any other type of photography – even more so if you happen to be using a compact camera. The problem is mainly technological; the design of most digital cameras means there is a slight delay between pressing the shutter and the picture being taken (if you include the time to focus, it could be up to two seconds), during which time anything moving at speed might not only have moved in the frame, it could easily have left the frame altogether. Here's a good example; shooting a local soccer match. You might be 20m (65ft) away from the action. At the long end of a typical 3x zoom the frame will cover an area roughly 5m (16ft) wide. A fairly fit man can cover that distance at a run in under two seconds, so the scene at the point the picture is taken will be very different to the one you saw in the viewfinder

when you pressed the button. Digital SLRs suffer considerably less from this lag, and are therefore much more suitable for sports and other action. So, what can you do?

Technical issues

Aside from lightning-fast responses and a fair amount of luck, there are several technical issues that will define how you set up and use the camera when shooting action. First is the need for a high shutter speed. What you need will vary according to the speed at which the subject is moving; whether you are using a telephoto lens or not; and what direction the motion is relative to your position – a speeding car moving from left to right needs a higher shutter speed than one heading right at you. As a rough guide, you need to be looking at more than 1/125th of a second to freeze even the most leisurely action – anything at walking speed, for example. If you are using a long lens or the action is moving at a faster pace you need shutter speeds of 1/500th of a second and more. This isn't a major problem for modern compact digital cameras, many of which have a top shutter speed of 1/2000th of a second or higher. Most cameras display the speed currently in use on the LCD screen if you push the shutter button half-way in.

How to ensure you get high shutter speeds will depend on your camera. If yours has an aperture priority mode you should use it, setting the aperture to the maximum value (the smallest f-number). This will allow the camera to set the highest possible shutter speed according to the brightness of the scene. On dull, overcast days you may find that even with the aperture wide open the shutter speed you get is too low; this is the point when you need to go into the camera's shooting menu and increase the CCD sensitivity (ISO setting), which will allow higher speeds.

Focus

Focus speed is the weak point of many compact digital cameras; the half second or so that some models take to focus is not only enough for the subject to move a fair distance, it is often too slow to lock onto anything. You will need to experiment with your own camera to find out how well the focus system works in a fast-moving situation. If your camera has a Continuous Autofocus (C-AF) option then try it. C-AF mode means it is continually refocusing as the scene changes, as long as you maintain half-pressure on the shutter release.

▲ Cameras with scene or subject modes invariably include a special mode for shooting sports. In sports (or action) mode, the camera will choose the highest possible shutter speed and may also increase the ISO setting (sensitivity) and change from single shot to continuous focus. It will also change to burst mode (continuous shooting). Of course, if you don't have a sports mode you can do all this yourself.

EXPERT TIPS

■ Don't try to follow fast-moving action with a long lens – you'll never keep up, nor will your camera. Watch the action and wait for it to enter your viewfinder before shooting.

▲ Sometimes a longer exposure, allowing blur into the shot, makes for a more exciting photo.

(In normal AF mode, the camera stops focusing as soon as it finds something.) Be careful though; C-AF mode allows photos to be taken that are out of focus (something the standard single focus mode is designed to prevent). Professional sports photographers – who are using much, much faster equipment – rarely rely on autofocus systems, preferring to prefocus manually and wait for the action

to arrive sharply in their viewfinder. Switching to manual focus can work for compact camera users too, especially given the huge depth of field offered by the smaller sensors.

Burst mode

Professional sports photographers also hedge their bets by taking literally hundreds of shots in rapid bursts at speeds of up to eight or ten frames per second. This considerably reduces the chance of missing the critical moment. Virtually all compact cameras have a burst, or continuous shooting, mode that can take a sequence of up to four or so shots in fairly brisk succession, so you should certainly try using this facility.

Shooting technique

The basic shooting technique for any fast-moving subject is broadly the same, and I should make it plain from the start that the key here is practice; sports photography in particular demands incredible skill on the part of the photographer, including an almost supernatural ability to predict where and when the action is likely to happen.

Panning

Panning is a specialized technique that allows you to capture a moving object relatively sharply while using a slow shutter speed (1/30th or 1/60th of a second, for example). Panning involves following the movement of your subject with the camera while the exposure is made. It takes some practice to get right, but the end results can be very impressive, with the moving subject in stark contrast to the blurred background, giving a highly dynamic impression of speed. The cyclist shot was taken from a vehicle moving at roughly the same speed as the rider, while the other images were shot by turning the camera to follow the movement during a fairly long exposure.

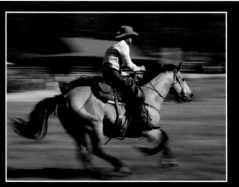

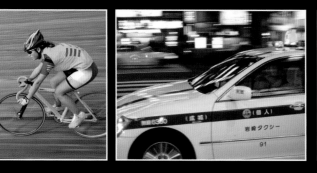

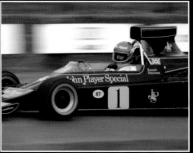

You also need to know your camera inside out, not only how to operate the controls without thinking, but also in terms of its foibles and its responsiveness and general performance. If you use the same camera often enough under pressure you will be much better at taking into account any delays in focus or shutter lag that would otherwise ruin the shot. This leads on to perhaps the greatest skill a sports or action photographer can have: timing. If you can anticipate where the action is going you can learn to shoot a fraction of a second earlier than your instincts tell you, safe in the knowledge that by the time the exposure has been made the main subject will be exactly where you want it. The colour screen can really help in these situations, as you can keep half an eye on the action and half an eye on the screen. You can watch the motion as it approaches the area inside your frame and start shooting at exactly the right moment, rather than peering through a viewfinder waiting for something to appear and hoping that you – and the camera – can react quickly enough. It takes a lot of practice, a fair amount of skill and a sprinkling of luck to grab a winning shot. It also helps if you are shooting something you are familiar with; rugby fans are more likely to know where the action is going than someone who's never watched a match before!

Using blur

Of course, freezing motion is not the only way to photograph action; by allowing some controlled blur into your shots you can often convey the impression of speed even more convincingly. There is an awful lot of luck involved, and you may need to take many shots before you get the photo that you want, but it is often well worth the effort. If your subject is moving fast the conventional approach is to pan; follow the action with your camera and keep moving as you take the picture using a much longer shutter speed – as low as 1/30th of a second in many cases. What you should get, if you track the movement pretty closely, is a fairly distinct subject against a nicely blurred background (see box opposite). You can also experiment with capturing blurred motion using a tripod; a long (say one- or two-second) exposure of a street full of people, for example, will look very different from a standard shot, with some figures pretty sharp (those standing still) and others ghostly blurs as they move through the frame. Give it a go and see what results you get.

Settings

Depending on which camera you are using, there are several settings that you should change before attempting to shoot action photos. The drive mode should be set to continuous – usually indicated by this logo .

If your camera has an adjustable ISO speed (or sensitivity setting) increase it if you aren't obtaining high enough shutter speeds.

ISO Speed				
AUTO	50	100	200	400

Then use the **Continuous Autofocus (C-AF)** or manually prefocus.

▲ A totally blurred picture can convey a powerful sense of frenetic activity, as with this shot of a New York street at night.

◀ Using the right shutter speed to allow some motion blur into the frame is the professional photographer's secret to action shots with impact.

Better portraits

Whether you are taking serious portraits or simply snapping friends and family, the simple tips on the next few pages will make sure that whoever you shoot will be delighted with the results.

▲ Using a simple point-and shoot-camera, lit using a window and a reflector (on the right side of the face), it is possible to take very professional-looking portraits. This was converted to black and white in Photoshop.

You could fill several libraries full of books written on portraiture technique, so only the basics are covered here. Most of the advice boils down to a few simple do's and don'ts covering pose, composition and lighting. If you have ever snapped your partner and seen the look on their face when they see the result, you need to start aiming for portraits that the sitter wants to put on the wall, not in the bin.

Lighting

Successful portraiture is about lighting, above anything else. It is more important than the pose or the composition, for example. Lighting is what gives a portrait its feel, its mood and its atmosphere. Good lighting can flatter any sitter; bad lighting can

▼ Shooting between poses can produce much more natural-looking portraits.

It is very easy to understand the enduring appeal of portraiture; it is seemingly simple yet is capable of infinite variety. A well taken portrait can be moving and evocative; thought-provoking or amusing. It is something that can be equally enjoyed by both the photographer and the sitter, as well as featuring the one subject that everyone in the world is utterly fascinated by: other people.

▲ Harsher lighting and a more contrasty treatment works well for bringing out texture in the face.

emphasize absolutely everything that they hate most about their appearance.

The first and most important thing to remember is that the built-in flash on a compact camera (as discussed previously) should generally be avoided when you are trying to take serious portraits. Flash lighting is too harsh, makes skin look terrible, produces hard-edged shadows behind the sitter, and tends to make people look pale, washed-out and rather flat-faced. Off-camera flash is the lighting of choice for the professional studio portrait photographer, but they use heavily diffused three-head systems and have many years of experience in using them. If your camera can accept an external flashgun then by all means experiment with using off-camera flash (using a cable to move the external flashgun over to one side and slightly higher than the sitter), but you will still find it hard to shoot subtle portraits without a lot of trial and error.

The best type of lighting for home portraits is daylight, preferably the diffused daylight of an overcast day. Put someone in a room by a window (not in direct sunlight) and you will obtain attractive modelling; the impression of depth you get when one side of the face is illuminated. If the light is nice and diffuse you will get

▲ Experiment with unforced poses.

▼ Shoot your subject in their own environment for a more interesting portrait.

▲ A simple snap can be turned into a graphic portrait with some image-editing.

▼ This picture – taken in my front room – shows how a creative approach can be applied to family snapshots.

a flattering texture to the skin. If the shadow side of the face looks too dark then you can try using a sheet of white card to bounce some light back in. Alternatively, if you have the budget for it, buy a special reflector from a camera shop. These are often white on one side and silvered on the other side (which reflects more light

and is slightly harsher). If the light is coming from high enough to put shadows under the eyes or nose (this is a danger on cloudless days), get your sitter to hold a reflector (or sheet of card) on their lap and angle it so enough light is reflected upwards to balance things out. It really is that simple. Once you have mastered the basic technique of shooting by a window, you can start to experiment with more advanced lighting (try using a bedside lamp as a spotlight, for example) or get yourself some flash heads, stands, diffusers and reflectors and discover just how complex the lighting for professional studio portraits can be.

Composition

There are a few simple rules to remember when setting up and framing a portrait, and they are worth listing and explaining one by one.

Lens choice. As mentioned earlier (see page 74) the choice of lens has a massive impact on the look and feel of a portrait. Unless you are after a special

▲ Use any unusual available light – and don't think your sitter always has to be looking at the lens. Note also that the rule about not photographing a woman from below can – like all rules – be broken!

Lens choice

effect you should avoid anything less than 50mm (equivalent) for head-and-shoulders or full-face photos. The reason is simple; to get close enough to fill the frame with a face using a wider lens introduces unflattering distortions that your subject will not thank you for. The ideal lens for head shots is around 90 to 105mm – near the long end of a typical 3x camera zoom. You will need to take a couple of steps back, but the perspective will be much more flattering.

■ **Crop**. Unless you are getting arty there are only four commonly used portrait crops; full-face, head-and-shoulders, three-quarters (which is actually waist up) and full-length. The reason is simple: if you cut someone off at mid-calf or mid-thigh they will look as if they're standing in a puddle; cut them across the chest and they risk looking as if they're standing behind a fence. Of course, there is plenty of leeway when it comes to framing your shots, and a lot of it depends on the pose and angle. If you stick closely to one of the four standard crops, however, you can't go too far wrong. Get into the habit of examining the preview image on your camera's screen properly before shooting; think about pictures before you take them.

■ **Angle.** Generally speaking, unless you are deliberately aiming to achieve a special effect or trying to emphasize someone's size, it is always most flattering to shoot at or near eye-level. At the risk of making gender-based generalizations, moving slightly higher can add a touch that can be quite flattering in female portraits and in pictures of children. Moving the camera slightly lower can help to add an impression of stature that suits slightly harder-edged – and usually male – portraits. One way to guarantee that a woman will hate her portrait is to shoot her face from below... it really isn't flattering!

■ **A few posing tips.** Avoid shooting people square on – tilt the body slightly so one shoulder is further away from the lens and have the sitter turn their head towards you. Remember, too, that in many of the greatest and most memorable portraits the sitter is not looking at the lens at all. You should generally avoid having your sitter look directly into the main light source.

Lens choice

▲ The same subject, same lighting, same camera and same room; the only difference is the lens... The top example shows the result of using the wide (short) end of a digital camera's 3x zoom; the one below is taken at the long end. Which do you think is more flattering?

▼ You don't have to use a plain background, but be careful of using anything that could distract from your main subject.

Photographing children

Children are one of the most rewarding subjects, and photographing them successfully is a simple case of following the same basic composition guidelines as for any portrait. By far the most rewarding portraits are those taken in candid style, using a slightly longer lens and keeping your distance. This will produce much more natural shots that show real character and capture the essence of childhood. From a technical point of view, children can be challenging, moving fast enough to keep a professional sports snapper on their toes. Use the techniques outlined in the section on shooting action (pages 92–95) and make sure you take lots of shots to be on the safe side. Finally, try to get down to the child's eye level for the most appealing portraits.

▲ Despite being natural posers, children can easily be distracted, and this is when you can shoot the most rewarding candid portraits.

▼ Babies can easily be given the portrait treatment, but you will need to catch them awake and in a good mood!

▲ Experiment with different angles, and get down to, or even below, the child's eyeline for something a little different.

Try to avoid clumsy and unnatural-looking poses and – above all – make sure that your sitter is comfortable with how they are posed. Nothing ruins a portrait like a subject who looks uncomfortable or uneasy. Make sure you keep talking to the person you are photographing and show them the pictures as they are taken. Many professional photographers use a full-length mirror to help people find a position they like, or even attach the camera to a television screen that the sitter can watch, giving live feedback of every shot.

Finally, experiment and take lots of shots from slightly different angles, try to relax your subject and don't force them to adopt a fixed grin for the entire shoot. Watch carefully, and try to take more natural pictures that look less posed. Some of my favourite portraits have been taken when the sitter thinks I am fiddling with the camera controls and relaxes for a second between poses!

■ **Focus and exposure.** With portraits, the golden rule is to focus on the eyes. If the eyes aren't in the centre of your frame the camera may focus on the nose, ruining the photo. Use focus lock (half-pressure on the shutter release) to first focus on the eyes, then reframe. In exposure terms you should certainly experiment with the AE-C settings to slightly lighten or darken the image according to the mood you are trying to create. This is especially important with portraits in bright light, where the highlights on the face (forehead and nose) can be burnt out (appearing as pure white). It is always better to underexpose slightly (have the picture a little on the dark side) as this can be fixed using software, whereas blown-out highlights cannot. As a general rule, portraits are usually shot using the widest possible aperture (the smallest f-number), mainly because this throws the background out of focus. Due to the limited depth of field when using a wide aperture and a longish lens, you should be extra careful to focus on the eyes.

■ **Background.** The last thing you want in a portrait is a distracting or cluttered background. For this reason, a plain white background is often the best choice – I use the wall of my dining room, which is conveniently painted white. Using a plain backdrop will also make your life much easier if you want to add a new background later using your image-editing software.

▲ With a willing model and plenty of time to experiment, a portrait can move on to become something much more than simply a picture of a person.

◀ Avoid posing problems by shooting people when they are going about their everyday business.

EXPERT TIPS

■ Many cameras offer a special portrait mode that automatically sets the zoom and aperture, and reduces the in-camera sharpening. You might still need to turn off the flash manually.

Quick portrait tips

■ Not all portraits need to be formal or even posed. Shoot your loved ones as they go about their daily lives and not only will the end result be more natural, it will put them in the context of their lives and interests.

■ Remember you are shooting digitally; blemishes and most background clutter can be removed later when you get the pictures onto your PC.

■ Focus on the eyes and use the right focal-length lens.

■ Holiday snaps of your family don't need to be hideous: remember the basic rules of lighting, composition and posing and you can take flattering portraits anywhere.

■ Remember: natural, diffused daylight is the most flattering illumination for portraits.

■ Use reflectors to lift dark shadows when shooting with a single light source.

Better landscapes

Whether you are on the holiday of a lifetime or wandering around your local neighbourhood, better landscapes are a simple matter of following a few basic rules and – above all else – thinking in terms of pictures, not snaps.

▲ **A very simple composition is brought to life by shooting at the very end of the day, just as the sun is setting. In this case, the sunset is behind the photographer.**

If you have ever wondered why your holiday snaps don't look like the picture postcards on sale in the hotel lobby, you have stumbled across one of the basic realities of landscape photography – it's a lot more difficult than it looks!

The beautiful landscapes you see in books and magazines are often the result of weeks of preparation and are chosen from hundreds of shots taken on many different occasions. This is a key point; really stunning landscapes require both dedication (getting up very early, travelling great distances in the hope of capturing an elusive break in the clouds and so on) and a huge amount of patience; none of which fits very well with the hectic pace of modern life. However, there are a few basic techniques that can lift your scenic shots above the norm, and a few digital tricks and cheats that can make the whole process a little easier.

What to shoot

So you want to take some impressive scenic shots; that means you need to find some impressive scenery, right? Not entirely. The secret of really good landscape photographers lies in their ability to find a picture in virtually any scene they point their camera at. You don't need to visit one of the planet's places of outstanding natural beauty to get a winning shot, although you might have to work a little harder to achieve it. As much of the appeal of the best landscape photographs comes from the quality of the light and the way in which the picture has been composed as it does from

the attractiveness of the scene in the first place. Obviously, holidays are an excellent opportunity for shooting landscapes, whether you are on a skiing trip or relaxing on a tropical beach. You will, however, need to set aside some time to take pictures as well as relaxing, and you may well need to venture off the beaten track to find photogenic scenes that are not teeming with hundreds of other tourists and packed with souvenir stalls.

Unless you live in the centre of a major metropolis, you are likely to find endless photographic opportunities near to your home. Most people live within easy driving distance of the countryside or a coastline, and anything near where you live or work has the advantage that you can keep revisiting the scene at different times of the year or under different weather conditions. This leads on to the second important consideration: timing.

When to shoot

There are two separate issues here: what time of year and what time of day you photograph a scene. The same scene will produce dramatically different photographs as the seasons come and go, yet many of us only ever take pictures outdoors in the height of summer, when the blue skies and verdant foliage offer a riot of bright, saturated colours, resulting

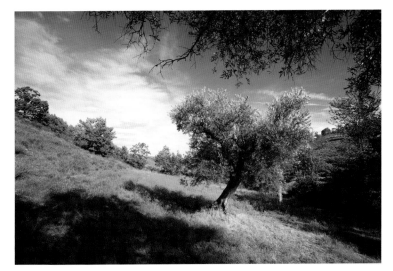

in uniformly vivid, crisply contrasted photographs of every scene. The truth is that, photographically speaking, shooting in the middle of a hot summer's day may be the easiest option, but it is also going to produce landscapes lacking in any subtlety or atmosphere. This is partly down to the quality of light on such days; the high sun and bright sky produce a very flat illumination of the scene, and a cloudless sky – even if it is a beautiful deep blue – lacks any drama or visual interest. That is not to say you shouldn't shoot in the summer; just that you shouldn't forget the photographic opportunities on offer during the rest of the year.

The time of day you take the picture is just as important as the time of year. This is especially true when photographing in the summer months.

▲ Careful use of angles and framing can bring a dynamic element to perfectly static scenes. In this image, the lack of straight horizontal or vertical lines produces an exciting composition.

◄ Shooting as the sun goes down on a bright winter's day (below left) allows you to capture the beauty and warmth of natural light in all its glory.

▼ You don't need perfect weather for stunning landscape images.

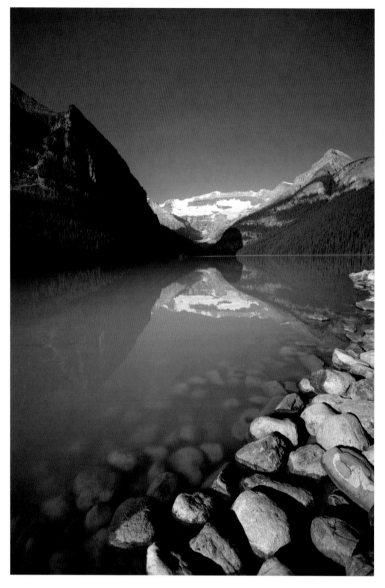

The long days see the quality of light vary enormously from dawn to dusk. Almost without exception, the best time to photograph is within an hour or so of sunrise or sunset when the sun is still relatively low in the sky and – during the winter months – shadows stretch across scenes adding interest to even the most mundane scenes. The colour of light starts warm (orange tones), cools down as you approach noon and starts to warm up again as the day draws to an end. We have all seen beautiful dawn and dusk skies from our hotel rooms; the dedicated landscape photographer will be sitting waiting for the perfect moment to take a picture. Wherever your travels take you, make sure you set the alarm for just before sunrise at least once; not only will you be rewarded with stunning light and the possibility of a truly dramatic sky, you will also be able to photograph even the most popular places at the one time they aren't busy with tourists. Exactly the same goes for the evening just before sunset – pick up your camera and go for a wander one night instead of heading straight for the bar. This is especially true in beach resorts: beaches are not that interesting, photographically, until they empty of people and the light takes on an almost magical quality as the sun sets.

Composition

More perhaps than any other subject, shooting landscapes is the one time where a fairly rigid application of the rule of thirds (see page 78) reaps rewards shot after shot. Think about how

▲ Shoot vertically to include lots of foreground. This helps to give a tremendous sense of scale.

▶ Experiment with unusual views, and remember that simplicity is often the key to a great landscape shot.

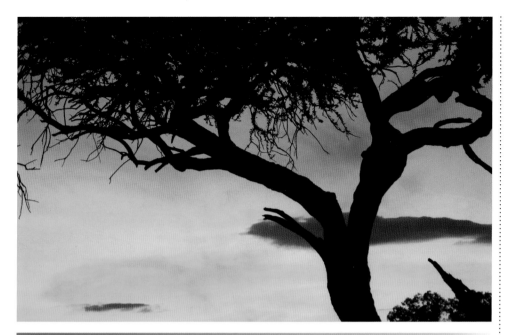

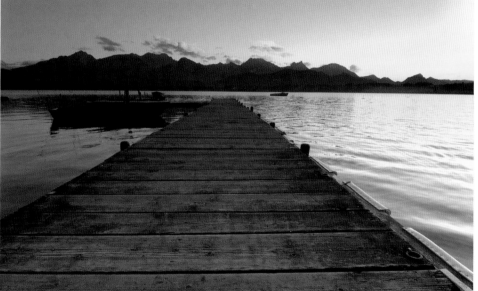

◄ Both these shots illustrate the value of getting up early – or staying up late – whatever the time of year. Neither of these scenes would have the atmosphere or beautiful colours if they had been taken in the harsh glare of the midday sun.

▲ A telephoto lens produces a flattened perspective, and shooting just after the sun has set gives a limited colour palette that makes for some unusual and eye-catching landscape images.

▼ Look for the unusual; not all landscapes need to be 'beautiful' scenes.

the scene works within the frame before you shoot and experiment with different zoom settings and orientations (not all landscapes should be shot in horizontal format – try turning the camera on its side to include more sky or foreground). Most of the best landscapes draw the eye into the frame; one of the most effective ways is to ensure you include something of interest in the foreground that connects near and far parts of the scene, or some form of natural framing.

Technical considerations

For most people, shooting a scene involves leaving the camera in its default fully automatic mode, pointing it in the right direction and pressing the button. But if you are after truly stunning landscapes, you will need to work a little harder – the same shot taken by a professional might involve an hour or so of preparation. First, scenic shots generally have a much finer level of detail than, say portraits, and you want to capture as much of it as possible.

▲ A dramatic sky and a horizon that is placed according to the rule of thirds makes for a superb landscape photograph.

▲ Add dynamism to everyday scenes by including diagonal lines to lead the eye around the shot.

There are few, if any, digital cameras that can capture every blade of grass in a scene, but there are a few simple steps to ensure you are at least getting the very best possible level of detail. Start by setting the image size to the maximum and the quality setting to the best you can – for really crisp detail you might want to consider shooting in TIFF or RAW mode, if available. You also want to use the lowest ISO (sensitivity) setting, to avoid noise, and – if you are using an SLR – the smallest possible aperture (the highest f-number) that is practical. A small aperture will not only give the depth of field required to ensure everything is in focus, but will produce the sharpest results from your lens (lenses are always sharper when the aperture is smaller). If you are using a compact digital camera you will get the best results leaving the aperture roughly in the middle of the range.

Of course, using a low sensitivity setting and small aperture inevitably brings a problem with it; you can end up with shutter speeds too long to handhold without getting camera shake, which is why a tripod is a necessity if you are aiming for the best possible quality. If you don't have any support for your camera then you should open up the aperture (use a lower f-number) until you get a usable shutter speed. Try not to increase the ISO setting unless you really

▲ Many cameras offer a special landscape mode that will attempt to use the smallest possible aperture and lowest ISO setting and, depending on the model, may also change the focus method, sharpening and contrast settings.

Additional equipment

Although you can very effectively shoot landscapes using a compact digital camera as it comes 'out of the box', you might want to consider a few add-ons:

■ If you're going out shooting for a whole day you will probably need extra memory cards, spare batteries and, possibly, a hard disk-based storage device.

■ You need a wide lens to fit in huge sweeping vistas. Most cameras can accept a wideangle adapter that screws or snaps onto the front of the zoom.

■ As with most types of photography, a tripod or monopod is essential for really professional results, especially when the light starts to fade.

■ A skylight filter will cut excess blue out of snow scenes or those at high altitudes and protect the front of the lens. More useful is a polarizing filter that can make blue skies much bluer. Check whether your camera can accept screw-in filters.

▲ **Extra memory card**

▲ **Tripod**

▲ **Wide adapter lens**

▲ **A digital photo 'wallet' with a built-in hard disk allows you to download your pictures in the field and free up card space.**

have to, as excessive noise is almost impossible to remove. Finally, colour. As discussed on pages 52–53, the colour of light changes throughout the day, and the warm glow of a low sun can add tremendously to the mood of a photograph taken early in the morning or late at night. Unfortunately, the Auto White Balance function is designed specifically to remove any overall colour cast, which can rob the final photo of all its atmosphere. For this reason you may want to switch the white balance to manual and choose 'daylight': this is designed for midday sunshine, which is much bluer, resulting in warmer photos at either end of the day. As with all things, every camera is different and it is advisable to experiment with different white balance settings to see what creative effects you can obtain from them.

The digital difference

One area where digital camera users have a real advantage over their film-based predecessors is in the ability to shoot less-than-perfect scenes in the knowledge that problems can be fixed later when the photo is loaded into your image-editing application. How far you take this will depend on the level of your Photoshop skills, but most people can master basics such as removing elements (cars, people, telegraph poles and so on) that are blotting otherwise perfect landscapes, stitching several shots into a panorama, or adding impact to a dull sky. This way of shooting 'loose', for want of a better word, is fundamentally different to that used

when shooting film, where for most people the process ends the moment they press the shutter, after which point they can only wait for the prints to come back from the photo lab. The digital landscape photographer can, if they so desire, swap skies, adjust colours, add or remove elements from the scene and completely transform what was captured into a winning print – as long as they can see the potential at the time of shooting.

Architectural photography

Buildings and cities offer a hugely rewarding yet often overlooked source of photographic subjects. You just need to start looking around you.

▲ **It's not difficult to produce creative architectural photographs – just look for the picture in every scene you survey. Shooting at night (above top) brings a whole new dimension to buildings (see page 86), while very modern buildings (above right) work well with an almost abstract, high-contrast treatment.**

We spend a huge amount of our time inside or around buildings, yet few of us ever take the time to stop and look at the infinite variety – and huge photographic potential – to be found in both cities and less urban areas.

Part of the secret of photographing buildings, from city skyscrapers to village churches, is to learn to look at what you normally take for granted in terms of photographic opportunities. It's easy to point your

camera at a famous building or monument and snap without thinking, which most people seem to do just to prove they were there. Much more challenging is to find a new way of looking at buildings, of taking pictures that say a little more than 'I was there' and that stand up on their own as creative works. Armed with a digital camera you can shoot away to your heart's content, experimenting with different compositions and viewpoints, and

thinking of how you can use the photographs you take to produce prints with impact when you get them into your imaging application.

Technical considerations

Buildings are generally easy to photograph from a technical point of view. Exposure is rarely a problem, unless there is a lot of sky in the frame, when you might need to use the AE-C setting to lighten the building slightly. You shouldn't have any colour problems either, as most buildings are pretty near to the neutral grey that digital cameras use as a reference for white balance. You need to use a wide lens if you want to fit much of a large building in. This can bring distortion into the equation, which you can either attempt to remove later using image-editing tools (see page 132) or use for creative impact. You'll notice that as you tilt the camera up

to get the top of a building into the frame the sides start to lean inwards. This phenomenon is known as converging verticals. You can only avoid this by not tilting the camera, which – if the building is tall – means you need to get a lot higher up or move a lot further away. Converging verticals can be corrected to some extent in software, or you can exaggerate the effect using the widest possible lens and shooting almost straight up – this can produce very arresting images of tall buildings.

Inside out

Don't forget the photographic opportunities offered by the interiors of buildings, but always check that photography is allowed before starting. You'll need a wide lens and possibly a tripod if it is dark (again, there may be restrictions on the use of tripods in public places). Spend some time looking for details you can pick out – both inside and outside the building – and shoot with a longer lens. Try to find a different viewpoint; get down low or even hold the camera above your head – the point is that you have to experiment to find new ways of looking at familiar places. Finally, don't restrict yourself to shooting in the middle of the day; early mornings, dusk and night time are just as rewarding when photographing buildings as when shooting mountains.

▲ Shooting at dusk for a different colour palette.

▲ Semi-abstract treatment for tall skyscrapers.

▲ Using a long lens to pick out detail and compress perspective.

◀ Look for unusual angles and dynamic composition. Reflections can be a powerful visual tool.

Places and people

Nothing defines a place as much as the people who live there, work there or visit it. They can provide a rich source of photographic potential too.

▲ **Wherever you go there are people, and photographic opportunities, so keep your eyes open and your camera at the ready.**

It takes a certain amount of confidence, some pretty quick reactions and a real eye for a picture, but with a little practice candid photography can add a human touch to your pictures of the places you visit. By turns poignant, heart-warming and amusing, photographs of ordinary people going about their lives can say much more about a place than shot after shot of public buildings and monuments. Some of the greatest names in photographic history

have been masters of the art. Armed with your digital camera, you too can learn to capture those everyday moments of humanity that bring a scene to life.

Rapid reactions

From a technical point of view, candid photography shares some of the issues surrounding action and sports shooting; you need to use a long lens if you want to photograph people without being noticed, and a relatively high shutter speed to avoid the associated risk of camera shake. For this reason it is usually advisable to increase the ISO (sensitivity) setting and to turn the camera's sports mode on, if available. It is also vital when shooting in situations where fast reactions are needed to know your camera inside out. The shutter lag (delay between pressing the button and the shot being taken) common to many digital cameras can be a real problem in such situations, but as you learn your

▲ Converting candid shots to black and white (or shooting in black and white mode in the first place) lends photos a timeless quality and often adds impact.

camera's foibles you will also learn the best way to compensate for any delays. As I mentioned earlier, the most common cause of out-of-focus shots comes from not waiting for the camera to focus before pressing the button. Try to get into the habit of using half-pressure, pausing for a moment to ensure that the focus confirmation light is on, then pressing the button fully in.

If candid photography does interest you, then get out and start shooting; the more you do it, the better you will become at spotting and capturing those fleeting moments in time that say something meaningful about your subject.

A few simple rules

Obviously, taking pictures of people you don't know, often without their permission, has the potential to be fraught with difficulties. Use a bit of common sense and you won't have any problems.

■ Have some respect for the people you are photographing, and for any cultural differences there may be when visiting far-flung destinations. If in doubt, do some research before you leave.

■ Lots of people are camera-shy. If someone spots you and indicates they aren't happy being photographed, don't push it, and try to let them know you understand. You won't usually be breaking any laws photographing people in public places, but that doesn't give you the right to upset anyone.

■ If in doubt, ask. Many people are happy to be photographed as long as you talk to them first. This takes some practice, especially if you are naturally shy, but it is nothing more than good manners.

■ Be very careful to get permission – and explain what you are doing – if you take candid portraits of children. Depending on where you are, anxiety about your motives might be so strong that it simply won't be worth the bother.

■ Don't be surprised if street performers, artisans, street sellers or beggars ask for payment for a picture, and don't try to snap and run!

■ Try to photograph people doing something, be it talking, laughing, running or working. This will produce more interesting and more human images.

■ Finally, don't hesitate – if a shot doesn't work you can always delete it; waste a few seconds deciding and it will be gone forever. And don't worry too much about technical excellence; a little blurring or noise can add to the atmosphere of candid shots – just concentrate on composing and taking the photo.

Still-life photography

Weather too bad to go out shooting? Don't worry – there's plenty you can do with even the most basic home still-life studio.

The winter months can be a depressing time for the active photographer. For every crisp, clear, frosty morning there are dozens of rainy, grey, dull overcast days. If you don't fancy wrapping up and shooting frozen scenes, why not discover the creative potential of still life from the comfort and warmth of your front room? You don't need any special equipment and all it takes is a little preparation and plenty of patience.

▲ **The most basic set-up (used for the shot above) is a simple cove made of a sheet of card near a large window, with a reflector placed on the opposite side of the subject. In the late afternoon, the low sun is perfect for shooting dramatic still lifes. You can control the light by placing obstacles between the setup and the window to alter the shape of the shaft of light falling on the scene.**

Lighting

Lighting is by far the most important consideration when shooting still life; perhaps even more than the composition of the photograph itself. How you light your subject can make or break a shot, and – in the absence of any specialist lighting – the key factor here is experimentation.

By far the easiest source of light to work with is sunlight, but it is also, by its nature, uncontrollable. The usual advice when shooting in daylight is to wait for the diffused light of a slightly overcast day. However, as the shots on these pages show, the strong directional light of a low winter sun can also be used to stunning creative effect. It is also easy to diffuse strong sunlight (using net curtains or a sheet, for example), whereas it can be difficult to create dramatic shadows or emphasize texture when shooting on an overcast day. In these cases, you can resort to using artificial light, be it flash or ordinary household lamps.

Shooting in daylight

I would always suggest you try shooting in natural light if you are new to still life. You need to set up your tabletop 'studio' near a window, and obviously you need to try to find a window on the sunny side of your house! For diffused light (the kind that creates soft, indistinct shadows), you will need an overcast day or a good diffusing material; a lightweight white sheet

▲ A simple set-up on glass below a well-diffused window (with the blind down). Note the dramatic effect of shooting in daylight using different white balance settings; fluorescent (left) and tungsten (right).

or a large piece of greaseproof paper hung over the window is ideal. As the light is coming from one direction, it is essential that you use some kind of reflector on the other side of the subject to bounce a little light back into the shadows and avoid too stark a contrast between the left and right of the frame. You can buy inexpensive collapsible reflectors, although a sheet of 5mm (⅛in) foamboard will do the job just as well. Reflectors have an annoying habit of falling over on to the subject when shooting still life, so it's worth clamping them to a stand of some description. Modelling or craft shops often have special miniature clamps, or you can try what I do, and tape a small reflector on to an anglepoise lamp. On clear winter days, the sun is so low that strong shafts of light come through the windows and stretch half-way across the room. You will need to chase them around, but these shafts can produce wonderful, dramatic still-life shots. Try filtering the light through lace or even through the outstretched fingers of your hand to produce an attractive and dramatic interplay of light and shadow.

Continuous artificial light

Artificial light is much more controllable than sunlight, and can (obviously) be used at night. In fact, it is often better at night, when your lighting won't be complicated by the intrusion of daylight. Many amateur photographers start out with simple tungsten floodlights. These are inexpensive and easy to use, and can be used for everything from macro and close-up work to full studio portraits.

The advantage of working with a relatively small subject is that you don't need large powerful lights, so you can use the alternative: household lamps. Although most pros would eat their camera before admitting it, a couple of basic anglepoise lamps can make an excellent lighting set-up for still-life photography. The main problem is that if you place the lamps near enough to the subject to illuminate it properly there is a tendency for 'hot spots' to develop. This is something you can counter by placing some kind of diffusing material in front of the lamp. Of course, you need to exercise caution when placing anything in front of a hot bulb, so avoid using plastics or thin paper, which are obvious fire hazards. If you want to work with household lamps then you will need at least two; three is ideal.

▼ Diffused daylight, a small reflector and careful composition produce perfect results.

market that will give you a powerful and versatile two-head system (including diffusers, stands and reflectors), but may cost more than your camera. If your camera has either a flash hotshoe or sync socket, you can try buying an inexpensive external flashgun and taking it off the camera using a lead, but you will need to soften the rather harsh light. Flash is also much more difficult to work with than continuous light. You can't see the effect of the lighting until you've taken the shot, and exposure is a rather hit-and-miss process. A studio flash kit is arguably the most versatile still-life lighting system you can buy, but I strongly recommend you leave that until you know you are going to use it regularly.

A suitable backdrop

At the bare minimum you will need an A2 (around 24x16in) sheet of fairly stiff white card, as well as something to support it. Ideally you want to bend the card into a 'cove' that goes underneath and behind the subject; this will provide a fairly seamless backdrop. But there's no need to stop there; you will find a wealth of potential background material in and around the home, especially if you are shooting directly down on to your subject from above (eliminating the need for a curved background). Anything from an old slate tile to a well-used chopping board, an open book, or a sheet of green glass placed over a sheet of white paper will produce interesting and richly textured results. You can even venture outdoors with your set-up and use a wooden deck or granite slab as a background.

▲ The same subject shot at different times on the same day in daylight with a point-and-shoot compact. The set-up was very basic; I used a cove made from card and some carefully filtered sunlight.

You will need to experiment with lamp placement and exposure to get the result you're looking for – but then that's part of the challenge, and half the fun.

Flash

I'm only going to touch upon flash as a light source for still life here for two reasons. First, you simply cannot use the built-in flash on your camera; it will produce uniformly appalling results with ugly shadows and flat, lifeless illumination. This means you have to buy additional equipment. These days there are several 'amateur' flash systems on the

Shooting technique

Part of the appeal of working digitally is that you can shoot 'loose' safe in the knowledge that you are going to touch up any pictures on the PC later. This has serious implications for still life; even the most basic Photoshop skills will allow you to tweak lighting (using dodge and burn), defocus areas (using a masked blurred layer) and clone out or crop away any bits of your front room that might make it into the frame. All that said, the phrase 'garbage in, garbage out' was never truer; you should always be aiming for the best possible shot

straight out of the camera. This is especially true of lighting, which takes quite some skill to correct convincingly. So what do you need to know?

■ **White balance**. Whether shooting under tungsten, flash or sunlight, you need to set white balance manually – Auto White Balance simply isn't up to the job in unusual lighting situations. You should also experiment with using the 'wrong' white balance setting to introduce either warm or cool tones to the image.

■ **Focal length.** Generally speaking, a slightly longer lens is better for still life than a wideangle. Anything from around 40mm to 150mm (equivalent) is ideal; longer lenses have a reduced depth of field that makes it easier to rid your shots of distracting backgrounds by throwing them out of focus. If you use the wide end of your zoom you'll also find you need to get so close to fill the frame that you may cast your own shadow over the subject.

■ **Lighting.** Although a single light source can be very effective, two is better (and three is often best). Your second light source can be a reflector placed on the opposite side of the subject to the main light source, or a second, less powerful light (or one further away). The third light would be used to illuminate the background (to avoid shadows) or placed directly above the subject to provide downlighting. This can often be achieved using a reflector if the main light source is powerful enough.

■ **A tripod.** Essential for still life; a tripod gives you freedom to leave the camera and tweak your subject, and steadies the camera in low light.

Subjects and composition

When composing for still life the usual rules (including the good old rule of thirds) apply, and possibly the best advice is to look out for still-life photos that catch your attention. Examine how they have been composed and framed, and try to learn as you experiment. As for subject matter; the list is virtually endless. Pretty much anything that can fit on your table and doesn't move under its own volition is a potential subject. Try to combine subjects and backgrounds that have a real-world or visual connection. An artfully placed tableau of bananas and bowling balls simply doesn't work as there is no reason for it.

◄ Using a long lens at its widest aperture allows you to use limited depth of field. Careful lighting and a black backdrop produce a classy result.

Top tips

■ Always take lots of shots and try experimenting with different white balance and exposure settings.

■ Fill the frame as much as possible to avoid having to crop out valuable pixels later.

■ Light should usually come from the side; otherwise, your subject will look flat.

■ Be on the constant lookout for potential subjects and backgrounds.

■ Don't place your subject too near the backdrop if you want to avoid shadows. You may find you need to light the background separately.

■ Coloured gels placed over light sources can add impact to a shot.

■ A tripod is essential to ensure that you get razor-sharp results.

■ Think ahead; if you intend to work on your pictures later in Photoshop this might affect or change the way you set up and take the picture.

■ The kitchen, garage, bathroom and the garden are a rich source of potential subjects. Also keep an eye out for unusual objects when you're out and about – the seashore is often a good source.

Close-up and macro mode

Move closer with your macro mode and you will discover a whole new world of picture opportunities right under your nose.

▲ No matter what your subject matter, with close-ups (like everything else in photography) lighting is key to the success of the shot. Often less – as here – is more when it comes to lighting close-ups.

Part of the beauty of close-ups is that there is a world of photographic opportunities to be discovered – often right under your nose, meaning you can experiment indoors when it's nasty outside. With a little creative input, even the most everyday objects can make excellent subjects and produce stunning photographs. When you get really close (using specialist equipment), you will discover a beautiful, intricate world of detail unseen, or simply ignored, by the human eye.

The digital advantage

Almost all digital cameras, even the least expensive, offer a decent macro mode as standard; something that is rare on 35mm zoom compacts. Digital cameras also offer the advantage of through-the-lens focus and composition (via the LCD monitor) and instant feedback for checking that you've actually got what you wanted in the shot.

How close can you go?

Most digital cameras have a minimum focusing distance (in macro mode) of between 2cm and 20cm (a few can get down to 1cm). But this is only half the story; the focal length (or zoom setting) has just as big a role to play. 20cm at the wide end of a zoom is very different to 20cm at the long end. This is why macro photography has traditionally been measured in terms of magnification, not focus distance. In fact, the term 'macro' actually means photography where the image (on the film) is at least the same size as the subject. On a 35mm camera this means being able to fill the frame with an area smaller than a book of matches. For a digital camera to be able to offer 'true' macro it would have to be able to sharply focus on an area less than a square centimetre; something none of them can. Take the example of a 20cm macro mode; at the wide end of the zoom this would equate to an area roughly about the size of a paperback book (200x150mm) filling the frame. Increase the focal length to, say, 200mm, and the area filling the frame would be more like 50x30mm; quite a difference. Some cameras allow you to use the macro mode at any zoom setting, but many restrict it to the wider end of the zoom, limiting the magnifications you can achieve. If you find your camera too restricting you need to look into a special macro converter.

Most compact cameras can accept special close-up lenses, which attach to the front of the camera's own lens in the same way as a filter, wideangle or telephoto converter and allow much greater magnifications. If you are lucky enough to own a digital SLR you can get really, really close using special lenses and adapters that will allow you to fill the frame with the tiniest insect.

Stay sharp

When you start working at very close distances you soon discover that depth of field – how far either side of the focused point is acceptably sharp – is severely limited. At extreme magnifications the depth of field can be as little as a few millimetres, and even the more modest macro modes of most compact digicams will have depth of field of no more than a couple of centimetres. Because of this you need to be very careful about focusing, and avoid any movement of the camera. This often means using some sort of support (ideally a tripod) to ensure you don't move. This is especially true if you want to increase depth of field by setting the smallest possible aperture – something that inevitably results in longer exposures and the possibility of camera shake. It is certainly worth taking several shots in rapid succession to ensure you get at least one that is perfectly sharp – you can always delete the bad shots as soon as you've had a close look at them.

Macro mode

■ Almost all digital cameras have a special macro mode that allows you to focus closer than usual. It is usually indicated by a small flower symbol and often has its own button on the camera body.

■ Macro modes vary widely in their usefulness; some can fill the frame with a coin, others struggle to focus on a sheet of writing paper.

■ Most high-end cameras offer a good macro mode – 1cm to 5cm – but you'll need to check it isn't restricted to the wideangle end of the zoom if the minimum focus distance is less than about 20cm.

■ Many macro modes select the smallest possible aperture, to ensure maximum depth of field.

▼ Try to match the lighting to the subject; here the white balance was set manually to give the warm, nostalgic feel.

▼ Get close enough and even everyday objects (such as this dirty car tyre) take on an abstract quality.

▲ **Flowers are an ever-popular subject, but don't ignore more unusual opportunities.**

Lighting

The rules for lighting are no different when shooting close-ups as with any other type of creative photography, but there are some unique differences that you need to consider.

■ **Flash.** The built-in flash on most compact digital cameras is simply too powerful to be used over very short distances, resulting in overexposed, burnt-out results. You can try cutting down the power using some folded tissue paper taped over the front of the flash. Note also that the flash may be obscured by the lens barrel at very close distances – you will have to try for yourself to find out if your camera's built-in flash is suitable for close-up use.

■ **Natural light.** No matter how good the built-in flash on your camera, it is likely to be far too harsh to produce attractive results. Much better is the soft, diffused light of an overcast day. If shooting indoors, work by a window and you'll get nice directional lighting that produces some modelling (where light and shadow show the shape and texture of the surface of your subject) without harsh shadows. Placing small pieces of black and white card around

Additional equipment

■ Close-up lenses (or filters) screw or clip on to the front of your lens and allow much greater magnifications. Focus range is limited, but they don't cut out any light and many are of very high optical quality.

■ A tripod, or some form of support, is essential once you start to get very close. You might also want to consider a tabletop studio with a built-in camera stand and lights. For extreme close-ups, a geared focus stage allows you to move the camera in tiny steps.

■ Special ring flashes attach to the front of the lens (although most can only be used on high-end cameras or SLRs) and offer the ultimate portable macro lighting solution.

■ If you have an interchangeable lens SLR, you can choose from a range of special macro lenses. This one from Canon allows magnifications of up to 5x.

your subject can be useful for lightening shadows or removing unwanted reflections. The beauty of working at such small distances is that your home studio won't take up half the spare room.

■ **Other lighting.** Experiment with any source of light you can find in the house; with such small subjects it can be difficult to avoid simply flooding the image with light, which produces rather flat-looking results. To get some modelling, try small, directional lights. I've had success in the past using torches, lamps or even a candle to illuminate small subjects. You can use your hands or a piece of card to direct the light and create areas of shadow. Just watch out for white balance problems when using mixed light sources.

Finding subjects

Even the most humdrum subject can reveal a wealth of detail once you get in close. Nature is perhaps the richest source of potential subjects; flowers – all plants in fact – are perennially popular, and, if treated creatively, can produce stunning images with relative ease. But you don't even need to set foot outside the house to find enough things to keep you occupied throughout the winter months. Wander into the kitchen and you'll find plenty of interesting and colourful subjects with a rich variety

of tones, textures and intricate patterns. If you do shoot fruit or vegetables, don't just photograph the outside; cut them open and get inside for some wonderful, almost abstract images. Look for textures – from woodgrain to leather, to the tread of an old car tyre. The world is full of potential for the macro photographer. Finally, don't reject anything as a potential subject, especially if you have equipment capable of higher magnifications. With a little experimentation, careful lighting and some perseverance you'll end up with a collection of images that are not only beautiful but that show something of the world we normally ignore.

▲ Here a small torch has provided an interesting spotlight effect.

▼ The kitchen can be a rich source of subject matter; this cabbage is typical of the abstract results you can produce if you get close enough.

◄ Insects are difficult to shoot in the wild, moving too quickly for you to set up the camera or for it to focus accurately. With patience, lots of memory-card space to hold lots of pictures and some luck, you should be able to snap a few winners.

Animals and pets

Animals make fantastic subjects for the digital photographer, but unless you only snap them while they're sleeping you need quick reactions.

▲ Whether on safari, at a safari park or visiting the zoo, you'll need a long lens and fast reactions to capture shots like this.

▼ Capturing birds in flight is one of the most challenging things for a photographer to attempt. An SLR makes it much easier.

▲ A wide lens allows you to include the background and get really close to use distortion for effect.

If you have ever tried to take photographs of your pet you will probably have discovered that it isn't as easy as you might have thought. The old saying about 'never working children or animals' may not be entirely true, but producing really impressive pet portraits is a challenge that rewards patience above all else.

Obviously, you don't need a pet to photograph animals; a visit to the zoo or even a local farm can provide a wealth of photographic opportunities.

Photographing your pet

Although there are plenty of tortoises, snakes, chinchillas and Vietnamese pot-bellied pigs in homes around the world, most people's pets are dogs, cats, rodents or fish. Dogs and cats make fantastic subjects for portraits, and since they know you well they are likely to be relaxed with the attention and untroubled by the clicking and whirring of your camera. For the best pictures you

should follow roughly the same rules as when shooting portraits of people: make sure you shoot at the animal's level (in other words, not directly from above), focus on the eyes, fill the frame, use a slightly longer lens and avoid distracting backgrounds or direct flash. You should also try shooting 'candids' of your pet (hang a little further away and shoot using a telephoto lens) for a more natural photograph.

In terms of lighting, once again natural daylight is usually the best option. If you want to pick up the texture of the animal's fur, you will need to use fairly directional light coming from one side; as with humans, the best pet portraits are often taken with the subject sitting next to a window. Very dark fur can fool your camera's metering system, and

you may need to alter the AE-C setting to lighten it slightly (using the '+' setting).

As with portraits of people, you should try to capture something of the character of your pet in the photograph. Use a favourite toy to attract the animal's attention, or make funny noises or gestures to get a reaction. You'll need to be ready to shoot at any moment; photographing animals not only needs patience, it requires fast reactions too! This is even more the case with smaller, more shy animals (such as hamsters or other rodents). In these cases you may need to get someone to hold the animal while you take the picture; with careful cropping you should be able to exclude most of the person from the frame. As with any photography where the subject is moving and you need to snap quickly, you need to insure yourself against focus or camera shake problems by using a fast shutter speed and taking lots and lots of shots.

Photographing in the wild

There are countless books, magazines and websites dedicated to wildlife photography, and countless photographers who have dedicated their lives to mastering the techniques. This is one area of photography where the better the equipment you use the easier it gets. But it's not only long lenses and a fast, quiet camera you need; it takes a lot of practice, a lot of time and almost superhuman patience to do well. Whether snapping kingfishers in the local woods or lions on the Serengeti plains you will struggle unless you are the owner of an interchangeable-lens SLR. Of course, if you're photographing farm animals or are on an organized safari that brings you very close to wildlife that is used to human presence, you are much more likely

to have success with a compact camera, especially if it has a decent zoom range.

Zoos are great places to snap exotic animals. The key here is to try to zoom in on the animal itself by using the long end of your lens. If you use a long lens and wide aperture (small f-number) you will usually find that the limited depth of field makes wire fences magically disappear. Obviously if you shoot 'between the bars' make sure you are not taking any risks (monkeys in particular have been known to grab cameras from over-eager snappers).

▲ Use your macro mode to get close to small animals. Of course, the slower the animal, the easier the shot!

▲ Don't forget to look for an interesting composition.

▲ Cats are natural posers and will usually allow you to get very close to them for detail shots.

◀ Move a little further away and shoot with a long lens for more natural-looking pet portraits.

Abstracts and textures

You've got no film to waste, so why not give your creative muscles a real stretch by experimenting with abstraction?

▲ Texture and colour are as important in making interesting photographs as shape and form.

For the creative photographer a digital camera positively encourages experimentation, while the power of image-editing software means that even the most uninspiring shots can be reworked into interesting images.

The beauty of photography is that it can capture the world in a way our eyes simply never see, presenting familiar objects or scenes in visually unfamiliar ways.

Driven to abstraction

There are so many ways to produce striking abstract or semi-abstract photographs that the only real advice you need is to start thinking creatively, and to always be alert to the potential all around you. If you find it difficult to see the world in photographic 'frames', use your camera's viewfinder to look all around – including above and below you – and experiment with the different zoom settings on your camera's lens. Above all, shoot, shoot, shoot. The more pictures you take the more likely you are to capture a winner – even if you don't notice it until days, weeks or even years later.

▼ Using motion blur (this shot was taken without flash out of a moving car) can produce interesting semi-abstract images.

Tricks of the trade

There may be no set rules for producing abstract photographs that work, but there are some tried and tested techniques that you should remember and use. Even if you are shooting a scene conventionally, try to train your eye to look for more unusual viewpoints and framing – there are few situations where the most obvious composition is the one that will produce the most striking image. Here's a quick run-through of the different things you can do to create more interesting images.

■ **Take a different viewpoint.** One of the easiest ways to make a more dynamic image is to shoot from a different viewpoint. Most pictures are taken from eye level, with the lens roughly parallel to the ground you stand on, producing an image that looks relatively normal to the human eye. So, as well as simply looking from left to right as you prepare to shoot a scene, look up and down. There are an amazing number of photographic opportunities above our heads and below our feet, yet few of us ever explore them. And don't just point the camera up or down – experiment with shooting from a

much lower or higher position – from ground level or holding the camera above your head.

■ **Removing context**. Zooming in on a small part of a scene to remove it from its context is perhaps the most effective way to produce truly abstract images. Whether you use your camera's macro setting to get really close to something, use a telephoto lens to isolate part of a scene, or simply exclude an important part of it, the idea is the same. By removing the visual clues regarding scale, surroundings and overall structure, you can produce an image that takes the viewer by surprise. Really successful abstract shots of this type will require at least a second look before the viewer works out what he or she is looking at.

The cropping tools available in even the most basic image-editing applications allow you to produce abstract images in seconds. Remember, the key to success here is as much about what you leave out of the frame as what you include.

■ **Blur.** A long exposure – or deliberately defocused shot – needs to be used with some care if you want to produce an image that still has something vaguely recognizable in the frame. With practice, and a little luck, you can produce truly stunning images using motion or focus blur. Of course, if you have some Photoshop skills, you can use these techniques in post-processing too.

These basic techniques – changing viewpoint, isolating detail and using blur – are only the beginning. The digital age has opened up a whole new world of creative possibilities by giving us powerful software tools that allow us to completely transform our photos.

Post-processing

Of course, there are literally millions of ways to make an abstract image once you have opened your photograph in your image-editing application. Aside from cropping, most applications allow you to distort the image in a myriad of ways, remove or alter colour (toned black and white works well for abstract architectural shots) and add any number of blur, texture and paint effects. This is what the long winter nights were made for!

Abstracts require little or no specialist equipment, and yet can provide almost endless creative challenges and opportunities. So, next time you point a camera at a scene or a person, take a few extra shots that do more than simply recording what you are looking at.

▲ Even the most recognizable subject can be made abstract by careful cropping.

▼ Look up, look down, look all around for details to photograph.

The digital darkroom

The real power of digital photography lies in the ability to enhance, correct, combine and transform images using your computer, and to share images in many different ways. Part four looks at some of the things you can do, and some of the tools you need to do them.

Tools of the trade

In order to start transforming your photos into digital works of art you need some specialist software. Luckily, there is plenty to choose from!

▲ Having 'preview' selected allows you to see what the effect of the manipulation will be before you apply it to the image.

What software do I need?

There are hundreds of software titles (both commercial and shareware) for the digital photographer looking to manipulate his or her images; some are good, some bad, some pointless.

You may have received some free software with your camera or pre-loaded on your PC; more often than not this will be a 'light' or 'limited' version of one of the more popular commercial packages. These can be an excellent (and free) starting point, but if you want to get serious about working in the digital darkroom you will inevitably reach the point where you want something a little more sophisticated. So what should you look for?

Image-manipulation software can be broken into three broad categories. At the entry level, you tend to find simple packages designed to automatically tweak brightness, contrast and colour and remove red eye or add some sharpening. Most of these packages also include several templates for turning your pictures into cards, calendars and websites as well as single-click special effects. These are the kind of applications you would typically find

bundled with inexpensive cameras, and for the casual snapper can be all that is needed. Perhaps the best of the bunch is Roxio's PhotoSuite, which also has some rudimentary montage tools. iPhoto – shipped free with all modern Apple Macintosh computers – and Google's Picasa (also free, Windows PCs only) are also good starting points.

Getting more serious

If you want a more hands-on approach or are interested in combining more than one photo into a montage, you need to look at full image-editing applications that offer a complete range of tools, layers, manual tonal controls and masking. A couple of titles dominate the home image-editing market; Corel's Paint Shop Pro and Adobe's Photoshop Elements are the most popular, with Ulead's PhotoImpact 12 and Microsoft's Digital Image Suite offering credible alternatives. All are similarly priced for home users, and there is little to recommend one over the other. That said, Paint Shop Pro is the most sophisticated (and therefore has the steepest learning curve), while Elements is

probably the most user-friendly. More importantly, the huge user-base of the top two titles means there is a wealth of information on the Internet and in print on how to get the most out of them, and magazines and books tend to base their tutorials on the most popular software, for obvious reasons.

Photoshop

There is one undisputed king of image editing: Adobe Photoshop. Nothing comes close in terms of power, popularity or elegance, and there can't be many professional photographers or publishers who don't use it on a daily basis. The problem is that it is very expensive – it costs more than most digital cameras (and not far from the cost of a complete computer system!). If you're really serious about your digital imaging (and have deep pockets) there isn't really any other choice. It is worth noting that much of Photoshop Elements' popularity comes from the fact that it is a cut-down version of the full Photoshop package, and shares many of the tools and commands, as well as having a similar interface. This means that many techniques

designed for Photoshop can be easily adapted to Elements, and that should you ever decide to upgrade you won't have to learn everything anew.

Other applications

The final category of software is by far the broadest, covering everything from 'funware' (single-purpose applications for adding your head to famous bodies or printing custom calendars) to simple image viewers, slideshow makers, 'art' programs dedicated to turning your photos into paintings, and digital photo albums to organize your growing collection. Some of these – such as a good photo organizer – are very useful. Others are of limited appeal, but are cheap enough to buy for a single project or for a single feature. It is always worth checking that you can't buy a similarly priced image-editing suite that does the same job as a specialized program; many applications such as Photoshop Elements offer panorama stitching, website generation and image thumbnail browsing in addition to their core image-editing toolset.

▲ There is no limit to what you can achieve with modern image-editing applications. This David Hockney-style 'stitcher' was assembled from ten different shots.

Basic image corrections

Few digital cameras produce 'perfect' results, and most images benefit from a few tweaks. Making basic corrections is usually straightforward.

Digital cameras are clever, but they are far from perfect. For one thing, they are designed to produce printable results in an almost infinite variety of situations, and they have no idea what you are pointing them at when you press the button. In an attempt to make sure that everything from the deepest shadow to the brightest highlight is recorded faithfully, most cameras tend to produce results lacking in contrast (which makes them look a little murky) and many slightly underexpose (which ensures highlight detail is captured, but does make the pictures look a little on the dark side). Throw in

the fallibility of Auto White Balance systems and the inherent lack of sharpness in digital capture and you can see why most digital photographs benefit from a tweak or two in post-processing. The corrections needed to get the best possible result from your original digital files fall into four basic categories: brightness/contrast, colour, sharpness, and cropping.

Brightness and contrast

If there is one thing virtually everyone can understand instinctively it is image brightness;

Brightness and contrast controls

▲ **What brightness and contrast controls lack in subtlety they make up for in ease of use.**

▲ **Increasing contrast makes dark areas darker and light areas lighter.**

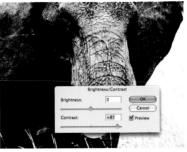

▲ **Push it too far and you lose all midtones, producing a graphic, unnatural result.**

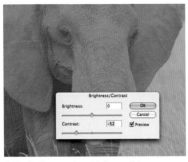

▲ **Reducing contrast brings all tones nearer to mid-grey.**

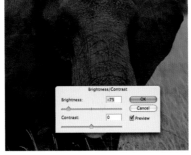

▲ **The overall brightness of every tone in the scene can be increased or decreased.**

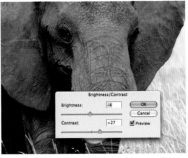

▲ **In this case, the brightness needed reducing and the contrast increasing.**

Before and after examples

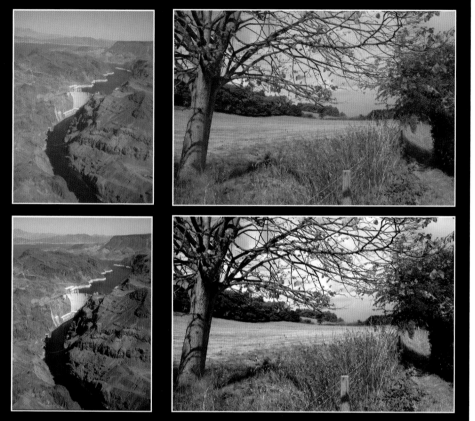

In both these examples the most basic corrections were applied; increase contrast, increase saturation slightly and Unsharp Mask. The Hoover Dam image was also rotated and cropped to correct the non-horizontal horizon (an inevitable consequence of shooting from a helicopter!).

Histograms

Histograms are found in cameras and editing software, and – despite looking complicated – are a valuable tool for correcting problems. The histogram is basically a graph showing the distribution of brightness levels in an image from pure black (far left) to pure white (far right).

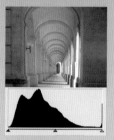

▲ If the histogram looks like this, the image is OK – there is a good spread of tones that start just about at black and go most of the way to white. Not much work is needed.

▲ Low-contrast images don't have values at either end of the graph; the tones are all bunched up in the middle. This can be fixed.

▲ Under- or over-exposed images have all their tones bunched up at one end of the scale or the other. If the exposure problem is extreme, you can't do much to bring back all the missing tones.

we can all tell at a glance if an image is too bright or too dark. Modern digital cameras tend to be fairly good in this area, and it is rare to have to change brightness settings considerably unless there is serious under- or overexposure (in which case there is only so much you can do anyway). Increasing the brightness setting too far will turn black areas of the picture grey and pale areas white. Conversely, reducing the brightness too far will make white areas grey and darker areas completely black. So don't touch brightness unless there really is a problem.

Much more important is contrast – the difference between the brightest and darkest tones in the picture. If contrast is too low there will be no real black or white in the image, the darkest tones will be mid-grey and the brightest areas a pale grey. This makes the picture look murky and lacking in any bite. By adjusting the contrast you can stretch the tones in the image so the darkest shadows are near to black and the brightest highlights white. This is by far the most common correction you need to make to digital camera shots.

How you do it depends on the software in use and the level of your experience. Most applications offer a simple one-click contrast correction (called Auto Exposure Fix, Auto Levels or Auto Contrast). This simply finds the brightest and darkest points in the image and resets them to white and black, stretching the range of tones in between to fill the gap. In 99 per cent of cases, it works very well.

Adjusting histograms with Levels

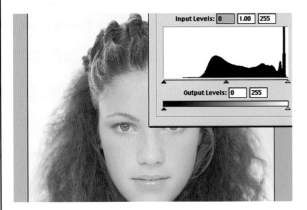

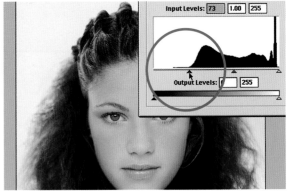

▲ As discussed on page 129, the histogram displays the distribution of brightness levels in the image. In this case, there are no values on the left-hand side of the scale, meaning there are no dark tones at all. The image is not overexposed (note that the highlight/right-hand part of the graph does not appear to go off the end of the scale); it simply lacks contrast.

▲ Applications such as Photoshop, Elements and Paint Shop Pro allow you to adjust the image directly using Levels (Photoshop) or Histogram Adjustment (Paint Shop Pro). By moving the black point slider until it is underneath the point where the histogram starts to rise above 'flat', we can remap the tones in the image to stretch from black to white, rather than from mid-grey to white.

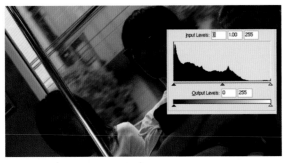

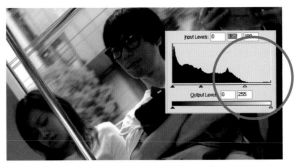

▲ The same goes for underexposed (dark) images. By moving the white point slider to the left (until it is under the end of the 'tail' of the histogram) we can remap the lightest tones in the image to white, so brightening the entire photo.

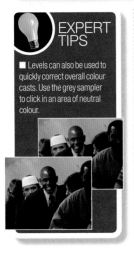
The only exception is with unusual images, such as those with lots of very bright or very dark areas. Most serious users prefer the manual approach, which gives them full control over how much the contrast is adjusted based on the characteristics of the image. The tools for such overall tonal corrections vary a great deal in sophistication, from simple contrast sliders to curves and histogram adjustments that allow you to individually lighten or darken shadow, midtone and highlight areas. In inexperienced hands these advanced correction tools can make matters much worse, so you need to learn how to use them before getting stuck in!

Colour corrections

Although they make a decent enough attempt at it, digital cameras will often get the colour of an image slightly wrong, and we often need to use image-editing tools to correct any problems. As with most things digital, there are several ways to achieve the same result: some are fully automatic, and some are fully manual. It is a good idea to learn what the various tools do, and when they are best employed. If you use any tool that requires you to judge the results by eye (on your screen) it is vital that you calibrate your screen as well as possible (both Macintosh and Windows XP systems have basic

▲ **Digital cameras often produce slightly grey-looking night scenes. A quick increase of the contrast, plus a tighter crop, produces an image with much more impact.**

calibration tools built in) or you may be surprised when you come to print the pictures.

The aim when correcting colour is to neutralize any colour casts that may have crept in due to white balance errors. If a grey building looks a little blue, you need to make a global alteration to the image to shift all the colours back to where they should be. But you may also need – or want – to change the strength or vividness of the colours to better match the scene as you remember it or for creative effect. Most applications allow you to alter the saturation of the colours in a photo using a simple slider.

Low-saturation colours look slightly grey, whereas highly saturated colours are strong and vivid and – if you go too far – totally unnatural.

Sharpness

The complex process used by digital cameras to capture full colour images has the side effect of softening the final picture slightly. Add to this the limitations of less expensive lenses and there is quite a strong chance that your photos will not look sharp enough if you zoom into them on screen or try to print them out at a decent size.

Unsharp Mask

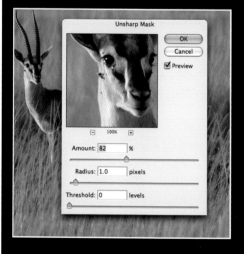

It may look complicated, but Unsharp Mask (USM) is simply too useful a tool to ignore. USM works by looking for areas where there is a rapid change in brightness or colour and presuming them to be edges. The contrast of these edges is then increased by a set amount, which gives the impression of a sharper join. The key here is that you can tweak the settings to give the best overall edge sharpness without affecting areas of solid tone.

Whichever program you use, the basic variables will be the same. The Amount is the 'strength' of the effect (it is a measure of how much the contrast will be increased at each edge). The Radius defines how far the contrast increase will stretch from the edge (in pixels). The Threshold sets the minimum 'difference' between two areas of similar colour for them to be considered to be an 'edge' – the effect is to protect areas of solid colour from the sharpening effect.

Ideally, you should tailor USM settings to your image (both its existing sharpness and the subject matter), but many people are perfectly happy just using the default settings and reducing the amount if the effect looks too pronounced.

Correcting converging verticals

Many applications, including Photoshop, Elements and Paint Shop Pro, have an advanced option in their crop tools that allows you to create a non-square (or perspective) crop. Other applications have special distort or deform tools that do the same thing. One use for such tools is to pull out the top corners of the image and thus correct – to some degree – the converging verticals encountered when photographing tall buildings. Note that in correcting verticals you always lose some of the image (you are, after all, stretching the top and not the bottom), and that it doesn't always make for a better picture!

▲ **Panoramic crops aren't just for the horizontal format, and don't even need to contain a scenic shot. Experiment with unusual crops to add emphasis to the main subject of your shot or to improve composition.**

Fortunately it is possible, using software trickery, to make soft images appear much sharper. All cameras offer some built-in software sharpening (which can often be increased, decreased or turned off entirely), but it is usually advisable to do it yourself when the pictures are loaded onto your PC, and you have full control over the process. The simplest image-editing applications have a basic sharpen command, sometimes with the option to set a level (say from one to ten). However, serious users prefer the versatility and control of a process known as Unsharp Mask (USM) – which, ironically, sounds as if it should soften images. USM allows experienced users to tailor various parameters to suit the image they are working on, but even using the default settings it will usually produce better results than the sledgehammer approach of basic overall sharpening commands. This is because USM is designed to sharpen areas of detail (ie edges) while leaving areas of solid tone (a blue sky, for example) untouched. Sharpening areas of

▶ **The Hue/Saturation controls can be used for dramatic overall colour shifts or to add a vivid brightness to slightly dull-looking shots. In the lower example, the saturation has been increased significantly, adding impact to the photograph.**

Curves

Curves are not the most user-friendly tool in the digital darkroom – certainly not compared to the simplicity of brightness and contrast or the single-click ease of Auto Fix. But, with a little practice, you can do things with Curves that are all but impossible with any other tool. This is especially true when dealing with awkward pictures – those with exposure or contrast problems. For most professional users, Curves is the first stop when adjusting contrast.

The curve represents the relationship between input (the horizontal axis) and output (the vertical axis) brightness values. So the horizontal axis shows all the tones in your image left to right from the darkest (0, absolute black) to the brightest (255, white). The vertical axis represents the tones after the curves have been applied. When you open the Curves dialog the graph is a straight line at 45 degrees – the input and output values are identical. By changing the shape or angle of the curve, we remap the input values to new (output) values. To move the curve, simply click on one of the end points and drag it, or click on the line itself and drag to add a new point and make the line curved.

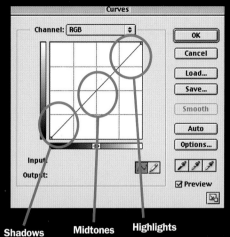

Shadows Midtones Highlights

By adding several points to the curve it is possible to fine-tune the tones within the image in a way not possible using simple tools such as brightness and contrast or even Levels and histogram manipulation. In the example here, the midtones have been protected by a straight line section in the middle of the curve. Dragging the highlight area up and the shadow area down produces this classic 'S' shape, which increases contrast without losing too much information in the midtones. This can be further refined to get exactly the tonal range you are looking for.

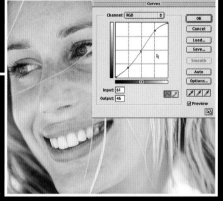

solid colour has no benefit, and in fact can seriously degrade image quality by increasing noise (grain) and destroying fine tonal gradients.

Cropping

This is perhaps the simplest edit of all; cropping tools allow you to reframe shots to improve the composition, or to make up for not having a long enough lens. Most crop tools also allow you to rotate the image (to correct sloping horizons, for example) and some also include perspective correction options, which can be used to straighten converging verticals when shooting buildings. Be aware that whenever you crop an image you reduce the number of pixels and therefore reduce the size at which it can be printed without looking blocky. Cropping can transform a humdrum shot into a winner, but there is no substitute for framing correctly in the first place!

▲ Even the dullest shot can be rescued by increasing saturation, tweaking the contrast and reframing (cropping) to give a more dynamic composition. Never throw an image away until you are sure there's not a decent photo hiding in there somewhere!

Black and white

The enduring appeal of black and white comes from its ability to look both modern and timeless, and digital-imaging tools allow you to turn an uninspiring colour shot into a monochrome masterpiece.

Many photography enthusiasts still consider black and white to be the highest form of the art. No doubt this is due to the sheer versatility of the medium. Where colour photography is about getting it right – the aim generally being to capture a scene and reproduce its colours faithfully – black and white photography allows for considerably more creative input when it comes to the final print. During photography's boom years, there were few serious hobbyists who left the developing and printing of their work to others; the darkroom under the stairs was where nascent masterpieces were transformed from mere snaps into unique works of art. From a single negative it is possible with even the most basic darkroom set-up to produce hundreds of different prints, once you have mastered a few basic techniques. The digital darkroom extends this versatility massively, allowing you not only to reproduce the techniques of the conventional darkroom, but to go much, much further, producing images that combine digital trickery with the timeless, classic appeal of the black and white print.

Many cameras have a special black and white mode, but don't use it; the images are still captured in RGB colour (so are no smaller), with the camera simply removing the colour as the photographs are saved onto the card. Instead, shoot in colour and do the conversion yourself wherever possible. Not only will this give you more control, but you'll still have the option to print the picture in colour should you choose to at a later date.

The process for turning colour images to black and white (or greyscale, to use the correct technical term) varies from program to program, but usually involves changing the colour mode from RGB to Greyscale or reducing the saturation to zero (using the Hue/Saturation controls). But this is just the tip of the iceberg. You can fine-tune the conversion

▲ **Dodge and burn tools allow you to lighten or darken areas of the frame individually, transforming your photographs.**

 EXPERT TIPS

■ Turning a blurred colour image into a high-contrast black and white shot can mask much of the blurriness and produce a perfectly printable image.

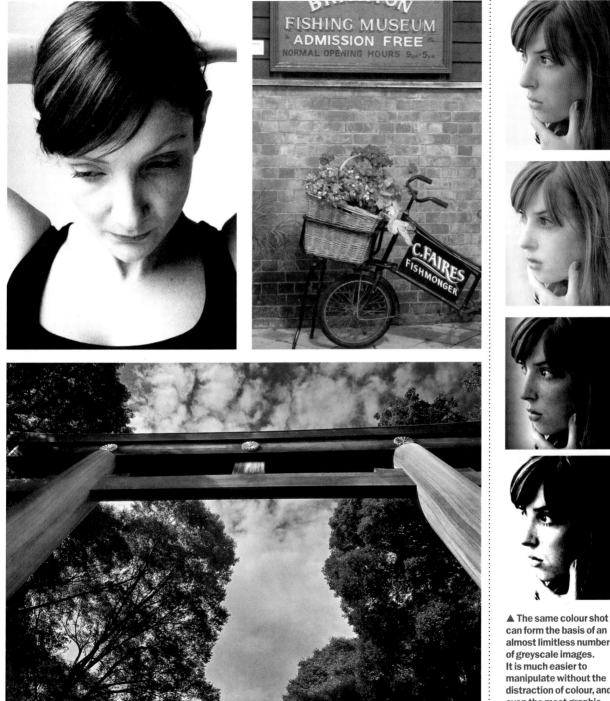

▲ The same colour shot can form the basis of an almost limitless number of greyscale images. It is much easier to manipulate without the distraction of colour, and even the most graphic effects leave the main subject recognizable. Most applications allow you to add a colour tone to a monochrome image, usually via the Hue/ Saturation controls.

process in many different ways, and you can tweak the result using all the standard tonal correction tools (Levels, Brightness/Contrast, Curves and so on). In fact, taking colour out of the equation often allows you to experiment to a considerably greater degree without completely ruining the image; the only limit is your creativity. So why not give your pictures a classy look that is both contemporary and timeless by playing around with the magical possibilities of monochrome?

Quick portrait fixes

No matter how well you shoot a portrait there is usually something you can do to improve the photo using the power of the digital darkroom.

▲ Here the original has been heavily manipulated using layered softening to produce an almost painterly effect.

▼ Converting to black and white is a quick way to disguise colour casts and skin blemishes and to produce a flattering portrait.

A well exposed, sharply focused portrait can be a fairly unforgiving thing, showing every blemish and wrinkle that we manage not to notice when looking in the mirror every morning. I've lost count of how many times I've seen people throw away prints that they consider make them look hideous. The problem is compounded by fundamental errors such as shooting with too wide a lens or using on-camera flash with its inherently unflattering and red eye-inducing nature. But with a little practice, it is possible to turn even the most unflattering snap into a perfectly passable portrait. Of course not even Photoshop can work miracles; the nicer the shot you start with, the less work you will need to do and the more chance you'll end up with something both you and the subject will be proud to show the world. See pages 96–101 for further information on shooting flattering portraits.

Removing red eye

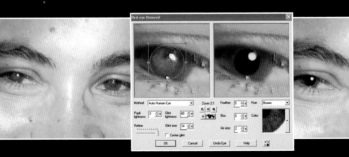

Although every application is different, most now have fairly sophisticated red-eye removal systems (the one shown above is from Paint Shop Pro). Some, such as this one, work by completely replacing the pupil with a computer-generated version; others simply ask you to select the eyes then look for anything bright red and turn it black. A few programs offer a red-eye removal brush (which replaces red with dark grey). Professional applications, such as Photoshop, require you to remove red eye manually. Search the Internet and you will find plenty of tutorials describing the necessary techniques.

Removing blemishes

One of the easiest improvements you can make to a portrait is to remove any blemishes (spots, broken veins and so on). To do this you'll need an image-editing application with a clone (or rubber stamp) tool. Cloning allows you to 'paint' over one area of a picture using pixels from another area. It takes a little practice, but it is easy to make any work you do invisible in the final image. Cloning can also be used to remove dark rings from under eyes, though this takes a little more skill. If your sitter has a ruddy complexion or lots of broken veins you can often improve things quickly and easily by simply reducing the saturation of the entire photo using the Hue/Saturation controls. Most programs also allow you to restrict the changes to particular colours, meaning you can reduce the saturation (or shift the hue slightly) or the reds in the image, thus reducing or removing entirely the offending coloration.

It's in the eyes

Removing red eye (caused by direct flash) is another simple and easy edit, and one that many applications have automatic tools to perform. If not, you can do it yourself in a couple of minutes using the basic tools found in any image editor. While you're at it, why not try giving your subject's eyes a little cover-star glamour by cleaning up the whites (using the dodge tool) and increasing the saturation, or even changing the colour of the iris (the coloured part of the eye)? You can also use the dodge tool (sometimes called 'lighten' tool) to brighten up teeth and to reduce darkness under the eyes. Always work on a duplicate image (or use a duplicate layer – see page 145) as it is easy to get carried away and overdo these corrections, resulting in an unrealistic, plastic-looking portrait.

Softly softly

As well as removing blemishes from the skin you can make very flattering portraits by adding an overall softening (soft-focus portraits have been the staple of the portraitist for over 100 years). The best technique is to combine the original image with a semi-transparent Gaussian Blurred version of itself

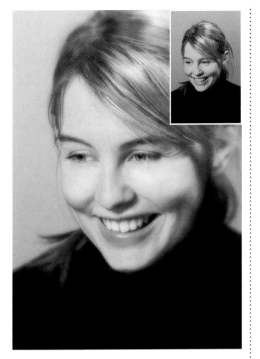

▲ A picture can be totally transformed in ten minutes using cropping, cloning, dodge and burn and softening/blurring (this example has different levels of blur in different areas).

(in a separate layer), and altering the opacity of the upper (blurred) layer to allow some of the original sharpness to show through.

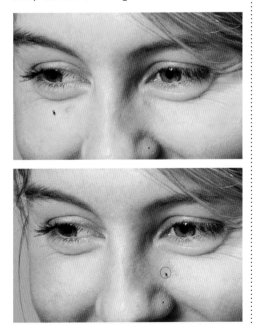

▲ Dark rings or bags under the eyes can be removed relatively easily using the clone tool to paint over the offending areas with skin tone from elsewhere on the face. Take care to clone from an area of similar brightness and colour.

▲ Use the dodge (lighten) tool to add sparkle to dark eyes and brighten the whites.

◀ Spots and other blemishes are easily removed using the clone (rubber stamp) tool. Simply alt-click on an area of similarly toned clear skin, then paint over the blemish. Reducing the saturation of the reds in this image has also produced a more flattering skin tone.

Improving scenic shots

The sky really is the limit when it comes to enhancing landscape shots in the digital darkroom. Whether you want to liven up a sky or perform a total transformation, you're only a few clicks away from a better shot.

There is not nearly enough room on these pages to cover the almost infinite variety of enhancements, corrections and effects that can be applied to landscapes and other scenic shots, so this section just concentrates on the basics.

By far the most common changes made to landscape photos are cropping (including rotating to straighten horizons), colour, brightness and contrast corrections, adding some life to dull skies and the removal of unwanted elements.

See pages 128–133 for a brief run-through of the basics of tonal corrections and sharpening. You may need to adjust the brightness and contrast of separate areas of the scene individually – it is not unusual to make changes that brighten up whatever

is below the horizon perfectly, only to discover that doing so removes all the detail from the sky. The only way around this is to use selection or masking tools to restrict the changes to the areas that actually need them.

Most scenes shot in anything but the brightest weather will benefit from a modest increase in saturation. This varies widely from camera to camera, however, with some models producing such vivid results that the images need to have the saturation reduced to look natural.

Once you have mastered the basic tools that your image-editing application has on offer you can move on to more ambitious projects; using the clone tool to remove people, telegraph poles, cars or whatever else blights your landscape. Of course, once you know you can do this, you can happily shoot less-than-perfect scenes safe in the knowledge that you can put everything right later.

The same goes for skies; living in England I know very well how many scenic shots are spoilt by dull grey or white skies; we can go for months without seeing a patch of blue above us. Fortunately – cheating though it may be – adding a new sky (or adding some impact to an existing one) is not too difficult with a little practice. Many digital photographers, myself included, keep a library of

▲ Adding a new sky – and in this case making a silhouette – can transform a dull scene into something much more special.

▶ Whether you take two or twenty shots, the latest stitching software can seamlessly blend images into a single panorama.

Localized tonal corrections

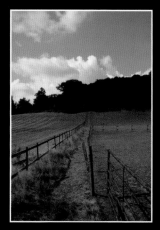

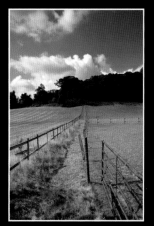

▲ This shot – straight out of the camera – obviously needs brightening up, and the contrast needs to be increased.

▲ Lightening the image enough for the foreground means we lose virtually all the detail and contrast in the sky.

▲ If we adjust the brightness and contrast to give the best sky, we end up with a very dark and murky foreground.

▲ The answer is to use selection tools to isolate the sky and make a different adjustment to each area.

▲ There are some scenes you'll simply never see free of other visitors. Armed with the clone tool, patience, and a bit of practice you can remove virtually anything by painting over with pixels from elsewhere in the frame.

sky shots taken on the few good days of the year specifically for the purpose of dropping into photos taken in overcast conditions. For a really quick boost you can pinch an old photographers' trick and add a coloured transparent gradient over the image to put some colour into the upper part of the frame.

Finally I should mention panoramic stitching. This involves taking a series of overlapping shots from the same point and using special software to 'stitch' them seamlessly together to produce a super-wide (or super-tall) image with a much wider view than your camera can manage on its own. Many cameras have a panorama mode (designed to make sure each frame lines up and overlaps correctly), and even relatively inexpensive software, such as Photoshop Elements, has stitching built in.

▲ They will never be masterpieces, but even the dullest shot can be given a new lease of life with a saturation boost and a new sky!

Adding impact

Digital-imaging tools give you the power to add real impact to your photos – all you need is a little imagination and plenty of practice!

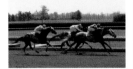

▲ I was quite happy with this shot, but felt it would look more exciting if it had been taken with a longer exposure and some panning. By isolating areas and blurring them I was able to produce a fairly convincing impression of movement. You need plenty of practice to undertake such a major image manipulation!

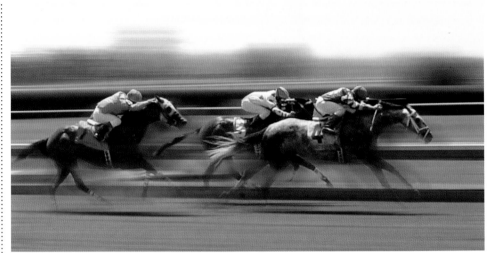

▶ There are many ways to lift a subject from a cluttered or distracting background. One of the simplest is to make a selection around the subject, invert the selection (so everything but the subject is selected) and remove the colour. In this case, the background was also blurred slightly to make sure all the emphasis was on the violinist.

The beauty of the digital darkroom is not only how easily you can turn your snaps into something special, but also how many different things you can do with one picture. Armed with a digital camera and some image-editing software, you can produce images with a real 'wow' factor in a few clicks, and, as you master the more advanced tools, you will discover that almost anything is possible.

Adding impact to dull shots is relatively easy, and there are enough books, websites and magazines full of ideas and techniques to keep you occupied for years. The real skill is to identify which treatment will work best with each picture; zoom blur looks great on a photo of your car; apply the same effect to a portrait of an old lady and it's just plain silly. It is also important to realize that not every picture needs a special effect to make it shine; a good shot will need little more than cropping, sharpening and possibly boosting the contrast and saturation a little. Not every photograph looks better after you have applied an oil-painting effect to it. In fact as you develop your skills you will find yourself less and less drawn to the predefined built-in effects offered by most applications simply because they are by their nature repetitive, and, given how many other people are only a click away from exactly the same effect, they can quickly become clichéd.

Techniques worth experimenting with if you want to produce images with immediate impact include boosting contrast and saturation, cropping for a more dynamic composition, adding frames or borders, removing colour from all or part of the frame, playing with blur and changing colours.

The specific techniques will depend on the software you are using and are beyond the scope of this book, but most are relatively simple and relatively quick.

As the examples here show, you often don't need to do much to an image to add real impact, and it often takes longer to decide what needs doing than actually doing it. But to own a digital camera and not at least experiment with image editing is to miss half the story, and most of the fun!

▲ There is no limit to what you can do once you have mastered some basic skills; here a boring day shot has been turned into a moody night shot using relatively simple techniques.

▼ Playing around with colours will often add impact to an uninspiring shot.

Montage and collage

The ability to cut and paste photographs, or parts of photographs, together into a single image is extremely powerful, and opens up a world of montage, fantasy images and, above all, creativity.

▲ The montage above is considerably more complex than it appears. Made from four specially shot photos (the face, the wall and one of each hand), the entire image is the result of around three hours' work. It is always easier to produce montages such as this if it is planned ahead, and the separate elements photographed specifically for the job.

Since the earliest days of film photography, people have been combining two or more photographs into a single image, in a process known as photomontage. The trouble was that no matter how skilfully each part was cut and glued down you could nearly always see the join, and if you got anything wrong the only answer was often to start all over again. Of course, in the digital age, we can throw away the scalpels, scissors and glue, and turn instead to the power of image-editing software. The digital darkroom makes montage a lot faster, and a lot easier, but it still requires a certain amount of skill and time to produce convincing results. On the other hand, if you know what you are doing there is little chance that you will go so wrong that you have to start again from scratch – multiple undo has at least rid us of that disheartening possibility.

The montage tools in most modern image-editing applications are extremely powerful; selection tools such as the magic wand and magnetic lasso

▲ Combining a simple montage with some blurring gives the illusion of depth of field.

▲ Why not set yourself a photographic theme? You can then produce a graphic collage of the individual shots; a simple but effective technique.

take away much of the need to manually draw round elements you wish to cut out. Layers (which are like sheets of acetate containing the separate elements of a montage) mean that you can move things around at will without ever committing to any permanent edits. Add to this the option to use masks to hide parts of layers (rather than deleting pixels permanently), the ability to reduce the opacity of layers or elements (so they become semi-transparent) and advanced blending options (which alter the way pixels interact with those in layers below) and there really is no limit to what you can achieve with a little practice.

Although most imaging applications offer rudimentary montage tools (making selections, cutting, copying and pasting), and all but a few use layers to keep the elements of your composition separate, you need to use one of the more advanced

▲ Always make sure the colours match when combining two images.

Replacing skies

So many scenic shots are ruined by bland grey or white skies that many digital photographers rush out whenever there is a blue sky to collect some snaps for later use. It is a relatively simple job to cut the old sky out and replace it with something else, although the complexity of the join in this case made the job more difficult.

▼ Combining several shots into a collage, rather than a montage, can be an attractive way to show your child growing up – why not make a card to send friends and family?

programs, such as Photoshop, Elements or Paint Shop Pro if you really want to develop your skills. Most programs, even the most basic, will let you replace backgrounds and produce simple collages, but the selection tools offered (essential to ensure you can't see the joins) will simply not be as sophisticated as those you will find in any of the more serious applications.

Making selections – defining which part of an image you are going to cut out – is the most important aspect of montage; poor selections, with stray pixels or jagged edges, will look very obvious, ruining any attempt at realistic results. It is also important to plan ahead, even shooting images specifically to be combined into a montage. There is a lot to think about; for truly convincing

Felix

▲ A simple 'sandwich' of several images using layer blend modes produces an interesting result in a matter of minutes.

Layers

Most imaging applications make montage as easy as it can be through the use of layers. Each layer acts like a sheet of transparent acetate with some opaque or semi-transparent areas. The transparent area of each layer allows any pixels in the layer below to show through, and they can be moved, scaled and edited independently, and their stacking order changed at will. The power of layers lies in the ability to experiment with different compositions without ever committing to anything – pixels in one layer do not permanently remove those underneath; they simply hide them. Layers can also interact in several ways (via blend modes), giving a huge variety of effects at the simple click of a button.

▶ Layers can have transparent areas that let pixels in layers below show through.

▼ A typical layer palette (this one is from Photoshop).

montages you will need to make sure that each element matches in terms of colour, lighting, texture, perspective and scale. Of course, if you are simply producing a fun image for a greetings card or a website you will probably not have to worry about realism, in which case a simple montage can be created from scratch in a few minutes. And then again, not all montage is about creating fantasy compositions; one of the most popular tricks for improving landscapes taken on dull days is to drop in a new sky from another shot. Portraits also often benefit from having their backgrounds replaced with something new; be it a scene, a texture or simply a block of solid colour. To make your life simpler, try to shoot your portraits against a plain white background.

▲ Shooting portraits against a plain background (white is best) makes it much easier to cut out the subject and drop in a new background without the join being visible.

Frames and edges

A good frame or border can be the icing on the cake that turns a good picture into something really special. And this being the digital darkroom, there are no end of options available for giving your pictures the edge.

▲ Make sure the frame or border suits the subject matter and style of the picture. This oil-paint effect works quite well with an ornate frame (although you may soon tire of it!), while the simple, modern flower macro needs only a deep, plain black border.

▶ I like to experiment with using the picture itself to make a border. Here a slightly larger, blurred and toned copy of the photo has been placed behind the original, with a subtle drop shadow taking the place of a keyline.

It is with good reason that the paintings you see hanging in the world's greatest art galleries have frames that are almost as impressive as the works themselves. Placing a picture – whether an old master or a simple snapshot – into a frame immediately increases its apparent value; it isolates it from its surroundings and forces the viewer's attention on to the picture itself.

Often a simple black or white border is all that is needed to add a finishing touch to your masterpiece, and these can be added in seconds using the most basic software. If the photo contains a lot of white or black it can appear to bleed off into the frame, in which case a narrow keyline (in a contrasting colour) is enough to establish where the picture ends and the frame begins. Of course, the story doesn't end there; the digital darkroom

▲ A keyline establishes the edge of the picture and avoids darker areas bleeding into the border.

offers hundreds of possibilities for adding not only different frames, but unique edge effects to your pictures too. Many of the more home user-oriented programs feature hundreds of frames you can simply drag and drop on to your pictures, as well as a wealth of edge effects from simple vignettes to special masks that recreate the effect of torn paper or canvas. You can also create your own custom frames and edges.

It is vital that any frames, borders or edges that you add to your pictures suit the subject matter and style of the photo itself; not everything suits a heart-shaped vignette. Equally importantly, don't over-use any single technique; if you use the same effect on every single shot you take it will soon stop being your 'signature' style and become tired and repetitive. This also applies to overdoing it; many applications offer garish multi-coloured frames that, though undoubtedly fun, will overwhelm the picture and soon lose their appeal. Like buying a shirt or painting the walls of your living room, you need to look for something subtle enough to have lasting appeal and something that enhances what's inside.

▼ Simple soft-edged vignettes are easy to create and can add a timeless quality to the right picture.

▲ 'Natural' or distressed-edge effects need to be used with care to avoid overwhelming the picture. They work well with simpler, more graphic images. Both these frames are part of the Extensis PhotoFrame plug-in for Photoshop.

Special effects

Mention image manipulation to most people and the first thing they'll think of is wild and wacky special effects. They are the easiest way to totally transform your pictures in seconds, but need to be used with caution...

inclusion of several options in most filters (variables you can experiment with to adjust the strength and nature of the effect), the very ease that makes them so tempting means that most of the better ones have been so over-used that they have become clichés. Few serious digital artists ever use the preset effects built into editing applications; even if they do it will be as part of a long process, often involving several filters applied in succession or to multiple layered copies of the same image.

Of course, this doesn't mean that you shouldn't use special-effects filters; just that you shouldn't rely on them to add interest to every shot you take. After all, it is your photography you want people to admire, not the clever programming that creates such amazing effects. By all means experiment – the better you understand how the filters work, and how the various options affect the result, the more likely you are to be able to decide when, and how, to use them on a case-by-case basis.

▲ By selectively blurring parts of the image – and thus giving the impression of very limited depth of field – this aerial shot of the Hoover Dam is turned into a pretty convincing fake scale model.

▶ Cartoon effect.

Virtually all image-editing applications come complete with a huge library of built-in special effects (often called filters). Typically split into broad categories covering everything from blurring to colour changes to paint effects and distortions, filters offer the fastest way to transform your photos beyond recognition. But they are also powerful tools that, if used carelessly, can turn a perfectly good picture into a complete disaster. Despite the

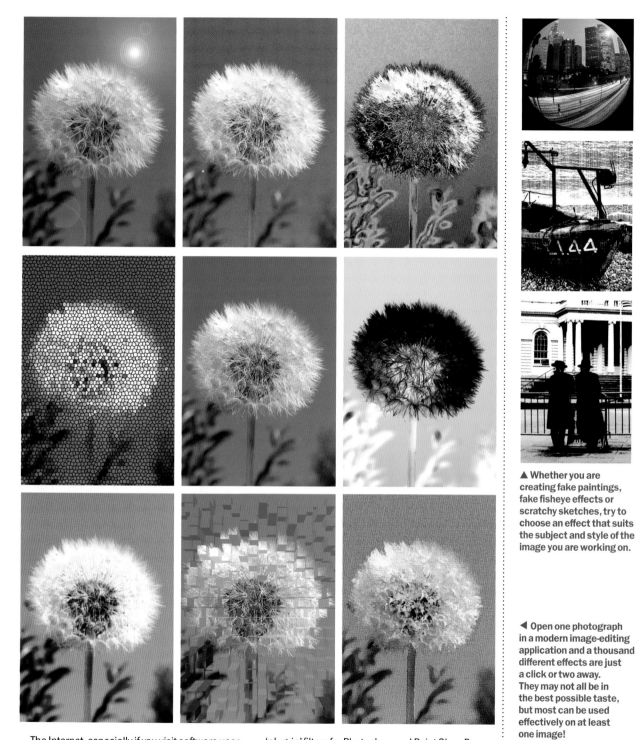

▲ Whether you are creating fake paintings, fake fisheye effects or scratchy sketches, try to choose an effect that suits the subject and style of the image you are working on.

◄ Open one photograph in a modern image-editing application and a thousand different effects are just a click or two away. They may not all be in the best possible taste, but most can be used effectively on at least one image!

The Internet, especially if you visit software user groups, is a fantastic resource for hints, tips and ideas on the use of the effects filters built into popular programs such as Elements, Photoshop and Paint Shop Pro; you can even download free 'plug-in' filters for Photoshop and Paint Shop Pro that will give you even more effects to play with.

One final word of advice; if you do experiment with filters, try to keep a record of what you do in case you ever want to repeat the effect on another photo.

Organizing and archiving

Digital camera users take on average ten times more pictures than their film predecessors, meaning organizing and finding any particular shot gets more and more difficult as time goes by. Start off on the right foot and you can make the process as easy as possible, and save hours in the future.

▲ **Thumbnail browsers (this is IrfanView) can make viewing images faster and easier until your collection starts to grow.**

▼ **Even simple things, such as using meaningful folder names, can make all the difference.**

In the first flush of excitement when you start taking digital photos you can easily shoot thousands of exposures without ever thinking about organizing or cataloguing your ever-growing collection of JPEGs.

Digital cameras typically save files with meaningless file names (DSCF0001.JPG, for example), and some even reset the numbering every

time you format the card, meaning you could end up with hundreds of pictures with exactly the same name. This can make finding a particular photograph difficult when you've taken a few hundred shots, and virtually impossible once you've taken thousands.

Keep a tidy house

For casual photographers taking a few hundred photos a year, the tools built into modern operating systems are usually enough to keep track of photos relatively easily. Both Windows and the Mac OS allow you to view a folder of JPEGs as thumbnails (tiny versions of the actual photos), although you may need to enable this option and switch views to see them. If you start as you mean to go on with a simple system for filing your images on your PC's hard drive, and you don't mind a bit of searching to find a particular image if you can't remember when or where it was taken, you can make do without any special software. Each time you copy images from your camera to the hard drive, create a new folder and give it a descriptive name that includes the date and location the pictures were taken (Spain May 2008, for example). If you use a more rigid naming system (050508_Spain) you will be able to view the folders chronologically in a listing, making it easier to find what you are looking for. It also makes sense to rename your files after you have copied and viewed them ('horse in field.jpg' is a lot more useful than P001002.jpg) – renaming 30 files now is a lot less tiresome than renaming 3000 in a few

years' time. Although I am a hoarder when it comes to photographs (working on the principle that even the worst shot might come in useful one day), I would recommend deleting any absolutely dire shots at the point of copying them, or you will just have an even bigger haystack to search through when looking for that elusive needle. It is also a good idea to turn off your camera's 'reset file numbering' option if you can, this will avoid duplicate file names and the associated risk of accidentally over writing old photos with new ones.

Such a system, using a sensible file and folder structure and descriptive naming (alongside a strict back-up policy), works well for smaller collections of photographs, but most digital camera users will eventually outgrow it. For one thing, it allows only two types of search, by date and by filename, and the use of subfolders to keep each 'roll' separate makes browsing your entire collection difficult.

Browsers and viewers

The next step up is to use a browser/viewer application to view thumbnails of entire collections of images without having to open each subfolder in

turn. There are numerous browsers available, both commercial and freeware or shareware. Most offer the basic function of viewing entire directories as thumbnails, with a double-click on any thumbnail opening the full-size image in a separate window. Most also let you view basic information about the images (JPEG files contain extra information, known as Exif data, that records camera settings, date and time and so on).

▲ Serious users might want to consider a professional image database such as Extensis Portfolio. Such products allow advanced searches and the ability to share databases across networks or even the Internet.

Something for nothing: bundle tools

▲ Fuji FinePix Viewer.

▲ Apple iPhoto.

Most digital cameras come with a basic image browser/viewer, although the sophistication varies considerably. Although such tools can be handy for checking a card full of files as you download them, few offer any true organization or cataloguing of your images, so become less useful once you've taken more than a few months' worth of snaps. Macintosh computers are shipped with iPhoto; this is a free (and fairly comprehensive) image database program with full keyword and search facilities, and much more besides.

▲ Windows has basic image browsing and viewing features built-in, but you can look at only one folder at a time.

something a little more powerful, and this is where image catalogue or database applications come into their own. This is especially true if your photo collection has outgrown your computer's hard disk and is stored on removable media such as CD or DVD; browsers can only work with files held locally (ie the disk containing the pictures must be in a drive to be viewed). Image cataloguing programs create their own thumbnails and store them in a database on your PC's hard drive. This makes viewing thumbnails quicker, and means the original file doesn't need to be present for you to find them; the application will prompt you to insert the correct disk only if you double-click on a thumbnail to view the full-size picture or edit it in your image editor.

Even more importantly, these are true database applications, meaning you can add a large amount of extra information to the thumbnails to make searching easier. This information, in the form of keywords, allows you to tame even the most extensive image collection spread over countless disks. You can, for example, find all images taken in the UK showing a horse with a blue sky in landscape format, as long as you have added the relevant keywords to every image. Some keywords will be generated automatically as you add images to the

The disadvantage of simple browsers is that they become less useful as your collection grows; looking for a particular photograph in page after page of thumbnails is time-consuming, and it's surprisingly easy to miss the picture you're looking for.

Catalogues and databases

Inevitably you will find that your collection of photographs has become so large that you need

CD inserts and contact

Once you start to archive or back up your pictures on to CD-R or DVD you need to develop a system for keeping track of what's on each disk. Although most image database or catalogue programs allow you to search and view thumbnails for images on disks not currently mounted, if anything were to happen to the database – or your computer – you could end up being left with hundreds of disks all looking the same.

For this reason, and to make finding images when you're not at the PC easy, many photographers produce simple contact sheets – printouts showing thumbnails and filenames – for every disk they burn. Many applications (such as Photoshop Elements) can produce contact sheets automatically. There are also several inexpensive programs designed specifically for the job available as shareware downloads.

Another good idea is to use a consistent naming system for the disks themselves – I simply use the date and a serial number – and to print the disk's name (or label) clearly on the contact sheet.

catalogue (date, time, filename, Exif information and so on), but the rest is up to you. As with file renaming it is a lot easier to do this as you go along than on a collection of thousands of pictures, so if this level of organization appeals to you I would recommend buying a cataloguing application as soon as you start, and rigorously keywording photographs as they are added. It takes no more than 10 minutes to fully keyword 30 photographs; doing the same for a collection of many thousands of pictures is such a huge job you'll have to take a week's leave just to make a start on it!

Backing up and archiving

There is an old truism in the computer world that no one ever thinks about backing up their data until the day they lose everything. It is difficult to understate the importance of regularly backing up your digital photographs safely. Hard disks, no matter how expensive they are or how well you look after them, will eventually fail, with no guarantee that the data can ever be recovered. Add the ever-present risk of infection by a virus or fatal system crash, and the possibility of the computer being either stolen or damaged and you can see just easy it is to lose a lifetime's precious memories.

Fortunately, keeping an archived back-up of your digital photos is neither time-consuming nor expensive. Most computers manufactured in the last few years have a built-in CD writer, and, if you buy in bulk, 700MB disks are now extremely cheap. It is worth buying decent branded disks, even if they cost a little more; so-called 'white label' disks are often less reliable, and may not have the longevity of premium brands. I would recommend keeping two sets of back-up CDs, one of which is stored well away from the computer (perhaps even in a different location, such as at work). It is also a good idea to produce a contact sheet showing thumbnails of every shot on each CD, and to use a sensible disk labelling system; something you will appreciate as your three or four CDs turn into tens or even hundreds.

A single 650 or 700MB CD is enough to hold anything from 50 to 1000 digital camera shots,

depending on the resolution and file format used. But what if you want to store more pictures on a single disk? Recordable DVD offers significantly higher capacities per disk (4.7GB is the most common) at a comparable price (per MB) to rewritable CDs (CD-R). The only serious downside is speed – both read and write speeds have a long way to go to catch up with CD – but the gap is slowly closing. It is also worth considering the risk associated with putting all your eggs in one basket – a scratch on a CD could lose you 100 photos; ruin a full DVD and you could lose thousands.

Ultimately the aim of any back-up and archive strategy is to minimize the risk of total loss of your photos, and by keeping more than one copy of each disk, backing up every picture as soon as it is taken and treating the disks you use as carefully as you would film negatives, you should be able to enjoy a lifetime of photography without disaster.

▲ Advanced image catalogues such as Jasc Paint Shop Photo Album offer much more than simple image browsing and searching. These include multi-image printing, image correction tools, emailing, web album creation and creation of slideshows.

▼ Recordable CDs and DVDs are an inexpensive and fairly secure way to archive and back up your digital photos.

Using and sharing

The beauty of digital photography is that you can do much more than just take and print your pictures. Once they are on your computer you will soon discover how to add colour and interest to a variety of online and printed projects.

▲ **Many simple image-editing applications offer built-in templates for using your photos to print cards, calendars and much more.**

The personal computer revolution has made it possible for anyone with the right equipment and a little patience to create professional-looking printed or online documents from the comfort of their own home. Whether you are producing a newsletter for your workplace or a website for your local history group you can add photographs in seconds at virtually no cost once you've got a digital camera. And that's only the start of it; many image-editing applications come complete with templates for producing cards for every occasion, calendars, certificates and even dummy magazine covers; all featuring your digital photos, and all only a few clicks away. Applications such as Microsoft's Publisher and FrontPage make the process of producing printed and online documents as simple as possible through the use of 'wizards', and even your word processor should be able to work with JPEG photos to produce rich, colourful reports, newsletters and websites. You can print the results yourself using a home photo inkjet printer, which is fine if you're only producing a few copies, or you can take the files to a print shop to be printed. In the latter case ensure you check beforehand that they can accept files in the format you are supplying.

Sharing your pictures

Film photographers have never had an inexpensive way of sharing their work with friends, family or the wider world. Prints can, of course, be handed around, collected in albums or given pride of place on the wall in a gilt frame, but to share them with others requires you to be physically in the same room, or to have expensive duplicates made. And that's not to mention the cost and time involved in posting them to relatives abroad. Digital photos,

on the other hand, can be reproduced in seconds and shared with anyone, anywhere, any time via the Internet. If you need to send pictures to anyone without a Internet connection you can simply burn them on to disk and pop them in the post. If they don't even have a computer you can always fall back on good old-fashioned prints in an envelope, or use inexpensive software to produce CDs or DVDs that can be played in a standard home DVD player. And if they don't have a DVD player, you can even record slideshows on to VHS tape.

With some inexpensive software and a little practise you'll soon be using your digital photos in a wide range of print and online projects.

Slideshows

Most image viewers/browsers (as well as some image-editing applications) have a basic built-in slideshow feature. This allows you to choose a folder of images and have them displayed consecutively (or randomly), full screen, with a preset delay (or using a mouse click to move to the next file). Many also allow you to choose between one of a selection of preset transitions, although specialist slideshow applications tend to be more sophisticated in this respect, with a much wider selection of dissolves and cross-fades. Many programs also allow you to 'bundle up' the whole slideshow into a single file that can be emailed as a self-running application, allowing you to share your pictures with anyone, whether they own the same software or not. It is now common for such slideshow applications to allow you to add titles, background music and even a recorded commentary, and most can even do the emailing for you! Many digital cameras also have a slideshow feature in playback mode and a video output socket that attaches to most modern video recorders and TVs, allowing you to view your pictures on the big screen – and even to record them on to VHS for sharing with anyone without access to a PC or DVD player.

▲ There are many applications designed to create slideshows that can be shared with anyone who has a PC.

▶ The latest programs use advanced graphics to produce fully animated 3D slideshows.

The wider world

Over the past few years, a huge industry has grown around the idea of online photo sharing. The idea is simple; once you've signed up you can upload your JPEGs to the site's server, and anyone you give the link to can visit an online photo album, view thumbnails and full-size images, and even slideshows. Most sites give you a small amount of free storage, but charge for unlimited space (there are exceptions, so look around before choosing which one to use). Virtually all photo-sharing sites also offer an online printing service, whereby anyone you give the album password to can order prints and other photo gifts using a credit card and have them delivered by post a few days later. If you intend to use these services, it is best to use a provider based in your own country.

As the demand for such services increases, you can be sure not only that prices will drop, but that the range of services on offer will increase and broaden; many now offer custom frames for your prints, as well as basic image corrections, such as the removal of red eye or cropping. The value of online photo sharing and print services increases dramatically when you have unmetered, broadband Internet access, something that is becoming more common in most developed countries. Once you have set up an account you can upload (and download) your photos from just about any computer in the world; the wonder of Internet cafés means it is easy to share your holiday photos with friends and family before you even get home!

▲ Online photo-sharing services make much more sense than clogging up everyone's inbox with huge emails. They offer a range of other services, most significantly the option to turn your digital photos into a wallet of real photographic prints. Most will also archive your shots onto CD for you at the same time.

Beyond prints

As with film processing before it, the digital printing industry has come up with a plethora of ways to use your photos on gifts of all shapes and sizes. These are surprisingly popular, not only for families looking for something a little different to give to grandparents, but for serious photographers wanting to put their masterpieces to use in their homes or offices. As well as photos on t-shirts and mugs, many of the online print providers now offer an enormous selection of items both useful and decorative that can be adorned with your favourite photo. From mousemats to wall-hangings to doormats, coasters, posters, calendars and even fabrics, all you need do is fill out the order form and attach your JPEG. Obviously, the quality of the result will depend to a certain extent on how good your camera is, and how high its resolution, but you'd be surprised at how good some of these gifts can look if you choose the right image.

▲ From t-shirts to mugs to jigsaws, mousemats and giant posters, your favourite shot could soon be adorning a wide range of useful and decorative gifts.

Photos on TV

It is now easier than ever to share your digital photos with anyone who has a home DVD player, or to view your pictures directly on the TV screen. Software such as Ulead's DVD PictureShow allows you to turn a folder of JPEGs into an interactive slideshow with titles, menus and a soundtrack in a few minutes. The results can be burnt on to DVD (if you have a DVD writer) and played in just about any domestic DVD player. If you don't have a DVD burner, fear not; you can also burn CD-R in a way that can be read by most (though not all) modern DVD players. VideoCD is not going to show your pictures in their best light (the resolution is appalling), but it's better than nothing.

If all you want to do is look at your pictures on your big-screen TV, the process is even easier. Many (although by no means all) digital cameras have a video-out connection that attaches directly to your television (or VCR); simply switch to playback and you can watch a slideshow from your favourite armchair. If your camera doesn't have a video-out socket you can simply buy an inexpensive card reader-cum-video viewer, which will accept any digital camera memory card and display the pictures on a compatible television.

Glossary

Like anything in the computer world, digital photography has more than its fair share of jargon; here's a quick rundown of some of the most common terms.

Analogue Continuously variable.

Anti-aliasing Smoothing the jaggy edges (aliasing) of selection or paint tools in digital imaging applications.

Aperture Variable opening that controls the amount of light passing through the lens.

Artefact A defect or flaw in a digital image.

Bit A binary digit, basic digital quantity representing either 1 or 0. The smallest unit of computer information.

Bitmap An image made up of dots, or pixels. All digital cameras produce bitmap images.

Blooming Streaks or halos seen around bright reflections or light sources in digital pictures. Caused by leakage of an electrical charge between CCD elements.

Burst mode (Continuous shooting) Digital camera feature allowing a series of shots to be taken in rapid succession.

Byte Standard computer file size measurement: contains eight bits. Other common units include kilobyte (KB; 1024 bytes), megabyte (MB; 1024KB) and gigabyte (GB; 1024MB).

Calibration The process of adjusting a device – scanner, screen, printer etc so it captures, displays or outputs colour in an accurate and consistent way.

Camera shake Blurring of an image caused by movement of the camera during a long exposure.

CCD (Charge-Coupled Device) Converts light into electrical current. The digital camera equivalent of film.

Cloning A feature of many image-editing software programs where part of an image can be duplicated over another part. Used to seamlessly paint out blemishes and for special effects.

CMOS Complementary Metal-Oxide Semiconductor – an alternative to the CCD as an image sensor.

CMY, CMYK (Cyan, Magenta, Yellow) Colour printing model used by dye sub and low-end inkjet printers. CMYK adds black (Key) and is used for most professional printing. Most modern photo printers add pale cyan and pale magenta inks for improved pastel tones.

Colour cast An unwanted presence of a single colour in an image, usually caused by a mismatch between the light source and camera's white balance setting.

CompactFlash Type of digital camera removable storage media. Available in two types (type I and the thicker type II).

Compression The 'squashing' of data to reduce file size for storage or to reduce transmission time. Compression can be 'lossy' (such as JPEG) or 'lossless' (such as TIFF). Greater reduction is possible with lossy than with lossless schemes.

Contrast The range of tones in an image between highlight and shadow.

Cropping tool A tool found in image-editing software. Allows you to trim an image.

Depth of field The area in front of and behind the focused point that is sharp.

Dialog box A window in a computer application where the user can enter options or change settings.

Digital zoom Camera feature involving enlarging the central part of an image to give a similar effect to a telephoto lens (in fact it is simply a crop).

Direct print capability A feature on many digital cameras allowing the printing of saved images via a special printer connected directly to the camera's USB port.

Dpi (Dots per inch) A measurement of the resolution of a printer or video monitor (see also ppi).

DPOF (Digital Print Order Format) A system that allows digital camera owners to select images and quantities for printing in-camera. Also supported by some direct connection printers and high-street digital printing shops.

Driver A software utility designed to tell a computer how to operate an external device (ie a printer).

Electronic viewfinder Tiny LCD screen mounted inside a viewfinder on a digital camera as an alternative to a purely optical system.

Exposure The amount of light falling on to the CCD of a digital camera. Exposure is determined by the combination of shutter speed (duration) and aperture (intensity).

Exposure compensation The ability to increase or decrease the exposure set by the camera's automatic system. Usually measured as + or - 'EV' (exposure values).

Feathered edge Soft edge to a mask or selection. Allows seamless montage effects.

File format The way that the information in a file is stored. In digital photography common file formats include JPEG and TIFF.

Filter Photo-editing software function that alters the appearance of the image being worked on.

Focal length The attribute that determines the magnification and field of view of a lens.

Focus Adjusting a lens so that the subject is recorded as a sharp image on the CCD.

Fringe A (usually) unwanted border of extra pixels around a selection caused by the lack of a hard edge. Can also describe an unwanted artefact in digital camera pictures, caused by lens defects or problems with the CCD itself.

Grayscale What photographers would call a black and white image, contains a range of grey tones from black to white.

Hue/Saturation Colour can be defined by hue, saturation and brightness, where hue is the colour and saturation the strength. Hue/Saturation controls are useful for altering colours without effecting overall brightness or contrast.